S0-AJD-385

CROSSROADS of AMERICAN SCULPTURE

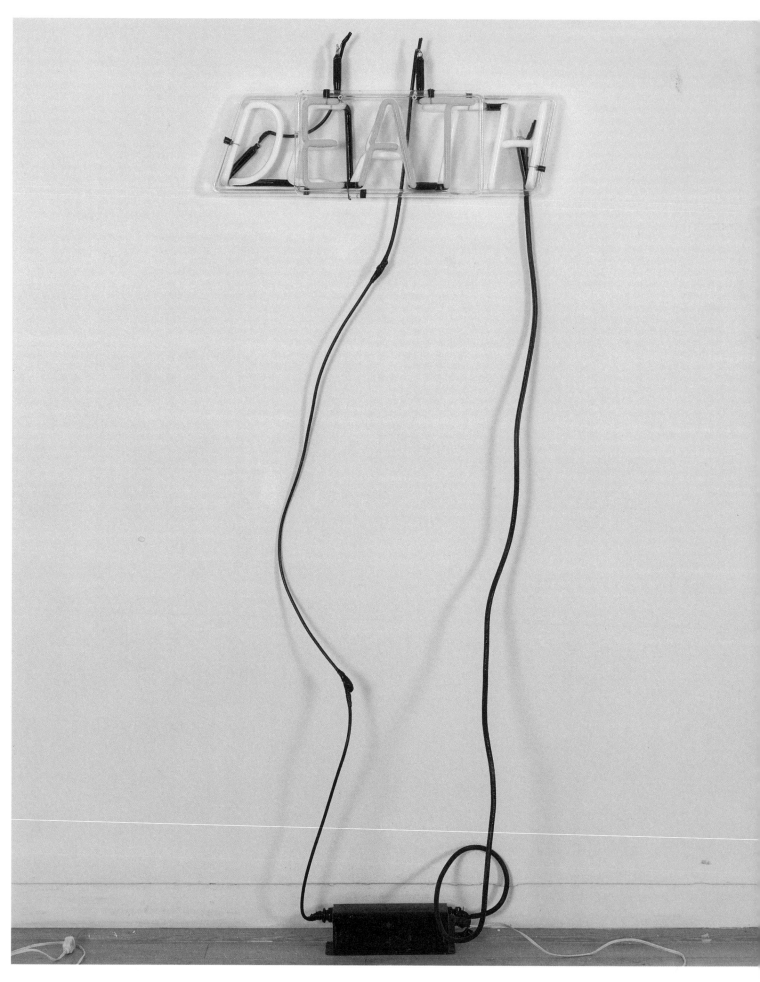

Yeshiva University Museum

WITHDRAWN

CROSSROADS

of AMERICAN SCULPTURE

HOLLIDAY T. DAY

with contributions by DORE ASHTON and LENA VIGNA

Yeshiva University Museum

DAVID SMITH · GEORGE RICKEY · JOHN CHAMBERLAIN · ROBERT INDIANA
WILLIAM T. WILEY · BRUCE NAUMAN

This book was published in conjunction with an exhibition of the same title organized by the Indianapolis Museum of Art. It was on view at the Indianapolis Museum of Art from October 14, 2000, to January 21, 2001, and at the New Orleans Museum of Art from June 30 to September 2, 2001.

Library of Congress Cataloging-in-Publication Data

Day, Holliday T.
 Crossroads of American sculpture : David Smith, George Rickey,
 John Chamberlain, Robert Indiana, William T. Wiley, Bruce Nauman /
 Holliday T. Day ; with contributions by Dore Ashton and Lena Vigna.
 p. cm.
 Exhibition catalog.
 Includes bibliographical references and index.
 ISBN 0-936260-72-6 (hardcover : alk. paper)
 1. Sculpture, American--Exhibitions.
 2. Sculpture, Modern--20th century--United States--Exhibitions.
 I. Ashton, Dore. II. Vigna, Lena, date.
 III. Indianapolis Museum of Art. IV. Title.
 NB212 .D39 2000
 730'.973'07477252--dc21
 00-009526

ISBN 0-936260-72-6

Published by the Indianapolis Museum of Art
1200 West 38th Street, Indianapolis, Indiana 46208-4196

All images of George Rickey's and William Wiley's work are used
with kind permission from the artists.

Edited by Jane Graham
Photography by Hadley Fruits, except as noted on page 243.
Photography coordinated by Ruth Roberts.
Designed by Antenna, Indianapolis
Printed by Design Printing, Indianapolis

Frontispiece:
Bruce Nauman
Eat/Death, 1972
neon tubing with clear glass tubing suspension frame
7 1/2 x 25 1/4 x 2 1/8 in., edition 2/6
Private collection, Courtesy of Sonnabend Gallery
©2000 Bruce Nauman/Artists Rights Society (ARS), New York

On the cover:
David Smith
Untitled (Forgings), about 1955 (detail)
exhibition print
black and white photograph
11 x 14 in.
The Collection of Candida and Rebecca Smith, New York, N.Y.
©2000 Estate of David Smith/Licensed by VAGA, New York, N.Y.

CONTENTS

08 FOREWORD

10 PREFACE

14 DIALOGUES WITH TRADITION: REFLECTIONS ON SIX AMERICAN SCULPTORS
 DORE ASHTON

26 SCULPTURAL CROSSCURRENTS
 HOLLIDAY T. DAY

40 INDIANA BORN: THE EARLY LIVES OF THE ARTISTS
 LENA VIGNA

61 CROSSROADS OF AMERICAN SCULPTURE
 HOLLIDAY T. DAY

 DAVID SMITH AND GEORGE RICKEY IN BLOOMINGTON, INDIANA, 1954-1955

 JOHN CHAMBERLAIN AND ROBERT INDIANA IN CHICAGO IN THE EARLY 1950s

 WILLIAM T. WILEY AND BRUCE NAUMAN IN CALIFORNIA IN THE EARLY 1960s

228 GROUP EXHIBITIONS

238 LENDERS TO THE EXHIBITION

240 ACKNOWLEDGMENTS

243 PHOTOGRAPHY CREDITS

244 ABOUT THE AUTHORS

246 INDEX

THE TERM "CROSSROADS" means, of course, the place at which roads intersect. But in a broader sense, it can signify "a crucial point or place," or "a place where two or more cultures meet." It applies in all these senses to the exhibition *Crossroads of American Sculpture.*

The last half of the century just ended was, indeed, a crucial period in the evolution of modern sculpture, a period that saw the introduction of motion, color, new materials, new forms and new ideas. It also was a period during which cultures met and sometimes clashed, as one school or movement succeeded another in rapid succession.

Each of the six artists represented in this catalogue and the exhibition it accompanies has played a significant role in shaping the course of sculpture in our time. Each has produced a body of work that points toward one of the several routes followed by subsequent generations of sculptors.

Coincidentally, each of the six artists celebrated in this exhibition has close ties to Indiana—a state known as the "Crossroads of America" in recognition of the convergence here of major ground transportation routes. Political geography, however, is not a concern of this exhibition. Rather, this assembly of significant works by six of America's most important visual artists is a true crossroads in the sense of being a gathering place where viewers can encounter seminal aesthetic ideas that have helped shape the world in which we live.

We are grateful to John Chamberlain, Robert Indiana, Bruce Nauman, George Rickey and William T. Wiley for their assistance and support. David Smith's daughters Candida and Rebecca Smith and the executive director of the artist's estate, Peter Stevens, have been generous with their help and advice and their loans to the exhibition. We are, of course, grateful to all of the lenders listed in the acknowledgments section for making their works available to us.

Crossroads of American Sculpture was conceived by my colleague Holliday T. Day, senior curator of contemporary art at the Indianapolis Museum of Art. Her vision has informed the exhibition at every point, and her energy and effort have brought it into being. Holly joins me in expressing gratitude to her fellow catalogue

authors, Dore Ashton and Lena Vigna, and to our museum colleagues Stan Blevins, Vanessa Burkhart, Jane Graham, Susan Longhenry, Sherman O'Hara, Sue Ellen Paxson, Amy Sorokas and Hélène Woodard.

I am delighted that this exhibition will travel from Indianapolis to the New Orleans Museum of Art, where it will coincide with the inauguration of an important new sculpture park. I congratulate my friend John Bullard, director of the New Orleans Museum of Art, and The Sydney and Walda Besthoff Foundation, whose generosity has led to the creation of the new park.

Bret Waller, Director
Indianapolis Museum of Art

THE CENTRAL PROPOSITION OF THE EXHIBITION *Crossroads of American Sculpture* and this catalogue is to examine how American ideas in sculpture were formed in the second half of the twentieth century. The exhibition first examines the transmission and transformation of an idea or motif over time from one generation to the next. Second, it examines the early lives of the six artists. Finally, the exhibition looks at three different time periods when pairs of these artists lived and worked in the same geographical area.

Other artists of these three generations and other places could have been chosen for this examination, but the motivating factors in the creation of twentieth-century American sculpture would probably be the same. Today, scholars generally approach the study of art using methods that are very different from the methods used in this exhibition. First, despite the various approaches that art historians take, ranging from connoisseurship to those based on feminist and social theories, the results of their studies are not as different as the intellectual battles would indicate. Historians, critics, and curators still focus on either of two things: a single artist's life work or the development of a movement or style among a group of artists. In either case, the artist or the movement is isolated from other art events or other movements taking place at the same time almost as if they did not exist. Historians ignore these conflicting items. It is interesting to note how often these six artists exhibited together although their work was informed by different ideas. (These exhibitions are listed in an appendix in this catalogue.) While one might expect these men to have shown together in a large, diverse exhibition like *American Sculpture of the Sixties* (1967) or *200 Years of American Sculpture* (1976), others seem more curious. *The Art of Assemblage* (1961) included Smith, Chamberlain, and Indiana, and *When Attitudes Become Form: Works, Concepts, Processes, Situations, Information* (1969) included Nauman and Wiley. *Pier + Ocean: Construction in the Art of the Seventies* (1980) included Nauman and Rickey. One could say that, despite the differences in focus and in age, these artists knew each other's work through first-hand experience and were seen by others as appropriate to be shown together for whatever reason. Thus, opinions of artists and curators are not formed in the vacuum of either place or

consciousness, as art historians often suggest. While each artist may perceive that his development as an artist occurred in one place, often ideas and events little noted by him bear on his development and the development of others far away. An identical art school can lead to two very different or two very identical experiences. The same could be said for the childhood experiences of an artist. There are many common threads among the childhoods of these artists, and there are great differences as well.

Dore Ashton's essay places the work of the six artists in the general context of sculpture being made during the second half of the century. Ashton wrote about these artists as their work was being produced and exhibited without the hindsight that tends to emerge in art historical texts that follow art movements or an artist's ascendancy. Because she saw the work when it was first shown in galleries, Ashton brings a special perspective to the art within this time period.

Although each artist's work in the exhibition is displayed within the context of a retrospective of his work, it has also been chosen to show the crosscurrents of ideas that permeate it from one generation to another. While the works could be arranged in the galleries thematically, a sense of the context within which they were made and a sense of the transformation of ideas that took place over the years within an artist's work and within art as a whole would be lost. Forms should echo in the viewer's mind rather than be compared one-on-one, especially when the intentions of the artists in making those forms were so different. If there is a sense of déjà vu for the viewer, it is perhaps because that idea has been seen somewhere before in the exhibition in another form.

Although real time only moves forward, there is a circularity to art that can be likened to walking on a Moebius strip, where one is never completely inside and never completely outside one's own environment. Human emotions and human concerns remain although exterior appearances change from age to age.

Holliday T. Day, Senior Curator of Contemporary Art
Indianapolis Museum of Art

Dialogues (WITH) Tradition

REFLECTIONS ON SIX AMERICAN SCULPTORS

BY DORE ASHTON

ONE OF THE MOST PRESCIENT OBSERVATIONS early in the twentieth century was Yeats's thought that the center could not hold. It did not. The experience of restless artists throughout the century, the facts of their art history—that is, the works of art—seem to confirm Yeats's augury. Yet, every artistic event, finally, can be seen as an attempt to challenge that awful apprehension. Artists have gone to the outer edges of experience, have used homeopathic doses of disharmony, disjunction, disequilibrium, habit-breaking, and sheer chaos to test, and in a sense, disprove the premonition.

Throughout the twentieth century there were repeated attempts to release sculpture from its traditional status as solid object sitting in its own still enclosure. Art historians have proposed that the experimental tenor of twentieth-century art is pitched to the scientific revolution that revealed a new concept of space as wedded to time. Quite possible. And they have linked the rupture with centuries of convention to the social and political upheavals that tormented so many generations. Also possible. A thousand reasons can be adduced, and have been, to explain the unprecedented velocity of shift and change in twentieth-century artistic endeavors; and, among them all, the only stable element remains the individual desire, evident in the entire history of art, to move on.

Where artists moved—for move is always from somewhere—after the Second World War, is not easy to chart. In the United States, there was a singular release of artistic energies that saw artists exploring all the idioms proposed in the early modern tradition, expanding them, and finally superseding them. Yet, despite the extraordinary effort to open new paths, most artists after the Second World War continued, as artists always have, to initiate dialogues with tradition. They carried with them in their minds' eyes the audacious examples of artistic invention of previous generations and, depending on their temperaments, either sought to extend the ideas of their predecessors or to overwhelm them with entirely different approaches. Either way, what Harold Rosenberg so aptly called "the tradition of the new" prevailed.

In sculpture, the break with centuries of tradition has always seemed more radical, and has led to attempts to create an overview that could encompass the diversity of direction. Linear history (not always so obliging as to be totally convincing)

highlights change and focuses on the theories of Boccioni; the practices of the Russian constructivists; the phenomenal experimentation of a single force, Picasso; and the equally impressive accomplishments of Brancusi, not to mention a host of other sculptors who added momentum to the tradition of the new. Brancusi notwithstanding, the most obvious shift in sculptural practice, historically speaking, has been the move away from modeling and carving to what William Seitz called "assemblage." In 1961, Seitz put forward his convincing thesis that the hallmark of the modern period was precisely the impulse to assemble, visible ever since Picasso's 1912 construction of colored papers and string added up to a cubist guitar. The exhibition *Assemblage* at the Museum of Modern Art included an exceptionally broad range of objects that, Seitz said, shared two characteristics: They were "predominantly assembled rather than painted, drawn, modeled or carved," and "entirely, or in part, their constituent elements are pre-formed natural or manufactured materials, objects, or fragments not intended as art materials." (William Seitz, *The Art of Assemblage* [New York: Museum of Modern Art, 1961], 6.)

Seitz's exhibition was international, for the sources of all this inventive energy were available to artists everywhere. The question of what is American in postwar American sculpture, then, can only be broached gingerly, and is probably expendable. Exuberance, often popularly associated with American culture and certainly evident in our postwar art history, is a quality that exists in most objects that we deign to call art. An exhibition of different generations, such as this one is, offers the possibility of using that old art historical tactic of generational distinction; and, as all the artists represented happened to be born in the United States, it would be a convenient way to impose some ordering principle on "American Sculpture."

If I take that path, I would have to designate both David Smith and George Rickey as belonging to a generation of American artists who readily conversed with the recognized predecessors in their formation, while sculptors of the following generations were less available to what is commonly called "influence," and were wary of anything that carried with it a tradition, no matter how new.

Smith, born in 1906, belonged to the generation of abstract expressionists who experienced the enormous upheavals of the 1930s and emerged, after the war, with a determination to supersede the ways of the past, which is to say, the several paths that had been opened by predecessors. But Smith, who can be compared with other members of his generation, such as Arshile Gorky, worked on the premise that to learn from great mentors, most particularly Picasso, was his principal task before

embarking on his own absolutely personal esthetic journey. Rickey, born in 1907, similarly and unabashedly learned from distinguished predecessors, specifically Alexander Calder and Naum Gabo. Both Smith and Rickey saw themselves as belonging to the great modern tradition. All the other artists in this exhibition began their sculptural inquiries and their general education after the Second World War when the great race was on to break with, rather than to incorporate, the past. A strong mood that favored discontinuity over continuity—the two ingredients that always seem to be vying in esthetic matters—permeated the American art world during their formative years. If there *was* a center, they willed themselves away from it.

Smith's concourse with history took many forms and never inhibited his fertile imagination. His training under John Sloan at the Art Students League not only brought him into the modern art world, but also into the world of political commitment. He always recalled that from Sloan he had gotten "cubes and anarchy." From his fellow students he learned of modern literature, and he never feared using literary motifs, thinking of James Joyce as one of his artistic influences. It was perhaps Smith's singular openness to experience of many components that enabled him to move so swiftly, so emphatically into the fields prepared by the early moderns. By assiduously following the artistic news from Europe, Smith learned, through reproductions, of Picasso's adventure with welding in the late 1920s. Once Smith saw the spare sculpture composed of welded rods that Picasso initiated in Julio Gonzalez's workshop, he immediately understood the potential of assembled sculpture. Trained as a painter, Smith continued all his life to think of himself as a painter—that is, one who assembles forms on a plane—who could assimilate the things of the world in his compositions. That is why, when he observed Picasso incorporating ready-made shapes, such as that of an ordinary kitchen colander, he set about finding ways to use the scraps and objects in his own environment, first in the Brooklyn foundry and later in the rolling landscape of upstate New York.

From Gonzalez he surely took inspiration for the use of line to induce an illusion of movement, but also, when the spirit moved him, to suggest calligraphy on a single plane. His play with letters and with unfamiliar alphabets (his use, for instance, of Greek "y's" and, later, Greek inscriptions in his *Medals for Dishonor* was possible thanks to his friendship with a Greek artist rather than his own scholarship) led him to further complications when, for instance, he scumbled in a mad penmanship the surfaces of his *Cubi* sculptures. There was no place that Smith was not willing to go, at least experimentally, and no shibboleth he honored in sculpture's his-

tory. When he saw a possibility, he tried it. Once he had seen Giacometti's *Palace at 4 A.M.*, Smith realized that a narrative in a stage-like setting was possible, and he set about making sculptures that suggested rooms, their ambiguous contents offering a cryptic biography. Throughout his oeuvre, up to the amazing accomplishments of a month-long sojourn in an abandoned foundry in Italy, which produced the *Voltri* series, Smith can be seen moving from form to form in a continuous experimental process that he saw as a way to create metaphors for the way he apprehended the world. He saw his work as "a chain of hooked visions" of what he called "realistic" elements, such as the arrangement of things under an old board, stress patterns, fissures, tracks of men, animals, machines, broken parts, and the force lines in rock or marble. These things, he saw, could be "transformed in analogy" into his own idiomatic expression (from David Smith, "The Language Is Image," *Arts and Architecture* 69, no. 2[February 1952]: 33).

Where Smith saw his work as analogy and metaphor, George Rickey saw his task as the elimination of metaphor. In a Kantian way he sought to reveal the esthetic allure of movement itself, movement-in-itself. Like Smith, Rickey looked to one of the early modern traditions and mined its possibilities. He has on many occasions discussed the instigators of his own sculptural thoughts, such as Alexander Calder, whose experiments with kinetics produced a lyrical oeuvre, and Naum Gabo, whose theories he eagerly embraced and extended. Gabo and Antoine Pevsner had summed up the aspirations of their generation in the early years of the Soviet Union, with ideas obviously drawn from what they knew of the prodigious new scientific theories of matter. They took what Rickey refers to as a "constructive" approach that paralleled the forces of nature. In Gabo's rather ecstatic "Realistic Manifesto," written in 1920, he lauded the growth of human knowledge "with its powerful penetration into the mysterious laws of the world which started at the dawn of this century." He declared: "Space and time are the only forms on which life is built and hence art must be constructed....we construct our work as the universe constructs its own." And, referring specifically to sculpture, Gabo declared that he renounced mass as a sculptural element. Many years later Gabo amended his manifesto, stressing the emotional character of his vision, asserting that "the human mind desires the sensation of real kinetic rhythms passing in space." In 1937 he felt that mechanics had not yet reached the stage where it could produce real motion in a sculptural work "without killing, through the mechanical parts, the pure sculptural content," and he said the solution of the problem would be the task of future generations.

Rickey was a member of the future generation that, through conviction, deep thought, and natural skill, found solutions to Gabo's problem in several stages of their work. In an essay written in 1965, Rickey reviewed his formative experiences as a painter trained in the cubist idiom, then as a burgeoning sculptor who took his first and only welding lesson from David Smith, and finally as a creator of kinetic sculpture in which he worked with "the simple movement of straight lines, as they cut each other, slice the intervening space and divide time, responding to the gentlest air currents." He pointed out that his technology was borrowed from crafts and industry and has more in common with clocks than with sculpture. Like Smith, he availed himself of industrial materials and the tools to shape them, but unlike Smith, he was impelled to use them only to abet the creation of virtual spaces. In increasingly fine-tuned techniques that depend on the laws of kinetics, Rickey succeeded in finding the essential equilibrium, or fulcrum, that could produce, without "killing through mechanical parts," pure sculptural content. As he wrote, "Ideally, the bearings themselves should so shift the center of gravity with turning (cam action) that gravity itself becomes the brake" (George Rickey, "The Metier," *Contemporary Sculpture, Arts Yearbook* 8 [1965]: 164).

Both of these strong figures in the history of American sculpture asserted their allegiance to the "real," and both assembled their evidence (with the rare exception, as in Smith's elegant forgings). Smith, who had been touched by the permissions of surrealism and the mystique of the found object, preferred to use found materials, such as old ploughshares or bits of engines, for their associations, their metaphoric powers. Rickey, touched by the quest for universals—the principles of the universe—locates the "real" in natural and invisible "forces," such as the wind, and wishes to make "a simple declarative statement," which nonetheless reveals an emotional content that can always be seen as the esthetic increment in the flow of man's artistic creations. For all Rickey's fealty to the laws and forces of nature and science, his oeuvre—which he has said seeks to express the "morphology of movement"—carries affective elements, such as the sheer sensuous character of drift found in skies and waters. Morpheus, after all, was the shaper. Both Smith and Rickey avail themselves of industrial and manmade materials and all available technology, but always in the service of what they confidently believed was art.

Subsequent generations have been far less convinced that there are boundaries between real experience and esthetic experience—the real things of the world and their distillation into "art." In fact, the works that emerged after the first postwar

decade were often consciously polemical, challenging even the existence of something called "esthetic" experience. In this, too, there were historic precedents–the Dada movement during the First World War and Surrealism in the 1920s and 1930s. If we resort to the decade approach, there are a number of observations that can be made about the 1960s, the period during which the four other artists in this exhibition made their public debut.

For one thing, there was a natural enough rebellion against the prevailing tendency then called "abstract expressionism." It occurred in several camps. The most apparent salvo was launched by artists who, in the view of one of its practitioners, Roy Lichtenstein, look out into the world and accept its environment. The Pop artist called attention to what industry produced, either by quoting industrial objects, as Jasper Johns did with his beer cans and Andy Warhol with his Brillo boxes, or satirizing them, as did Claes Oldenburg. The so-called Minimal artist, on the other hand, eliminated the things of the world and tried, as well, to eliminate the elements of illusionism and analogy. They prolonged an early modern process of elimination (such as the cubist elimination of vanishing-point perspective) in a drastic way. Like Bartelby the Scrivener, they "preferred not" to do any number of things—especially in sculpture—that their predecessors had established. But even Minimalists, such as Donald Judd and Robert Morris, sought for grounding in modern ways of thinking of the universe, and such ideas as non-hierarchical composition and periodicity can be found in their works. Sometimes, the way of thinking of sculpture veered toward untried but existent ideas in new psychology or philosophy. Experiments with anti-form (when Richard Serra, for instance, threw liquid lead against the wall) led to what was called "process" art, in which the contingent and random were reckoned into the final work. Such contingencies as nature provided also informed the movement that sought to create three-dimensional works outside of the purviews of galleries and institutions, such as the creation of earth works and so-called conceptual works: Robert Smithson's *Spiral Jetty* (contingent upon the tides in a remote place), for instance, and Sol LeWitt's spare geometric constructions based on what he called an "idea concept" that he said was far more important than "form."

What was apparent during the 1960s was a strong will, expressed in many directions, to demolish esthetic preconceptions, and, of course, to move on. In sculpture, this took the form of expanding the boundaries of conventional definitions to the point that, at least in the work of certain conceptual artists, it flickers away into verbal exclamations in neon. As a symptom rather than an explanation, it was dur-

ing the 1960s that the "perennial one-man movement," as de Kooning called Marcel Duchamp, re-emerged as a ubiquitous presence in the formation of young artists.

Both John Chamberlain and Robert Indiana had been included in Seitz's *Assemblage* exhibition, behind which hovered Duchamp's varieties of experiences. Chamberlain, born 1927, and Indiana, born 1928, both worked with found materials, but they assembled their works to different ends. Chamberlain began his sculptural odyssey by ingesting the welded techniques and forms of David Smith. But like others of his generation, he was impatiently seeking to move on. He found the means in his discovery of automobile graveyards as suppliers of ready-made materials. Ready-made, that is, only in their irregular and torn appearance, and their strong colors. In the way he assembled these fragments of industrial origin, Chamberlain appeared to perform, in three dimensions, compositional rites similar to those of the painters called abstract expressionists, most especially de Kooning. Many of Chamberlain's sculptures of the early 1960s were large reliefs—that traditional sculptural form that always fuses painting and sculpture. In them, the randomness of wreckage is not salient, (though the forms do carry the suggestion of the machine forces that compressed them); nor is the identification of the function of the material, as in motor vehicles, of great relevance. Rather, there is a readable composing of light and shadow, convex and concave forms, and evident concern for coherence—all characteristics that can be safely consigned to the modern tradition. Chamberlain's experimental attitude might lead him later to such feats as the formation of urethane foam masses, or the shaping of brown paper bags coated with polyurethane resin, or crushed aluminum foil treated with acrylic lacquer, but his experiments with soft or unaccustomed or unartistic materials are never as prepossessing as his polychrome sculptures in steel. Form, and not the antiform courted by others, reigns in his best work, which stands and thrusts into environing space within the limits suggested by the commonplace notion of sculpture.

Robert Indiana, who like Chamberlain was drawn to New York in the mid-1950s, brought with him a love for literature (he wrote poetry) and a strong will to avoid what he called being "an internationalist speaking some glib Esperanto." When he exhibited in the *Assemblage* exhibition of 1961, he noted, nevertheless, certain international art historical associations. He wrote that his piece *Moon* had a very distant relative, Dada, but in his description of his technique, it appears not so very distant: "The technique, if successful, is that happy transmutation of the Lost into the Found, Junk into Art, the Neglected into the Wanted, the Unloved into the Loved,

Dross into Gold...." (*Robert Indiana* [Philadelphia: Institute of Contemporary Art, University of Pennsylvania, 1968], 54). Certainly, what arrested attention in Indiana's earliest constructions was his fusion of signs, which include numbers and letters, and found objects, such as bicycle wheels. In this practice, he comes closer to the Dadaist Kurt Schwitters than to any of his contemporaries. But in terms of his conscious decisions, his work inevitably calls up certain poetic fathers, most particularly William Carlos Williams, whose consecration of place and whose search for signs "in the American grain" was of signal importance to Indiana. In general, with his assembler's technique, Indiana produced stelae that for many conjured up not only his own waterfront milieu in Manhattan, but Midwestern barns and painted signs that only existed in America. His insistence on emblazoning, and suggesting heraldic provenience, distinguished him from others who were deploying junk and found materials. Many of his standing pieces were likened to the ancient form of the herm—yet another dimension in Indiana's cultured approach to the task of sculpture.

Indiana's stelae, and even his monumentalizations of the alphabet, as in the witty and solid sculpture *LOVE*, are far removed from the boisterous adventures of William T. Wiley, born 1937, and his erstwhile student Bruce Nauman, born 1941. Wiley and Nauman inhabit a space that can only tentatively be discerned in sculptural terms. In 1983, the critic Hal Foster asked himself: "What is sculpture today?" His answer: It exists in its own abyss, in "the evacuated space of the old category, 'sculpture.'":

> *Secure, prior to the 19th century, on the pedestal of public representation, secure still in the 20th on the altar of autonomous art, sculpture has come to inhabit the uncertain space of the world, a space of contingency, where it sits amongst all the other ruins of transcendence.* (Hal Foster, "Sculpture After the Fall," *Connections* [Philadelphia: Institute of Contemporary Art University of Pennsylvania, 1983], 10.)

The grave tone of Foster's obituary hardly suits the goings-on of such irreverent artists as Wiley and Nauman. While they shared in the pronounced impulse during the 1960s to get sculpture off the walls, off the ground, off the floor, and to extend it, often into random conglomerations and indeterminate spaces, they often did so in a spirit very close to Dada and Surrealism. Their particular concern, as Wiley once said, was to find a way of working that doesn't exclude anything. Both Wiley and Nauman completed four-year college-level educations that certainly pro-

vided them with historical backgrounds in modern art against which they obviously rebelled, and their use of visual and verbal puns can probably be attributed to their familiarity with the initiator of that hybrid art form, Duchamp. But there are circumstances that must be noted if we deal with certain works, such as Wiley's celebrated agglomeration, mid-way between so-called installation art and circus happening, *Nomad Is an Island*. The very badness of the pun has a California tinge.

Wiley was one of the most important protagonists in the regional eccentricity called Funk art. "If these artists express anything at all," wrote Peter Selz in the catalogue for the 1967 exhibition at Berkeley that first attempted a definition of Funk art, "it is senselessness, absurdity and fun." He wrote of their "wholesale rejection of traditional aesthetics" and their "free-wheeling and often rebellious life," which paralleled the antics of the Beat poets in northern California. Selz thought that Duchamp's stance was of importance, "his total absence of taste (good or bad) in the selection of his readymades, his indifference to form and indifference even to certain objects he created," (Peter Selz, *Funk* [Berkeley, California: University Art Museum, University of California, Berkeley, 1967], 3,4). Wiley produced paintings and objects, and assorted combinations of the two media, that he usually consigned to a spiritual dustbin, always moving on. And on. No one could ever predict where Wiley would go, least of all himself.

Nauman, partaking of the madcap activities of the Funk episode, learned to divest himself of fixed goals at an early age and, like his mentor, did not want to exclude anything. His oeuvre to date is of such a diffuse character that his most serious defenders, such as Robert Storr, are at a loss to define his activities. For Nauman, the autonomous object has ceased to exist (although he still produces three-dimensional objects). In its place is a wild assortment of often disparate experiences (video screens, neon signs, photographs, tunnels, walls, sounds) brought together in unsettling ways. To unsettle is one of Nauman's cardinal rules. "I don't think you can pick any one piece and figure out what the motivation was," he told Robert Storr, with evident pride; and Storr, in his commentary, opens: "Bruce Nauman leaves us nothing but room for doubt," going on to say that his environments, "though often symmetrical, have no centers, none, that is, that one can occupy without feeling out of place, or no place at all...." (Robert Storr, *Dislocations* [New York: Museum of Modern Art, 1992], 31-32).

It was precisely someplace "out of place" that André Breton proposed we should all inhabit in the interest of truth. In his preoccupation with objects during

the second phase of Surrealism, he even proposed a poetry "devoid of any obvious or intentional relation to the object" in which words were inscribed on objects themselves but would "exceed the limits of 'inscription' and entirely cover over the complex, tangible and concrete shapes of things" ("Surrealism and Painting" [1928], reproduced in Herschel Chipp, *Theories of Modern Art* [Berkeley, California: University of California Press, 1968], 424). By insistently goading his readers to enter the no-place made up of places of the imagination, he, like Yeats, suggested that if there had ever been a center, it could not hold. The centrifugal nature of so much twentieth-century painting, always flying out from the center, as in the paintings of Kandinsky, until finally the center didn't matter at all, as in the paintings of Pollock (although Pollock always brought his line back from the edges), infected the sculptors who no longer wished to see the world whole, or who perhaps could not envision their language with the thought of the old sculptors, whose thoughts, governed by centuries of logic, went to simple juxtapositions—couplets such as repulsion and attraction, solid and void, form and space, light and shadow.

And yet, history could not be extinguished, nor could categories of thought that could give meanings to even the most extravagant rejections of tradition. During the 1960s, artists had recourse to many prior theories (often drawn from science, such as Robert Smithson's view of entropy, or from psychology, such as Robert Morris's reconsideration of Gestalt, or from so-called Chaos theory, implicit in many of Nauman's works). They re-considered the idea of "concept," which, after all, had been carefully examined by philosophers from Descartes to Wittgenstein. "Conceptual" art took root in the 1960s in the paradoxical geometries of Sol LeWitt and the repeatable symmetries of Donald Judd, who had said, "A work can be as powerful as it can be thought to be" (Donald Judd, "Specific Objects," *Contemporary Sculpture, Arts Yearbook* 8, 78). These positions were countered by the chaotic character of much installation art, which drew on the tradition of Surrealism and the premium the Surrealist set on shock value.

There are, always, historical lines that can be discerned in any artistic phenomenon. But the rents in the fabric of art history are perhaps more evident in the works produced during the second half of the twentieth century. Kurt Schwitters, whose hand can be felt in so much sculpture since 1950, could say: "Art is an arch-principle, as sublime as the godhead, as inexplicable as life, undefinable and without purpose" (Kurt Schwitters, "Merz," *Der Ararat* 2 [1921], Munich). Very few today would feel comfortable with the reverence toward art implied by the word "arch-

principle," though they might agree that art is undefinable. Much of the story in this exhibition is a story of what artists would not do or, like Bartelby, "preferred not" to do. It should be remembered, though, that Melville never told us why Bartelby preferred not, and the work remains a tantalizing tale of human obduracy. Perhaps the proliferation of new technologies and new and more flexible materials have altered the meaning of works in three dimensions, but they have not altered the impulse to give shape or form—only modified it. By their mere presence as "works," the newest works in three dimensions have implicit boundaries, although those boundaries have been greatly extended, and enter our consciousness, no matter how diffusely, as *works* and not chaotic matter.

Crosscurrents Sculptural landings

BY HOLLIDAY T. DAY

A NUMBER OF FORCES brought dramatic changes to sculpture in the twentieth century: the abandoning of the distinction between sign and form and the use of sign and form interchangeably; the blending of not only traditional pictorial and sculptural vocabularies, but also vocabularies from poetry, architecture, theater and music; the search for essentials necessary to call a work art; the adoption of vocabularies, materials, and techniques from industrial production, technologies and science. It is difficult to think of another century where art changed so fast or so dramatically as it did in the last century. It did not change in an orderly way, nor can one say that it progressed or developed linearly. The notion of what art is expanded outward in all directions as ideas collided and mutated until it is perhaps impossible to trace their evolution.

Just as art has diversified, so have methods of discussing it. Regardless of method, all successful methods must foster meaning. The viewer must be able to understand art's vocabularies and its references enough to grasp a meaning of some kind within the social/cultural/philosophical/moral context of the viewer's own world. In its meaning, art is useful to human beings as a way to understand the world, or at least some small corner of it. It is the purpose of this essay to examine, through a variety of methods, the factors that allowed these changes to occur or that necessitated them in order to maintain art's meaning or usefulness as a human endeavor in the twentieth century.

Traditionally, freestanding sculpture, or art in the round, has depicted the living—people and animals, and occasionally plants—whereas painting traditionally has a much wider subject matter. In painting, artists have depicted a wide variety of inanimate objects, from household items and buildings to panoramas of land formations.

Until the twentieth century, the painted or sculpted image had a counterpart in the natural world but was not that thing it depicted. If an artist painted an image of a vase on a canvas, no matter how closely it resembled the vase, it still was not a vase. If a sculptor modeled a human figure, it always remained an image and never could be an actual human, except in the myth of Pygmalion. On the other hand, if a sculptor created a vase, it was not an image of a vase but became another vase, even

though the vase might be art. Thus, both sculpture and painting were art objects, not the things they depicted.

In the twentieth century, the advent of abstract and nonrepresentational art brought change to the traditional means of separating art objects from their counterparts in the natural world. An artist could not only sculpt a vase, or a bottle, or a guitar and still maintain through abstraction that the depiction was art without any confusion between its role as art and its role as an object of the real world, but also could make a nonrepresentational object that referred to nothing in the real world. In that sense, the sculptor became more like an architect. The geometric and abstract volumes of a building could be called a gigantic sculpture or three-dimensional form completely invented by the architect. It did not imitate an object in the real world but became itself an object in the real world when it was built.

As sculptors, all of the artists in the exhibition in some way address that issue of maintaining the separation between their images and the objects of the real world. They blur the distinction between the depiction of something and the creation of something else that is not a depiction of the real world.

David Smith and George Rickey explored certain themes that are both within and outside of the tradition of sculpture of the body. They confused the nature of line or plane with the three-dimensional object in space. They chose subject matter that subverted the traditional subject matter of sculpture, and they extended the concept of sculpture by making real or implied time a component of the sculpture.

Rosalind Krauss says that Smith's early works, like his constructions of wire and coral in 1932 (page 77), can be seen as his early attempts to incorporate linear and planar elements into a sculpture. These elements also suggest the traditional armature that sculptors use to build up a clay or plaster form, so that the works maintain their connection with traditional figurative forms.

In most of Smith's work in the 1930s, he took a pictorial Cubist vocabulary and used it to create a freestanding sculpture by assembling various planar and linear metal elements and separating them by real space instead of implied space. Often, his subject matter, like Picasso's, was the female figure.

Although open constructions were certainly made by other sculptors and painters in the 1930s, they were not common. What made Smith's work unusual was that he transformed a pictorial language into sculpture. Thus, he used a pre-made abstraction from reality (i.e., a pictorial language) instead of using a sculptural vocabulary derived from transforming three-dimensional solids like wood, stone, plaster

and clay into sculpture, as many Cubist-inclined sculptors, such as Jacques Lipchitz, tried to do. As Smith discovered, the rigidity of wire and sheet metal provided the means to make this transformation.

The consequence of Smith's early attempts to use a pictorial language was that he also was not limited to sculptural subject matter. Early on he chose subjects "unsuitable" for sculpture in works like *Interior* (1937) and *Amusement Park* (1938) (page 80). In a work like *Steel Drawing I* (1945) (page 81), one can see perhaps the most obvious example of the connection of his work to drawing. A drawing of an interior scene is directly cut into and through two sheets of metal and the Cubist displacement of space is achieved by physically placing one sheet of metal in front of the other. Following this work, Smith made a series of landscapes that culminated in works like *Hudson River Landscape* (1951) and *Star Cage* (1950) (page 87), which, unlike the landscapes of the 1940s, are suspended in the air atop a small pointed base rather than arranged on a long, narrow, flat base, which had acted as a pictorial foreground in his earlier landscape sculptures. By 1950, Smith was relying less and less on the Cubist pictorial language and was using a variety of pictorial languages, such as those used by Pollock, Matisse, Cézanne and Léger, or those used in Surrealism, Impressionism, and geometric abstraction. His subject matter is equally diverse and includes all types of "unsuitable" subject matter as well as "suitable" figural ones, traditional to sculpture.[1]

In the 1950s and early 1960s, contemporary sculptors concerned themselves with making truly nonrepresentational sculpture whose centers were open, without a core figural element, and sculptures that spread horizontally on the floor without a pedestal. These purely formal concerns were frequently carried out in steel and other industrial materials. Some artists took the formats Smith developed and enlarged them into massive steel arrangements that could be placed outside on plazas. Unlike these artists, Smith's formal innovations in sculpture were never used for their own sake. All of his work is first concerned with a subject or the expression of an idea and the proper vocabulary to express it in his unique way.

There were for Smith no "rules" that restricted him as to where that visual vocabulary might come from; it could come from either painting or sculpture or a combination of both. While other artists developed a style or a signature look, Smith did not. One day his work might be in one style and the next day he would choose another. Each of Smith's works has its own unique personality, as different from the others as each human being is different from all others, not only in surface appear-

ance but also in temperament. In that one sense Smith followed the figural sculptural tradition. All his works were about the essence of the human being whether they appeared superficially to be landscapes, still lifes, or figures.

This eclectic sculptural vocabulary and subject matter that Smith adopted for himself provided hundreds of new ways for other artists to think about art. Although Smith's sculptures were always humanistic, unitary forms, it is clear that once sculpture was free to use any visual vocabulary or subject matter to express the ideas of the artist, its potential was enormous. For example, works as diverse as Rickey's *Wave I* (page 117), Chamberlain's wall reliefs and *Thicket* (page 163), Wiley's *Nomad Is an Island* (page 199), and Nauman's videos, performances and installations can be seen as variations of the landscape genre.

Rickey, like Smith, departed from the traditional vocabulary of sculpture. Unlike Smith, whose inspiration mostly came from painting, Rickey found a visual vocabulary in the manifestations of underlying physical laws and geometry of the world. Just as Renaissance artists had studied anatomy to understand how to depict the human figure, Rickey delved into the way space could be scientifically described. The impetus for looking at non-art schemas to develop a visual vocabulary may have been Naum Gabo's writings and Bauhaus theory, but Rickey's own early fascination with motion was the impetus that led him to seek out a means to incorporate motion into his work. The idea of creating moving sculptures is not new if one considers sculpture to include puppets, marionettes, and those elaborate European clocks where carved figures are mechanized to perform when the hour strikes. Likewise, artists have often sought to convey a sense of motion or to imply motion when depicting moving objects through a variety of pictorial devices. What was different was that Rickey considered time itself as a fundamental dimension of sculpture, as opposed to using motion to imitate or suggest the activity of an animate object or being. For example, many of Calder's organic mobiles and Rickey's early glass mobiles certainly can be seen as sculptures that use movement to animate the things depicted rather than using motion to incorporate time as a fundamental, abstract component of the description of space in four dimensions.

To create a visual vocabulary that would include an invisible dimension, like time, Rickey made a number of works in the early 1950s that he called "machines of no use." "Of no use" was an important element; if they had been useful machines, they would be machines rather than art, much as a sculpture of a vase would be a vase and not art.

Perhaps the twentieth-century artist best known for his "machines of no use" was the Swiss artist Tinguely, whose moving and noisy assemblages of old machine parts have a Dadaistic humor about them—quite a different approach from Rickey's aims in *No Cybernetic Exit* (1954) (page 115), a "machine" that referred to graphs that tracked the depletion of bituminous coal reserves over time.

Eventually Rickey realized that it was necessary to use geometric configurations exclusively. By eliminating any referential subject matter in the visible part of the sculpture, he would focus the viewer's attention on the implied volumes traced by the moving parts and the time it took to create these implied volumes. The more he minimized the physicality of the steel elements, the more the viewer would be made aware of time as a dimension.

Since the speed at which the steel elements would move could be calculated using equations of motion, Rickey could adjust the dimension of time as well as the sizes of the three other dimensions. While many artists made kinetic sculptures in the mid-1960s, many of these were more like busy cuckoo clocks than sculptures that emphasized the natural laws. Their makers often did not understand how to use time esthetically as a dimension.

The twentieth century perhaps more than any other century has been dominated by science. The technology that could take a man to the moon or annihilate the world has produced both optimism and despair among the general public. The intriguing beauty of an equation like $E=mc^2$ captured the imagination of people who had no idea what its scientific significance was, yet realized that it expressed some essential explanation of how the world functioned. It is not surprising that twentieth-century artists, like artists in the Renaissance and classical Greece, other ages of discovery, should also be interested in the principles of geometry, physics and mathematics or the properties of matter itself.

In the 1960s the search for essentials not only produced sculpture, like Rickey's, but also underlay the work of Donald Judd, Carl Andre, Richard Serra, and of many conceptual artists, like Sol LeWitt.

The complexity of Chamberlain's sculpture appears at first glance to relate to the Abstract Expressionist paintings, as David Smith's work did, and to have nothing to do with Rickey's or Judd's search for essentials. But, Chamberlain's work can be seen as a search for essentials as well. Even Chamberlain's most Smith-like sculptures of the 1950s were not constructed with a pictorial language. *Calliope* (1954) (page 145) may suggest, at first, a "drawing in space," but it reads like a mechanism where part

A is connected to part B. One can sense the tensile properties of steel and the pressure one piece of steel exerts upon another piece of steel and the latent energy stored in the pieces. The viewer doesn't see a single, unitary, overall image but rather follows a complex trail with spatial gaps that the eye must leap across as sparks of electricity jump across two charged poles. In contrast to an abstract language of the pictorial or a geometric language, Chamberlain constructs his sculpture with the everyday physical language of the materials he works with, which is the essential language of objects.

By 1958, Chamberlain had noticed that sheet metal, a common, ready-made material, could be crushed and fitted together to enclose a volume of air and form a three-dimensional object. The cheapest, most available sources of sheet metal were the automobile "graveyards" that dotted the American landscape at the time. The crushed auto bodies came in a myriad of colors as well. These graveyards provided a selection of random forms, mostly meaningless by themselves, but quite interesting when Chamberlain assembled and fitted them together to make a sculpture. What was essential to his process was that, unlike a collage where one adds a mixture of things to a pre-existing structure, these sheet metal forms created new forms by the way they fit together three-dimensionally without an underlying structure or armature to hold them together. The colors were interlocked three-dimensionally as well, rather than added to the outer surface of the sculpture.

Chamberlain's method was intuitive and not predetermined. The result was mechanistically built without being a machine or a tool, a pure 3-D object essentially without reference either to the real world of things, either living or inert, or to the world of Euclidean geometry. Consequently, it was a very tough object to digest visually. Its order was obtained by a mechanical fit without an easily grasped overall order or harmony.

Chamberlain's method arrives at the essential nature of sculpture as a mass consisting of interlocking volumes and partial volumes that are self-supporting. Despite their lack of regularity, Chamberlain's sculptures have many features of the purely geometric sculpture that Donald Judd would subsequently make. The size of his sculptures is actual rather than relative. To borrow Judd's term, Chamberlain's sculptures are "specific objects." This quality is most apparent in photographs where, without actual measurements or external reference points, the actual size of the sculpture is indecipherable. Frank Gehry's museum in Bilbao could in fact be a giant Chamberlain sculpture of interlocking partial volumes. Unlike Judd, but like both Gehry's buildings and natural land formations, the view of one side does not neces-

sarily give an idea of the view from the other side. At times, photographs of different views of the same Chamberlain sculpture may look so different that it is difficult to believe that the photographs are of the same sculpture.

Experiencing Chamberlain's work as a kind of geological landscape is possible in many of his pieces. Layers of sheet metal press against each other to form folds and ridges in the same way that the plates that form the earth's crust are compressed and thrust to the surface to form land masses.

Artists also developed a sculptural vocabulary from the two-dimensional abstract shapes of letters, numbers and geometry. Smith employed found letter-like metal forms to make *The Letter* (1950), *17h's* (1950) (page 85), and *24 Greek Y's* (1950). The original intended use of these found metal pieces is unknown, but they resembled the letters "h," "y," and "o." *The Letter* also contains two sections that look like script. Like Picasso and other Cubists who employed letters and partial words in their work, Smith used these letters both to suggest words and to work as abstract forms in the composition. Both the "h" and the inverted "y," or lambda λ, also read as stick figures and are in keeping with Smith's employment of forms to have multiple associative meanings. *The Letter* has been extensively analyzed by Rosalind Krauss and Edward Fry. The sculptures *17 h's* and *24 Greek Y's* have no such concrete associations with literature. They make no words or partial words, such as "Yoo-Hoo" in *The Letter*, but contain only one type of letter, although it may be reversed or inverted.

Chamberlain has said he sometimes thinks of the pieces of crushed metal sheets that lie around his studio as "words that he can put together because they look well together." As titles for his works, he often invents new words that are combinations of syllables that he thinks go well together.

In Indiana's early sculptures, made from 1960 to 1962, short words, numbers, and geometric shapes are painted onto the surfaces of the sculptures as if the sculptures were canvases. The words themselves are not sculptural, but a design imprinted on the wood to break up the surface of the wood like a pattern. All of Indiana's free-standing early sculptures are vertical slabs of wood, or as he calls them, herms, that both stand for the figure and act as sign posts for messages. At times, a word may identify the figure, as in *Ahab*. At other times, the slab is a vehicle for signs or numbers that have no obvious connection to the shape they grace, as in *Six* (1960–62).

When these sculptures have been exhibited in the past, they have been grouped much the way Smith grouped his *Forging* series to suggest a group of personages. It is clear from Indiana's drawings of the herms that he thought of them as

essential flat surfaces that could be embellished. The wood slabs themselves were actually wooden beams removed from buildings. These slabs suggest their original architectural function as Indiana left the beams' mortises and tenons as part of the sculptures. Like the sculptures of saints that doubled as columnar elements on the doorways to European cathedrals, Indiana's herms have iconographies that are as essential as the esthetics of their forms, whose very rigidity echoes the moral upright-ness conveyed through their iconography.

"Eat" and "Die," words frequently used by Indiana, oppose each other like heaven and hell. They preach against the hedonist culture whose motto is "Eat, drink and be merry, for tomorrow you may die," in addition to being a reminder of the well-known story of the death of Indiana's mother. (Indiana's mother's dying words to her son were to inquire if he had eaten.)

Serving as a mystical sign for the unrepresentable is perhaps the most ancient function of sculpture. Although many twentieth-century sculptors looked at ethnic art and prehistoric cultures with the hope of rediscovering the essence of mankind that lay under the veneer of European civilization, Indiana looked for this essence in the road signs of the American landscape.

Later, Indiana was to free these signs from their support entirely with such works as the *LOVE* and number sculptures. By making his signs independent forms, Indiana broadened the "suitable" subject matter of sculpture in yet another way.

It is interesting to note that the works of Indiana, Chamberlain and Smith were all chosen to be in *The Art of Assemblage* in 1961. Curator William Seitz chose them because they assembled their sculptures from found parts, although each artist based his sculptures on different premises of space. Assemblage is basically a sculp-ture technique, like carving or casting. It was a technique developed because it suit-ed the concerns of twentieth-century sculptors, even when the concerns were as diverse as those of these three artists. Although not assembled from pre-existing parts, Rickey's work is also put together from parts, and certainly all of Wiley's sculptures are assemblages, even though he mixes invented forms with found forms.

Concurrent with the enormous cultural changes that took place in U.S. soci-ety after World War II were equally vast changes in the arts. By the time Bruce Nauman was enrolled at the University of California, Davis, in 1964, college students everywhere were questioning every assumption, not only in politics and social con-duct, but also in all the arts. Unlike artists such as Smith and Rickey, who were inspired by industrial technology, art students now condemned the power of the mil-

itary–industrial complex built on technology. The power of the art gallery system also drew their condemnation. In their minds, producing a durable, salable art object was not necessarily the job of an artist. They sought new ways to make art provide meaning without producing a commercial object.

Earlier sculptors had borrowed analogous vocabularies from other disciplines, like poetry, music, painting and drawing, but artists trained in the 1960s used the forms of these disciplines and collaborated with musicians, poets, dancers, and actors as well. Such ideas were not new to the sixties, as artists had had the examples of the Bauhaus, Dada and Marcel Duchamp, although many Americans regarded Dada as a nihilistic protest rather than as art. Neither Wiley's nor Nauman's art is nihilistic. Inclusiveness and diversity—two popular words of the 1990s—characterize their work from 1964 onward.

Wiley uses inclusiveness and diversity as a means to break down the traditional separation that exists between art objects and the world of things and the living. He does not worry whether a vase and a sculpture of a vase are identical objects or whether a mechanical structure is a machine or a "machine of no use." A sculpture might be useful to make music, or his own living body could be a moving sculpture when he dresses himself as Mr. Unatural, a wizard-like character who wears a kimono, clogs and a pointed hat. Poetry, narratives, signs, words, movement, and music could all be part of art as well as of living. At some level the viewer is included in the conversation or dialogue that the art instigates.

Inclusion is very different from empathizing with the work of art or reacting to it or appreciating its beauty because the object is not separated from the living world or the world of things by being exclusively art. Rather, art becomes a vehicle to exchange ideas or information. For example, initially Robert Rauschenberg's famous *Bed* (1955) invited and provoked outrage from viewers because they thought Rauschenberg was putting them on by claiming a quilt and pillow covered with paint could be a serious work of art, or they saw it as making fun of something that they believed in, such as Abstract Expressionist painting or beauty or the sublime. *Bed* is witty but not humorous. Wiley, on the other hand, creates equally outrageous objects made of equally mundane materials and with equally provocative messages, but he invites the viewer into a conversation as opposed to setting up an opposition between the art and the viewer. Wiley, although outraged by a political event or by the destruction of the environment, invites the viewer to share his outrage with genuine humor or by providing some common ground that the viewer can share with the artist. He

further draws the viewer into the conversation by presenting a secret or enigma that arouses the viewer's curiosity. Like a real conversation, his work rambles about and has side issues and interruptions and diversions that break up the dialogue. These rambles occur both visually and in the meaning of the work, although the overall tenor of the conversation remains the same. Moreover, Wiley's sculpture is never art about art, but always art about life. Like sculpture of the past, it refers to the real world of the living. It does not imitate the real world, however; it is both part of the real world and the world of the imaginary that viewers can appreciate by projecting themselves into it.

Consequently, Wiley borrows materials, images and visual vocabularies from painting, drawing and sculpture and combines them with non-art materials, images, and vocabularies. He often uses all of them together side by side in the same work. Wiley's *Nomad Is an Island* (1981) (page 199) is perhaps his most dramatic example of this combining of art with life. The base of this multi-part sculpture is a palette-shaped horizontal sheet of steel representing an island. The steel sheet depicts a landscape viewed from a cartographer's eye. Letters spell the name of this place, as on a map. Atop the island are silhouettes of Mr. Unatural, pop-up letters, animals, a small boat and other objects. An actual steel oil drum, dwarfing the island's inhabitants, rests like a time bomb in the center of the island. The oil drum symbolizes the nuclear waste dumped on the Farallon Islands, small islands off the California coast visible from the mouth of the San Francisco Bay, where Wiley frequently fishes for salmon. Surrounding the island are assorted objects, including a skull of sheet steel and a mover's loading cart. Amidst this apocalyptic vision of ecological disaster, paint in primary colors is spilled across the midsection of the island and a windblown Mr. Unatural.

The sculpture looks like a giant children's pop-up book whose narrative is spelled out in a dizzying array of images and words, signs, and symbols. But the 20-foot long, sprawling work not only is a statement about the Farallon Islands, but also stands for the whole world. Human activity, including the activity of making art, cannot be divorced or isolated from this world by placing it on a metaphysical pedestal. The space of art and the space the viewer occupies are one and the same. As Indiana suggests, we all eat (i.e., live) and we all die. Signs are everywhere and Wiley's purpose, like Hieronymous Bosch's, is to make us aware of them before not only we die, but the earth and its creatures die as well. Life and art become part of a single raucous struggle against death that is beyond a single person's control.

Nauman uses a wide variety of art forms from many disciplines to investigate the relationship of the human figure to the space the body occupies in the world. The

problems he poses himself have a structural rigor that questions both the age-old traditions of sculpture and the real life conditions and consequences of actual human beings occupying space in the world, often in competition with each other. If viewers are made aware psychologically of how they occupy space, then art has some purpose in that world beyond being beautiful or inspirational. Nauman doesn't propose art as a rational reflection of the world in the sense that Rickey does, but rather presents life as a never-ending psychological tension between humans and the space they occupy and move in.

In early works, he frequently treated space as a solid and objects as voids, like *Mold for a Modernized Slant Step* (page 215) and *Cast of the Space under My Chair*. In others, he used his body and body-like objects to confirm and conform to the space they occupy. He imagined a world without gravity and how a gravity-less world would change the relationship of the body to its space. He imagined the body confined to underground spaces. He made photographs and objects that literally enact words of common phrases. What would it be like to literally "eat my words" or exist from "hand to mouth"? These "what if" questions are the kinds of questions scientists ask themselves and that lead them to new understanding of the world. Einstein asked himself, "What would a light wave look like if I could travel along with it at the speed of light?" The consequence of that hypothetical question was his famous formula $E=mc^2$ and the theory of relativity.

Nauman investigates how words come to stand for objects. He examines the sign language of the hand against the hand as a kind of mobile body sculpture. He examines the disparity between what we see and what we know by comparing video monitor images of people with their real-time actions. What if our words formed in the air so that we could see them as well as hear them? Could light be a sign of truth? Or is it the opposite, like some lighted advertising? Einstein wrestled with the paradox that light was both a particle and a wave and ended up concluding that it was both. Nauman puzzles over the paradoxes that life presents and how humans keep hitting themselves and others on the head even though it hurts. Sculpture keeps returning to its basic function of fitting humans into the world they live in. Art can be useful and of no use.

In posing questions or paradoxes to the viewer rather than providing answers, Nauman's sculpture often operates on several levels. The questions are not only questions about life but about art as well. *Fox Wheel* (page 223) and his other pieces that use taxidermy forms engage the viewer not only with associations about the object itself, but with pure sculptural questions about the importance of armatures that create sculptural forms and the importance of surface details that refer to or imitate the

real world. When is a sculpture finished? When the form is made, or when the surface is defined? How complete does a sculpture need to be to articulate an idea?

Often he uses a sculptural tradition, like modeling a head or a pair of hands or making multiple bronze casts, but he then interrupts the viewer's normal association with this form or technique. When Nauman uses the same head or hand over and over or places several of them together in one sculpture, it is difficult for the viewer to confer upon either this sculpture or the artist who made it any heroic aura, as one might do with a Rodin bronze. Rather, the sculptural head or hand becomes a sign of a human being, despite its realism or resemblance to a real head or hand. Theoretically, one could replace the head or hand with the word *I, you*, or *them* or with a chair or some other sign, like a stick figure, which Nauman has done from time to time. Nauman generally chooses the sign that sets up the most psychological tension in the viewer.

Movement, whether mechanical or in a video or neon or through the participation of the viewer in a space, becomes an important part of involving the viewer as it creates a sense of dislocation and a real either/or situation for the viewer.

In many ways, Nauman's sculptures are like medieval morality plays, drawing on sound, script, movement, and masquerades to psychologically and actively involve viewers in the paradoxes of their own human condition. Nauman and others in his generation give a role to sculpture that is very different from its earlier purpose of inspiring the viewer to contemplate the beauty of the divine or of the natural world, or of teaching a moral lesson or of reflecting upon the human condition.

The century that produced so many changes in the way Americans live and think produced equally dramatic changes in the way sculpture was conceived and made, and in what it meant or what its purpose was. What I have hoped to convey is some of the ways these artists, in their sculptures, have struggled to find ways to both embrace change and yet maintain a connection with sculptural traditions. New vocabularies, new materials, new subject matter, new art-to-viewer relationships, new concepts of space, and new uses for art all combined with references to classic techniques, classic forms, and classic metaphors, and, above all, to classic relationships of humans to the world they live in, however different that world might be.

[1] For a lengthier discussion of Smith's drawing, see Holliday Day, David Smith: *Spray Paintings, Drawing, Sculpture* (Chicago: The Arts Club of Chicago, 1983).

Indiana Born

COINCIDENTALLY, the six sculptors featured in *Crossroads of American Sculpture* were all born in Indiana: David Smith in Decatur, George Rickey in South Bend, John Chamberlain in Rochester, Robert Indiana in New Castle, William T. Wiley in Bedford, and Bruce Nauman in Fort Wayne. Only two of the six artists spent a large part of their childhoods in the "Hoosier" state, Smith until he was 15 and Indiana until he was 16. But, interestingly enough, there are a few notable similarities in the early biographical and ancestral histories of these six men. Both David Smith and John Chamberlain were direct descendants of pioneers who were involved in founding the Indiana towns where the artists were born. Both David Smith and William T. Wiley had ancestors who were blacksmiths, and both artists have found this heritage to be important for themselves personally and for their artistic ideas. Both George Rickey and Bruce Nauman were sons of men who were engineers and whose places of residence were determined by the demands of the companies for which they worked. William T. Wiley, Robert Indiana, and Bruce Nauman were moved about frequently as young children, and while it is not an uncommon experience in a child's life, the artists have pointed out this fact of their young lives at one time or another. David Smith, John Chamberlain, William T. Wiley, and Bruce Nauman all had a fondness for music that stemmed, in various degrees, from childhood interests.[1]

In the years that spanned the birth dates of these artists, 1906 to 1941, the nature of America's cultural landscape changed significantly. Americans were affected by two world wars, the Great Depression, and numerous other social and political events. Is mere coincidence the reason for any similarities in the early lives of these men? Were their young lives fairly typical products of the Midwest in the early twentieth century? It is outside the art historical realm to speculate any further about the cause of such facts in their lives. But one more interesting final point: In later life, all six men chose to live in fairly remote areas of the United States, from the mountains of rural Bolton Landing, New York, (Smith) to the rugged terrain of the foothills of the Sangre de Cristo Mountains, near Pecos, New Mexico (Nauman).

Four of the six sculptors were born in relatively small Indiana towns. The modern configurations of these small towns generally include a grid of residences that are arranged around a grand courthouse and central commercial area. But to classify them as typically Midwestern small towns does not explain enough of the character of each place. An attempt has been made to give an idea of the nature of the town during the era in which the artist was born.

The amount of biographical information about the six *Crossroads* artists varies greatly. The resulting biographies are the products of primary and secondary research, and, in some cases, interviews with the artists and/or their family members and friends. The artist's life is discussed through the end of high school, whether or not the family was living in Indiana at that point.

DAVID SMITH

When Roland David Smith[2] was born on March 9, 1906, the Smith family was living at 522 Jefferson Street in Decatur (FIG. 1). Near the turn of the century, Decatur, located near the Ohio border and about 25 miles southeast of Fort Wayne, was a rural community of about 4,500 people. The town's economy was centered on agriculture. As the result of an executive job opportunity for Smith's father, the Smiths left Decatur fifteen years later, in 1921, and moved to the nearby Ohio town of Paulding. Paulding might have been a new place, but it was a town very similar to Decatur in terms of size and appearance, and its economy was also based on agriculture. But Decatur had a special ancestral connection to the Smiths. One of David Smith's maternal ancestors, Samuel J. Rugg, was one of the founders of the town of Decatur. A one-time blacksmith, Rugg petitioned in 1836 to establish Adams County, Indiana, with Decatur as the county seat. In addition, Rugg donated the land for the courthouse and helped pay for building the original courthouse in Decatur.[3] Smith sensed an affinity with his pioneer ancestors. This connection is reflected in his determination and individualism, as well as in the manner with which he regarded his own heritage. "I was raised with enough food, but I come from pioneer people. Grandmothers and grandfathers, great-grandmother, my great-great-grandmother, all of those people I talked with were early settlers. They had been deprived of salt, flour, sugar and staples like that for periods of time. I came directly from pioneer people who were scared for survival and this reinforced my consciousness of the Depression."[4]

Smith's father, Harvey, worked for a telephone company and spent time inventing things. Of course, Smith once said that when he was a child, "everyone in

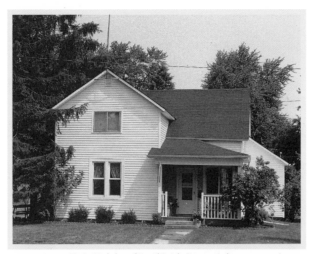

Fig. 1. Birthplace of David Smith, Decatur, Indiana.

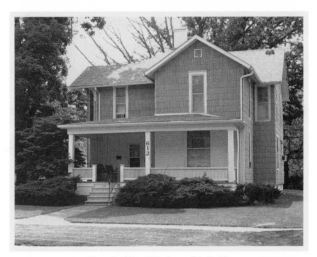

Fig. 2. Paulding, Ohio, home of the Smiths.

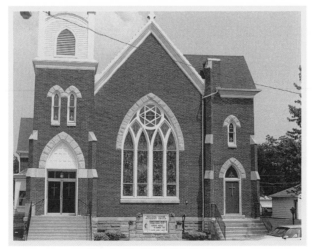

Fig. 3. Paulding United Methodist Church.

town was an inventor."[5] When the family (including at this point Smith's younger sister) moved to Paulding, Harvey became the manager and part owner of the small, independent Paulding Telephone Company. The family lived at 612 North Williams Street (FIG. 2). V. Louise Reinhart, a long-time resident of Paulding and a high school acquaintance of Smith, described Harvey Smith as "hard-working and dedicated to his job."[6] Smith's mother, Golda, was involved in church activities, and as a teacher, stressed the importance of education. Paulding townspeople said that there were two things that they would always remember about Golda—her devotion to the church (in later years, she would spend every day there involved with some project) and her ability to cook.[7] The Methodism that Golda subscribed to was strict; drinking, dancing and gambling were forbidden. In Paulding, the family attended the Paulding United Methodist Church, a few blocks from their home (FIG. 3). Smith remembered, with some animosity, that his mother made him work when his friends were at play.[8] Money was saved for Smith's education, and it was expected that he would become either a stenographer or a schoolteacher.

At an early age Smith showed a fondness for machinery, notably trains, factories and the telephone. The railroads and factories were a vital and dominant part of life in the Midwest in the first few decades of the twentieth century, and Smith recalled that he watched the trains go through town and played around the local factories. "I've always had a high regard for machinery....It's never been an alien element, it's been in my nature," he explained in an interview in the early 1960s.[9] Following his father's habit, Smith investigated telephone equipment: "Some of the first things I played with were telephones. I took them apart and used the magnets."[10]

Figs. 4 and 5. Drawings by David Smith in the Paulding High School yearbook of 1923

When the family moved from Decatur to Paulding, Ohio, Smith was already in high school. He started his sophomore year at Paulding High School in 1922 and was soon involved in extracurricular activities. He starred in both his junior and senior class plays[11] and served as vice president for his senior class. In his junior year, as a member of the yearbook staff, Smith drew many of the illustrations for the annual.[12] The images are cartoonish and satirical. In one drawing, a bespectacled "senior" labors over the construction of a "World of Life," attempting to build it with diagrams and charts (FIG. 4). In another drawing, a giant-sized ghostly representation named "Caesar," complete with toga and ivy wreath encircling his head, frightens a pig-tailed "sophomore" out of her sleep (FIG. 5). This talent for the artistic, combined with the fact that Smith actually took a correspondence course in cartooning from the Cleveland Art School in 1923, seems to have impressed his schoolmates. After 1923, Smith is referred to as "Bud" by his classmates. The name is apparently a reference to Bud Fisher, the creator of the then popular comic strip *Mutt and Jeff*.

The caption under his junior-year picture describes him as "A flattering painter who made it his care, to draw men as they ought to be, not as they are." If others considered him an idealist, he was also seen as something of a bohemian. Reinhart recalls that Smith sometimes rolled up his pant legs and walked around town barefoot.[13] Even at this early age, Smith also took an interest in the political and controversial debates of the day. The caption below his senior-year picture, which reads "Bud argues that men were developed from monkeys," refers to the on-going debate in the 1920s about theories of evolution that culminated in the 1925 "Scopes Monkey Trial" in Tennessee.

With hindsight, it is easy to read Smith's graduating class prophecy and smile. Fellow classmates wrote of Roland Smith that he was to be a "future artist." We know Smith now not just as an artist, but as one of the great twentieth-century sculptors.

GEORGE RICKEY

George Rickey's family was in Indiana for only six years before they had to move to Scotland. But since South Bend was where they had lived prior to going abroad, it was thought of endearingly as their "American home."[14] In 1904 Rickey's father, Walter, a mechanical engineer for the Singer Company, had been transferred from the plant in Schenectady, New York, to manage the company's factory in South Bend. The Rickey family was living in a rented farmhouse on the outskirts of South Bend when George Rickey was born on June 6, 1907. An Italianate-style home from the 1880s at

1005 West Washington Street, to which the Rickey family eventually moved, was being renovated at the time of his birth. The Washington Street home is the subject of at least one of Rickey's early childhood memories—"sitting with his sisters at the bottom of the stairs and watching them write and being upset that he could not."[15]

South Bend was a booming city in 1907. Local industry was connected to the manufacturing of transportation equipment and contributed to an environment where "technology and industry thrived."[16] The population nearly doubled between 1900 and 1920.[17] The Rickeys adapted fairly well to life in the Midwest and were active in community affairs. Walter Rickey was even president of the YMCA when the new building for the organization was dedicated in 1912.[18]

George Rickey started school in South Bend, attending kindergarten at the then Colfax School. But most of his school years were spent in Scotland, where he attended private day schools for both elementary and secondary education.

George Rickey's grandparents were descendants of Yankees who had come to America from England in the seventeenth century.[19] Rickey recalls his grandparents with fondness and attributes his interest in art to their influence. His paternal grandfather, also George Rickey, was a clockmaker in Athol, Massachusetts. His brief visit with this grandfather before the family's departure for Scotland and his grandfather's subsequent presence at the Rickey home in Scotland left a lasting impression on the artist. "My technique is borrowed from crafts and industry. It has more in common with clocks than sculpture," Rickey explained years later.[20] The elder George Rickey was largely responsible for introducing Rickey, at a young age, to mechanical devices. He took Rickey with him to wind the clock in the Athol church tower and gave the boy old clocks to play with.[21] Rickey's maternal grandfather was a lawyer and eventual judge on the New York Supreme Court. His maternal grandmother had taught drawing at a girls school in Schenectady. Rickey delights in pointing out the creative side of his family, which includes not only his grandparents, but other close relatives and himself. "I was interested in art early on, and won drawing prizes as a child, as did my sisters, and, as a matter of fact, so did my first cousins," he said in an interview in 1985.[22]

Rickey was exposed to and took an interest in art at a young age. He recalls going to art museums in Glasgow with his mother where he took pleasure in looking at the pictures as well as model ships (especially those found in one particular institution on Sauchiehall Street). But given Walter Rickey's chosen profession and Rickey's own young experiments with mechanical devices, it was assumed that Rickey would choose a mechanical career. Even if art-making interested Rickey enough, he

determined that to pursue it would seem frivolous. "My clear purpose was to become an engineer; being an artist was for people of special talent and not for practical people the likes of us."[23] It was not until years later, after he had already graduated from college with a degree in modern history, that he began to study art seriously.

John Chamberlain, in his own words, "broke the family tradition of being a saloon-keeper."[24] The line of Chamberlains who owned and operated taverns in Rochester, where John Chamberlain was born, extends back to 1835. Alexander Chamberlain, great-great-uncle of John Chamberlain, built a tavern and stagecoach inn on Main Street, part of a stagecoach route through the state of Indiana. This establishment did a good business, and it set the tone for the places operated by succeeding Chamberlain family members. Alexander platted and named the town of Rochester in 1835, and he owned quite a bit of property in the area. Sylvester, Alexander's brother and Chamberlain's great-great-grandfather, was a hatter by trade who arrived in Rochester in 1835, not long after his brother.

When John Chamberlain was born on April 16 in 1927, his father was running the family tavern that Jesse Chamberlain (John's grandfather) had established in 1921 at 128 East Eighth Street (FIG. 6). Chamberlain was born to Claude and Mary Chamberlain when the family was living on the courthouse square in Rochester on the corner of 9th and Main, in a second-floor apartment over Taylor's Butcher Shop.[25] Rochester, a small town located in the northern part of the state about 50 miles south of South Bend, had prospered in its early years by being on a stagecoach line. In the twentieth century, the agricultural industry has determined the success of businesses in the community; those factories most closely related to agriculture have been the most successful.[26]

Like George Rickey, John Chamberlain was in Indiana for only a short period after his

Fig. 6. Chamberlain family tavern, Rochester, Indiana.

birth. Unlike Rickey, Chamberlain would return in subsequent years to visit his family. When Claude and Mary Chamberlain divorced in 1931, Chamberlain, then 4 years old, was moved to the home of his maternal grandmother, Edna Waller, who lived in Chicago. "My grandmother sort of ran the house, and my mother and my Aunt Jane went out to work. My mother and my Aunt Jane were waitresses at the World's Fair in Chicago in 1933 or 1934."[27] Chamberlain was to remain in Chicago for much of his childhood. Although he graduated from high school there, throughout his youth he made trips back to Rochester to see his family, and his memories of the town stem from these occasions. He did go to school in Rochester for a short time, attending Columbia Elementary School for the fifth and sixth grades. When he was in Rochester in these later years, he often stayed with his paternal grandparents, who lived on the corner of 10th and Franklin Streets (FIG. 7). Chamberlain recalls that he felt most "at home" during these stays when he was resting in a large pear tree that he could climb to from his room at his grandparent's home.[28]

Although not formally exposed to art in his childhood, Chamberlain was creative, mechanically inclined, and something of an inventor, "designing aircraft and discovering radar."[29] He was also very interested in music although he did not study any instrument. In fact, it was because of the discovery of the music of Schubert at about age 12 that he made a serious life-affecting decision. Until that time, he wanted to be an aeronautical engineer. The haunting melodies of Schubert exposed Chamberlain to what he described as "loneliness,"[30] ("The poetics and the agony of Schubert were so impressive to me," he explained in an earlier interview[31]), and with that discovery, the focus of his young desires changed.

Fig. 7. Chamberlain's grandparents' home in Rochester, Indiana.

ROBERT INDIANA

Of all the *Crossroads* artists, Robert Indiana lived in the state of Indiana the longest, although his childhood was far from geographically stable. Born Robert E. Clark in New Castle

on September 13, 1928, Indiana (a surname that he adopted in the 1950s), by his own count, lived in 21 houses before the age of 17.[32]

It has been noted, by Indiana himself and others, that the automobile had a prominent role in both his childhood and in his mature understanding of his parents. He remembers a childhood filled with car trips and highways signs, and, in Indiana's eyes, his father was the quintessential "American Dreamer." The Model-T Ford that shows up in a portrait of his parents, *Mother and Father,* was important in his parents' lives, "the very keystone of their 'dream'—the chugging chariot carrying them on to greener pastures and redder passions."[33] Indiana's personal connection to the automobile makes the fact that he lived as a child in New Castle and Indianapolis, two important automobile manufacturing centers, more interesting. New Castle, in the early part of the century, was the site of the Maxwell Davidson Car Company, the producers of the Maxwell. When the production of the Maxwell stopped just prior to World War I, Chrysler bought the plant, and the large-scale manufacture of automobiles continued.[34] Automobile manufacturing in Indianapolis peaked in the years prior to the Great Depression with production rivaling even that of Detroit. Major manufacturers located in the city included Marmon, Dusenberg, Stutz, Waverly, Premier, National, Overland, Cole and Pathfinder.[35] Indianapolis in the 1930s and 1940s was a still a leading producer of commercial auto bodies, but the major players in the popular automobile industry fell away.

Indiana's stay in New Castle was short; the Clarks moved to Indianapolis in 1929.[36] Indiana remembers living on Irvington Avenue (FIG. 8) near the International Harvester plant (now Navistar) on the southeast side of the city. At that time, the International Harvester plant produced large trucks and truck parts. Indiana remembers the dense clouds of factory smoke near their home. "That was in the day of soft coals and this absolute cloud of smoke was on top our house."[37] During these first years in Indianapolis, Indiana's father, Earl, worked for various oil refining companies.[38] The southeast section of Indianapolis, where the Clarks lived while in the city, was primarily composed of blue collar neighborhoods where one-story homes and bungalows prevailed.

In 1934, when Indiana was six years old, the Clarks left Indianapolis for Mooresville, where Indiana started school at the age of seven. Because of the moving, he had to enroll in school a year later than was usual at the time. Indiana's interest in art-making had already begun to show itself. Even at this early age, Indiana was thinking of the future, and he told his parents that he would be an artist. Uncertain

Fig. 8. Robert Indiana home at 732 Irvington Avenue, Indianapolis.

Fig. 9. Robert Indiana home on English Avenue, Indianapolis.

Fig. 10. 4th Church of Christ, Scientist, Indianapolis.

about the origin of this prediction, Indiana now theorizes that it was the result of his interest in a popular source, the old *Life* magazine, with its "color, photography and occasional art... ."[39] Indiana was also encouraged in the pursuit of art by an elementary school teacher, Ruth Coffman Hasse.

Soon, though, the Clarks moved back to Indianapolis and a home at 4843 English Avenue (FIG. 9). Because of the frequent moves, Indiana attended three different schools for the second grade. Like many other major American cities in the 1930s, Indianapolis had been hit hard by the Great Depression. Throughout the 1930s, towns attempted to recover with the help of government jobs and slowly renewing economies. By the late 1930s, with the United States' entry into World War II, automobiles, agriculture and a wide range of manufacturing contributed to an improved way of life in Indianapolis. During this period, Earl Clark was working for the Phillips Petroleum Company. Indiana's mother, Carmen (née Waters), was also working during the artist's childhood, usually in a restaurant or café.

Indiana remembers attending Christian Science services as a child at the 4th Church of Christ Scientist on the southeast side of the city (FIG. 10). He was impressed by the minimal amount of ornamentation within the Christian Science church and the absence of carvings or paintings. The general scarcity of decoration served to direct Indiana's attention to an inscription that affected him for many years. As Indiana himself explained, it is found in most Christian Science churches, "a small, very tasteful inscription, in gold usually, over the platform where the readers conduct the service. And that inscription is God is Love."[40]

According to Indiana, the caliber of art instruction in the first Indianapolis schools that he attended was poor. "Practically all through grade school, the art instructor was always the music teacher, which was always bent in the direction of music, so I'm afraid the art instruction was very poor."[41] But his interest in art did not wane. Indiana's parents divorced in 1938, and while Indiana and his mother moved to the country, his father remained in Indianapolis. Indiana, desiring a school that could match his artistic interests, moved back to the city to live with his father and attended Arsenal Technical High School from 1942 to 1946.[42] Again, the young artist was encouraged in his artistic pursuits by a reassuring teacher, Sara Bard. Miss Bard helped Indiana strengthen his convictions, even with the "parental resistance" to art that he was experiencing. Indiana remembers that his strict stepmother, Sylvia, urged him to take on part-time jobs to support himself. Early jobs included being a messenger boy for Western Union and an advertising copyboy/dispatcher at the

Indianapolis Star. When he was a senior in high school, he was photography editor for the school yearbook.[43] In 1945, Indiana attended Saturday scholarship classes at John Herron Art School. In 1946 he gave up a scholarship for study at John Herron to join the U.S. Army Air Corps.

WILLIAM T. WILEY

William T. Wiley was born on October 21, 1937, while his parents were living at 1753 25th Street in Bedford (FIG. 11). Bedford, located about 75 miles south of Indianapolis, was then and is today a rural community and the home of the Indiana Limestone Company. In this town known for many years as "Limestone Capital of the World," the economy has been driven by the production of the limestone quarries. Even with the bite of the Depression in the 1930s, the limestone quarries provided many jobs for the Bedford townspeople.

Wiley was born into a family of blacksmiths, many of whom were employed by the Indiana Limestone Company. This rich heritage is a fact that he both respects and honors. He has said that his creative talent comes from his grandfather, "a multifaceted Hoosier artisan who sketched, played music, and shaped metal."[44] This maternal grandfather, Thomas J. Abel, and his son, Marshall, Wiley's uncle, were important Bedford blacksmiths. Thomas J. Abel had moved to Bedford in 1894 to make tools for the limestone industry and eventually ran the most successful blacksmith shop in town.

Wiley's father, Sterling, worked at a variety of jobs in Bedford, including state highway inspector. With the onset of World War II, the Crane Naval Ammunition Depot opened in nearby Burns City, and he took a job there. Wiley's mother, Cleta, worked as a stenographer for many years at a local real estate company in Bedford. Wiley lived in Bedford for 10 years, from 1937 to 1947, but his family did not live in the same residence that whole time. After leaving Bedford and before settling for a while in Richland, Washington, the family also lived in various places outside of Indiana.[45]

Wiley's young life was not without art. In her book for an exhibition in which Wiley's work was exhibited, Christine Giles explains: "His earliest memory of art is of his parents reading to him while he looked at picture books. He remembers that as he grew older he would spend hours getting lost drawing horses, cowboys and tractors while listening to the radio."[46] While at high school in Richland, Washington, Wiley was encouraged by his art teacher, Jim McGrath. McGrath also encouraged Wiley's concern for preserving the natural ecology, a concern that has been an integral component and subject of Wiley's art.[47]

Fig. 11. Wiley family home in Bedford, Indiana.

Fort Wayne was a busy town in the late 1930s and early 1940s, with a steadily increasing population and economic base due in part to the entry of the United States into World War II. During the war, "virtually every type of war-related equipment was produced in the city," including electronic equipment, copper products, manufacturing tools and automobile parts.[48] Located in the northeastern part of the state, Fort Wayne has traditionally prided itself on its wealth of skilled labor and rich community heritage.

Bruce Nauman was born in this thriving environment on December 6, 1941, to Calvin and Genevieve Nauman. As in the case of George Rickey, the location of Nauman's birth was directly linked to the circumstances of his father's employment. His parents were both from the Chicago area, and his father had studied engineering at the Armour Institute in Chicago (presently Illinois Institute of Technology). After obtaining a job with General Electric as an engineer, Calvin Nauman moved his family according to the company's directives. Bruce Nauman was born in Fort Wayne, but about five years later the family had moved to Schenectady, New York, the location of the General Electric headquarters. The Naumans returned to the Midwest when Bruce Nauman was still young, this time to Wisconsin.[49] While the Naumans moved to various towns in Wisconsin—Milwaukee, Appleton, Wauwatosa—they were in that state longer than any other during Bruce Nauman's childhood. He remembers that he was always living in either a small town or suburb. He graduated from high school in Wauwatosa, a suburb of Milwaukee.[50]

The frequent moving had its effect on Nauman. He felt that he maintained a sort of distance from the places where he lived as a child and that he did not really achieve a "sense of place" because the family often relocated. He has admitted that making friends was not always easy, and he cultivated a life that revolved around solitary pastimes like building model airplanes and learning to play musical instruments.

He also enjoyed being out of doors; he was a member of the Boy Scouts and has recalled family camping trips with fondness.

Bruce Nauman, like David Smith and John Chamberlain, was not introduced to the visual arts at a young age but was introduced to creative enterprises. When he was asked if he had grown up with art in his background, he replied that his great-grandfather had been cabinetmaker by trade and that his father had spent time making furniture. He remembered that he had spent some time with his father building things and learning about tools.

The concepts of music and of music's relationship to time have played a large role in Bruce Nauman's art. His interest in the structure and composition of music is long-standing; he studied classical guitar, bass guitar and piano in his youth, played in the orchestra in high school and in various types of bands as a young adult, and took music theory and composition classes when he was in college. The interest in music and playing an instrument was largely self-cultivated. Neither of Nauman's parents played any instruments, and while his choice to do so was not discouraged, it was not wholeheartedly encouraged either. Nauman's father was more concerned with practical matters although the children were generally encouraged to try out new things. Nauman understood his father to mean that "whatever you want to try in the world, you should do that, do pretty much what you wanted."[51] Nauman's father strongly encouraged him to be a mathematician or to study business administration. While Nauman did graduate with a bachelor of science degree from the University of Wisconsin at Madison, where he studied mathematics and physics,[52] he had already decided by the second year of college that he wanted to be an artist.

Nauman believes that art should have a moral value. His own work is often concerned with political and social topics. He says that the source of these beliefs is his childhood in the Midwest (particularly Wisconsin). "In part it [his moral stance] just comes from growing up where I grew up and my parents and family. . . . Wisconsin was one of the last Socialist states, and in the '50s when I lived there and went to high school there, Milwaukee still had a socialist mayor. So there were a lot of people who thought art had a function beyond being beautiful—that it had a social reason to exist."[53]

1 In the Midwest there is a high value placed on learning musical instruments. Although they were not all formally trained on an instrument, music has, in some manner, played a role in their artistic production. Smith listened to the radio (WQXR out of Canada) while in the studio; Chamberlain was inspired by the music of Schubert; Wiley has made sculpture built around the theme of music as well as objects that were musical instruments (that he in turn would play); and Nauman, who played piano and guitar in his youth, has consistently referred to the structure of music not only in his art, but in his thought processes, and he has created work in which he has played music.

2 Widely known as David Smith, the artist was called by his first name, Roland, during his years in the Midwest and even today by extended family members (like his uncle who still lives in Decatur).

3 Gary Rutledge, "History of Courthouse Told," *Decatur* [Indiana] *Daily Democrat,* July 7, 1972, 2.

4 David Smith, "The Secret Letter," interview by Thomas Hess in *David Smith* (New York: Marlborough-Gerson Gallery, Inc., 1964).

5 Ibid.

6 Interview by Holliday T. Day and the author, Paulding, Ohio, June 10, 1999.

7 Sweet yeast rolls with icing on top, called "rusks," were a specialty dish of Golda Smith.

8 Stanley E. Marcus, *David Smith: The Sculptor and His Work,* (Ithaca and London: Cornell University Press, 1983), 22.

9 Smith, "The Secret Letter."

10 Ibid.

11 In his junior class play, *The Hoodoo,* Smith portrayed "Hemachus Spiggot." His senior year, in *The Girl in Waiting,* he acted in the role of "Mantague Witherspoon."

12 These illustrations were not Smith's first attempt at art-making. Karen Wilkin, in her monograph on Smith, indicates that Smith had memories of constructing a "mud lion" as a small boy. Apparently, the work was admired, but his inclination towards the artistic was discouraged by his family, particularly his mother.

13 V. Louise Reinhart, interview.

14 Dr. James L. Mullins, "The Rickey Family and South Bend," *George Rickey in South Bend* (South Bend, Indiana: Art Center of South Bend, 1985), 7.

15 Mullins, *South Bend,* 7.

16 Ibid., 6.

17 Robert M. Taylor, Jr., Errol Wayne Stevens, Mary Ann Pondner and Paul Brockman, eds., *Indiana: A New Historical Guide* (Indianapolis: Indiana Historical Society, 1992), 525.

18 Mullins, *South Bend,* 7.

19 Nan Rosenthal, *George Rickey* (New York: Harry N. Abrams, Inc., 1977), 20.

[20] George Rickey, "Observations and Reflections, 1964," in *George Rickey: Kinetic Sculpture on Clydeside* (Glasgow: Scottish Arts Council and Glasgow District Court, 1982).

[21] Ibid.

[22] Steve Mannheimer, "South Bend honors noted sculptor George Rickey," *Indianapolis Star,* September 1, 1985.

[23] George Rickey, "I Remember—Or Do I?" in *George Rickey: Kinetic Sculpture on Clydeside.*

[24] John Chamberlain, "Auto/Bio: An Interview with John Chamberlain," interview by Julie Sylvester, in *John Chamberlain: A Catalogue Raisonné of the Sculpture* 1954-1985 (New York: Hudson Hills Press, 1986), 8.

[25] Shirley Willard, Letter to the editor, "Background on the Chamberlains of Rochester," *Rochester Sentinel,* April 23, 1985. The oldest of four children, Chamberlain has one brother and two sisters. The building at the corner of 9th and Main no longer exists.

[26] *Indiana: A New Historical Guide,* 568.

[27] John Chamberlain, "Auto/Bio," 8.

[28] John Chamberlain in conversation with Holliday T. Day and the author, Shelter Island Heights, New York, September 24, 1999.

[29] John Chamberlain, "Auto/Bio," 8.

[30] John Chamberlain in conversation with Holliday T. Day and the author, Shelter Island Heights, New York, September 24, 1999.

[31] Ibid., 8.

[32] "'I'm Not Pop Artist," says Robert Indiana," *Indianapolis Star,* January 13, 1966. Moving frequently was certainly not easy, but at least it was just Indiana and his parents; he is the only *Crossroads* artist who did not have siblings.

[33] Robert Indiana, "A Mother is a Mother and a Father is a Father," in *Robert Indiana* (Philadelphia: Institute of Contemporary Art, 1968), 36.

[34] *Indiana: A New Historical Guide,* 467.

[35] *Trinity Episcopal Church Parish Profile,* Fall 1999, 26, 28.

[36] Consistent with the transitory life that Robert Indiana has described for his childhood, city directory listings for Indianapolis indicate address changes for almost every year Earl Clark and his family resided in Indianapolis. Until 1944, these residences were rentals. 1944 is also the first year that a phone number is listed for the family. Following are the addresses of the Indianapolis residences for the years 1929 through 1934 and 1937 through 1944: 1929—Rural Delivery P.O. Box 3420; 1930-31—Rural Delivery #9 P.O. Box 620; 1932—no listing; 1933—732 South Irvington Avenue; 1934—802 South Irvington Avenue; 1937-39—4843 English Avenue; 1940—412 North New Jersey Apt. 29A; 1941-42—1729 Broadway Apt. 3; 1943—1731 Broadway Apt. 4; 1944—558 Tacoma Avenue.

[37] Fred D. Cavinder, "Robert Indiana by the Numbers," *The Indianapolis Star Magazine,* January 17, 1982, 10.

38 The following is a list, compiled from city directories, of the Indianapolis-area companies that Earl Clark worked for while living in Indianapolis from 1929 through 1934 and 1937 through 1944: 1929—traffic manager at Western Oil Refining Company; 1930—office manager at Perino Oil Refining Company; 1931—secretary/treasurer at Indiana Home Oil Company; 1932—no listing; 1933—clerk (no company listed); 1934—clerk at Phillips Petroleum Company; 1937-1944—clerk at Phillips Petroleum Company.

39 Cavinder, "Robert Indiana by the Numbers."

40 Susan Elizabeth Ryan, "Eternal Love," in *Love and the American Dream: The Art of Robert Indiana,* (Maine: Portland Museum of Art, 1999), 79.

41 Cavinder, "Robert Indiana by the Numbers."

42 Arsenal Technical High School has been a large and dynamic metropolitan public school for quite a few years. Located a few miles from Earl Clark's home, Arsenal Tech has a reputation for having a strong and quite large art program with courses in painting, design, metalwork, and ceramics (among others). At the time that Indiana went to school there, the faculty included at least ten professional and practicing artists who taught a number of art courses.

43 Cavinder.

44 Tracy L. Kamerer, *William T. Wiley* (Bloomington, Ind.: Indiana University Art Museum, 1993).

45 Wiley recalls that he lived in a number of places. Complete information for the years that Wiley was living in Indiana, 1937-1947, was not available. The following partial list, taken from city directories, indicates that Wiley's family moved at least three times within a five-year span: 1937—1753 25th Street; 1940—1617 18th Street; 1942—1828 15th Street. During a conversation that curator Holliday T. Day had with the artist, he talked about one particular move. The entire family was in the car and ready to move again when Wiley stated that he did not want to move anymore. Apparently his words had some effect because the decision was made not to leave, the car was unpacked, and the family stayed.

46 Christine Giles, "William T. Wiley," in *Collaborations: William Allen, Robert Hudson, William Wiley* (California: Palm Springs Desert Museum, 1998), 71.

47 Ibid, 75.

48 *Indiana: A New Historical Guide,* 5.

49 Genevieve Nauman, in conversation with Holliday T. Day, September, 1999.

50 Most of the details about Bruce Nauman's youth and about his family contained in this section of the essay come from one invaluable source, an interview with Michele DeAngelus recorded May 27 and 39, 1980 (William George Allan Papers, Archives of American Art/Smithsonian Institution, Washington, D.C.). During the interview, Nauman spent a great deal of time discussing his childhood and family (pages 1-15), as well as his education and early career.

51 Bruce Nauman, interview by Michele DeAngelus, May 27 and 30, 1980, audiocassettes and transcript, William George Allan Papers, Archives of American Art/Smithsonian Institution, Washington, D.C., 6.

52 Although he studied art and music in college, mathematics and physics formed the core of Nauman's academic undergraduate program.

53 Bruce Nauman, "Breaking the Silence: An Interview with Bruce Nauman," interview by Joan Simon, *Art in America* 76, no. 9 (September 1988): 142.

CROSSROADS

of AMERICAN SCULPTURE

HOLLIDAY T. DAY

David Smith and George Rickey in Bloomington, Indiana, 1954-1955

IN JANUARY 1954 at the College Art Association meeting in Philadelphia, art historian Henry Hope, chairman of the Indiana University Department of Fine Arts, asked David Smith, at George Rickey's urging, to teach at the university in Bloomington for the 1954-55 academic year. Smith accepted the appointment. These two artists, who were nearly the same age but whose work was quite different, shared a conviction that their sculpture should reflect the materials and technologies of their era. They also believed that drawing was a crucial aspect of their artistic thinking, not merely a plan for a sculpture. They had arrived at this conviction by quite different routes.

Smith spent his childhood in small Midwestern towns; Rickey grew up in Glasgow, Scotland. In the summer of 1925, while Smith was working as a welder and riveter at the Studebaker plant in South Bend, Indiana, Rickey was on a freighter going from Scotland to the Mediterranean and back. Smith had yet to see any "real" art. Rickey was getting his first sight of the great churches and Renaissance art of Italy. But for both men, it was the non-art experiences they had that summer that presaged the form their art would eventually take. Each artist would look back in later years and see that his passion for sculpture was influenced by his youthful experiences as well as by inherited traits from his forebears, inventors and blacksmiths in Smith's case, and engineers and clockmakers in Rickey's. As a factory worker, Smith learned to weld, a technique necessary to making his future sculptures and one that he would teach Rickey at Indiana University. Rickey's diary of his trip is notable not for his observations on masterpieces of Continental art, but because he reveals how fascinated he was with motion. On arriving in Florence, he promptly took a train to Pisa and "went at once to see . . . the lamp whose swinging Galileo watched."[1] It was Rickey's understanding of the physical laws that govern the motion of pendulums, formulated by Galileo, that the sculptor was later to incorporate into his art.

Not only did their early lives have marked differences, but they also received very different formal educations. While Rickey acquired a university degree in history at Balliol College at Oxford, Smith's higher education ended after one year at Ohio University. Despite these differences, their art education experiences had similarities nevertheless. Both artists were "schooled" as painters and introduced to Cubism early in life. Rickey had attended the Ruskin School of Drawing at the Ashmolean and had studied Cubism with André Lhote, Fernand Léger and Amédée Ozenfant in Paris. Smith had taken classes with John Sloan at the Art Students League in New York and learned about European innovations and Cubism from Jan Matulka and John Graham. Both Smith and Rickey had worked on WPA projects as painters and had

jobs on magazines in the New York area in the 1930s. They both attended the American Artists Congress in 1937, the Woodstock Art Conference in 1947, and various College Art Association meetings in the 1950s. Both men shared the conviction that their sculpture should reflect the modern industrial world in a way that totally separated it from the sculpture of the past. This conviction came from separate but parallel experiences of Cubism, painting, and living in New York.

They met for the first time in 1937, at a party at Woodstock, but their paths crossed infrequently until Rickey began to visit Smith in the 1950s. During this time, Rickey was teaching in the summer at Treetops, a camp in Lake Placid a few miles from Smith's place in Bolton Landing. It was these meetings that led Rickey to urge Henry Hope to invite Smith to Indiana University, where Rickey was teaching.

Despite its isolated location in a small town in a hilly wooded area some fifty miles southwest of Indianapolis, the university had a lively fine arts department under Henry Hope. Its seven art historians and eight artists taught painting, sculpture, photography, ceramics, metal-working, weaving, print-making and design. Hope organized regular art exhibitions on campus, ranging from a selection of European masterpieces from the Metropolitan Museum of Art in 1948 to paintings by the Abstract Expressionists in 1951. In addition, Hope bought works by Picasso, Braque, and Miró for his own home, where frequent parties for the art department were held.

For both artists, the 1954-55 academic year was an important turning point for their sculpture. For Smith, the year solidified ideas he had been developing since the creation of *Hudson River Landscape* and led to the creation of the *Forging* series, eleven radically minimal sculptures based on his conviction that the identity of the artist is expressed through his work, especially through his drawings, the "life force of the artist," as he called them. All but one of the series were completed in Indiana in 1955. (*Forging X* was finished in 1956 in Bolton Landing.) This idea, although always present in some form for Smith since his arrival in New York in 1928, had become solidified and shaped over the five years between 1949 and 1954 and was the main subject of his many talks given to groups around the country. The *Forging* series is the purest sculptural example of Smith's convictions. To form the sculptures, he made use of the intuitive and spontaneous process of forging. The forms themselves recalled the gestural marks that make drawing the life force of the artist and assert his identity. Although the shapes of later sculptures would have less reference to the gestural marks of drawing, all of these later works would be achieved by processes that allowed Smith to construct them in a direct intuitive fashion without the aid of pre-drawn plans.

For Rickey, the Bloomington experience (1948-54) was the period in which his convictions and identity as an abstract sculptor took form. For the previous five years he had experimented with a number of different mechanical motions for his sculptures. He thought of them as esthetic machines in which time, the fourth dimension, was as important as any of the three spatial dimensions. All of his sculptures from this point on would be based on these mechanical motions.

One indication of the increasing confidence that these artists were beginning to have about their ideas was their willingness to make large uncommissioned sculptures as opposed to pedestal pieces, which were more easily sold. Creating large works posed two practical problems: the cost of materials and machinery to make them and storage space for them if they were not sold. Rickey was quite amazed by Smith's willingness to spend huge sums of money on materials and equipment and commented in a letter to a friend[2] that Smith had told him that he spent $5,000 a year on his art productions. Since $5,000 in 1953 was equivalent to a university professor's yearly salary and several times greater than the cost of a new Ford or a year's tuition and board at Harvard, one can sense the enormity of the sum, especially for artists who had lived through the Depression, as Smith and Rickey had. Not only was Rickey amazed at the sum Smith spent for materials, but he also commented in the same letter on the equipment Smith had assembled at Bolton Landing to make his sculpture. "He maintains a complete welding shop with the expensive equipment of a big factory."[3]

Although ten years later both Smith and Rickey were working extensively with stainless steel to make large outdoor sculptures in geometric shapes, when they were in Bloomington, they usually made indoor metal sculpture. The largest sculpture Rickey had made up to that point was *Silver Plume II* (1952, 114 x 144 x 36 in.), which he had shown in January 1953 at the Herron Art Institute (forerunner of the Indianapolis Museum of Art). *Silver Plume II* was an exception to the majority of his work at that time, which tended to be small enough to sit on pedestals. Smith's largest work at that time was *Australia* (1951, 79 x 107 x 17 in.), but increasingly he had been making his work large by the sculptural standards of the day and had made a number of pieces over six feet tall, including his *Tanktotem I* and *II*, made in 1952.

Sculptures on this scale were considered by American critics and the public not only unusual, but somewhat outrageous and impractical. In the immediate past, works of such size had been created only as commissions for public monuments. Creating large sculpture required enormous confidence in one's ability and a courage to act on one's convictions. Smith's example must have encouraged Rickey to make more large works.

Rickey also encouraged Smith. He, perhaps more than others, understood the importance of drawing to Smith, because, like Smith, he had begun his artistic career as a painter rather than as a sculptor.

For Smith and Rickey, "drawings" was a broad term that included anything put down on paper, not just those works made with a linear instrument, such as a pencil, pen, or stick of chalk. Both Rickey and Smith, although their approaches were different, recognized the importance of drawing as part of the creative process. Moreover, both artists had begun their artistic efforts drawing and painting and only turned to sculpture later. For them, drawing was how an artist thought, not just a preliminary to an art work or a means of practicing one's skill. Rickey's appreciation of the importance of Smith's drawings was evident on at least two occasions. Before he knew that Smith would be coming to Indiana University, he had expressed an interest in doing an exhibition of Smith's drawings at the university during the 1953-54 academic year.[4] In 1955, when he left Indiana to head the art department at Tulane University, he asked Smith to come to Tulane to speak about drawing.

At first, Smith wanted his sculpture to reflect the spontaneity and self-expression found in drawing. Eventually, he came to the conclusion that his sculpture should not just reflect a drawing's spontaneity but could and should be made by techniques that paralleled those used for drawing.

The first inklings, literally, of Smith making the connection between drawing and sculpture came in 1951 quite by accident. As he was shaking a bottle of ink, it accidentally spilled on a drawing, making an expressionistic landscape. He used it to create *Hudson River Landscape* (1951), the first of a number of sculptures done between 1951 and 1953 that seemed to be linear "drawings in space." Silhouetted against a cloudless sky, the linear steel elements of the sculptures would replicate the lines of ink he could draw on a sheet of paper.

While teaching at the University of Arkansas in 1953, he made a number of linear sculptures he titled *Drawing*. The titles, and in some cases the image itself, emphasized the integration between drawing and sculpture. For example, a picture taken by Rickey shows Smith relaxing on Rickey's patio in Bloomington with *Drawing 3/23/53* on a pedestal in the background. This work's image could be interpreted as the artist with a palette and brush.

Prior to coming to Bloomington, Smith, always the experimenter, had made a number of moving, hanging sculptures[5] that also might be seen as his toying with the idea of literally making a "drawing in space," as the sculptures had no

Blacksmith using a trip hammer.

contact with the ground. Seeing Rickey's moving work must have convinced him that this path was not the right one for him, as he never made another mobile work.

But it was in Bloomington that Smith made a fortuitous discovery that allowed him to truly integrate his gestural drawing methods with his sculpture fabrication. He located a commercial metal forging shop run by Leroy Borton, where he could use a power-driven hammer, called a trip hammer, that could shape or forge heated steel bars. With this equipment, he made the *Forging* series.

Unlike the *Drawing* series and other linear sculptures, like *Egyptian Barnyard*, the *Forging* series was about the painted, gestural line rather than the line of a pen or a pencil. Like a rapidly made brushstroke of paint, the outcome of any one of the *Forging* sculptures was not entirely predictable. He placed a metal plug in a previously drilled hole in a hot steel bar and then used the trip hammer to pound the plug into the hole. The pressure sent the sides of the bar outward in the area around the hole, much as a brush would splay out from pressure that the hand applied to the brush.

The importance to Smith of linking his sculpture to the personal gestural brush mark, not only of his drawings but also to the paintings of his contemporaries in the New York School whose philosophy he shared, can be found in two speeches: one at Arkansas in April 1953 and one at the Southwestern College Art Conference at the University of Oklahoma in May 1953. The talks, called "Thoughts on Sculpture" and "A Sculptor's Point of View,"[6] articulated the creative force and power needed to make sculpture and the view of art as an act of personal conviction and identity guided by the artist's instinctual being. In his first talk, Smith said, "The work of art can have subject to any degree of abstracting or the artist himself can act as subject,

wherein the act itself is the subject for celebration or identification."[7]

In "A Sculptor's Point of View," he reiterated the same ideas. "The artist is now his own nature, the work is the total art. There is no intermediary object. The artist has now become the point of departure. . . . He is a part of nature. He is the nature in the work of art."[8] Smith regarded the artist as a person called to the profession, as a minister is called. He said that the artist's "devotion and conviction of purpose must exceed that of other men. He has no [financial] security. . . . His position is wholly irrational."[9] He went on to say that the artist "feels the strength of numbers, for his profession gains force and new recruits. . . . He knows that the product of the artist is the work of art."[10]

In some sense then the *Forging* series can be regarded as a series of abstract self-portraits, not because of any external resemblance to the artist but because they were essentially a gesture in steel, akin to a gesture in paint denoting the personal mark of the artist.

In the same speech, it is interesting to note that he discusses Chinese *rei sho* character writing and Japanese painting, not as he says "to show that we are directly influenced by oriental art," but to demonstrate that the urge to give energy and power to one's artistic marks is universal. "The sentiment of strength must be evoked and felt" and "statements of action . . . power the object with belligerent vitality."[11]

He said that "in Chinese *rei sho* character writing, the [artist's] graphic aim was to show force as if . . . engraved in steel." In Japanese painting "the power intent was suggested by conceiving a stroke outside the paper, continuing through the drawing space to project beyond, so that the included part possessed both power origin and projection."[12]

In the *Forging* series, Smith made sculpture as if the painted brush stroke could be freed from the support of the canvas or paper. He used the malleability of steel as if it were paint. It is as if he imagined to himself: "What would the brush stroke look like if I could paint it in the air and walk around it and see not only the back side but the edges as well?"

The title *Forging* may not have been immediately given to these works by Smith, but may have been arrived at just before they were exhibited at Willard Gallery in New York City in March 1956. E. C. Goossen wrote in an article printed simultaneously with the March exhibition that Smith would be showing "some new pieces which he calls *Verticals*" at Willard that month.[13] This title, as opposed to *Forging*, links these works to his 1952-53 gestural drawings.

The eventual title, *Forging*, a generic word for the industrial process that Smith used to make the works, coincided with his view of an artist's mission in life

and his own identity as an artist. To forge metal is to heat it, and then, while the metal is hot, beat it into a shape on an anvil. The blacksmith who makes a horseshoe uses this technique. In Roman mythology, the blacksmith Vulcan is a god whose strength is protean and whose power comes from the heat and fire of his forge. The word *volcano* comes from *Vulcan*. The product of the blacksmith is one born of fire. The surname *Smith* derives from the trade of blacksmithing. Samuel Rugg, David Smith's ancestor and one of the founders of the artist's hometown of Decatur, Indiana, was a blacksmith and pioneer from Pennsylvania.

Although Smith continued to make numerous abstract paintings on paper for a number of years afterwards, the *Forging* series may have been his only sculptures conceived as painterly personal gestures. In March 1956, he showed the entire series at Willard Gallery along with some related, more figural vertical works, also made in Indiana: *Sitting Printer, Construction in Rectangles* (2-26-55), *Construction with Forged Neck* (4-25-55), and possibly *Yellow Vertical*. As recounted by Stanley E. Marcus, Smith was extremely proud of these works and paid to have them reproduced in the gallery brochure. None of them sold and Smith was gravely disappointed that they were not financially successful. [14]

The *Forging* series is remarkable in another way. It is a true series based on variations of a single esthetic theme and subject matter, unlike many Smith series, such as the *Agricola* series or *Voltri* series, which are named for their materials or the place in which they were made rather than their theme and subject matter. Like Smith's drawings, where he would explore in rapid succession a single theme or topic that interested him, the *Forging* sculptures were made over a short time period based on a single theme.

While the *Forging* series remain Smith's most painterly sculptures in that they seem to be the most direct translation of the painting gesture, both in form and method, into sculpture, they also mark an end to his use of linear drawing as a preliminary to constructing a sculpture. Direct construction through collaging metal units together became his preferred method after 1954. However, configurations were tested before actual welding occurred by various methods that included drawing and painting.[15]

The eleven *Forgings*, shown at Willard Gallery in 1956, were favorably reviewed in *Art News* in a long article by Betty Chamberlain, managing editor of the magazine. She considered them to be the highlight of the exhibition of "twenty-two large sculptures and many drawings." Conveying the excitement these works generated in at least one viewer at the time, she wrote, "The beaten metal, with its force and rigor and gleam full of powerful expressions, has an additional and unexpected

element of joy, as if pulsating from the echoes of a triumphant shout."[16] It is the hope of this curator that the same excitement for these rarely shown or discussed works will occur in this exhibition, which brings together seven of the eleven *Forging* sculptures for the first time since 1956.

While Rickey appreciated and supported Smith's work and took heart from the conviction and confidence with which Smith made it, his own sculptures were based on different premises. By 1954, both Smith and Rickey had rejected Cubist premises. Smith's work was multidirectional as it embraced both constructivist tendencies and the gestural tendencies of Abstract Expressionism. It frequently had references to the figure or to the natural world. Rickey wanted to construct kinetic sculptures that eliminated these pictorial references to the natural world.

Rickey in particular admired Naum Gabo and Paul Klee, whose work he was exposed to at the Institute of Design in Chicago from 1948 to 1949.[17] Gabo believed that art should reflect the fundamental laws of nature, rather than imitate its appearance. Klee's work is sometimes called "a walk with a line," a phrase that could be applied as well to Rickey's mature work, like *Two Lines Oblique*. Since time was a component of space, Rickey believed it should be incorporated into sculpture. Thus, for him, art was to be "constructed" from the four abstract dimensional components of space: time plus the three spatial dimensions. The forms were to be geometric shapes rather than those abstracted from nature. Although fascinated by Calder's mobiles, which used time as a component of art, he felt that the paths traced by the movements of Calder's mobiles were too predictable and the forms too organic. After 1951, with one exception (*Cocktail Party*, 1954),[18] Rickey rejected forms that suggested the organic.

By 1955, he had developed mechanisms that would create five different types of forms in motion in his sculptures.[19] Although he still called them mobiles, they were even then truly "kinetic" sculptures,[20] (the term he adopted in 1956 to describe his work). Most of Rickey's work in 1954 was linear and open with thin wires and delicate planes, and each sculpture moved in such a way that it was literally a drawing that "took a walk in space," as if a Klee watercolor had come off the page and come to life. The works that rested on the table or floor seemed to defy gravity at the same time that the pull of gravity was the means by which they moved. The slightest movement of air created an instability so that the force of gravity would come into play to create movement. Since the exact force exerted by moving air was unpredictable, the movement of the parts was likewise a surprise.

He constructed several pieces that he called "machines without use." They

looked like functional, precisely made mechanical objects, but unlike true machines, they did not perform useful work and were not predictable in the timing of their movements. In this sense, Rickey's sculptures resembled waves at sea. The movement of the ocean always takes the form of waves, but no two waves are ever alike. Under any given set of conditions, some are higher and wider or steeper than others. Occasionally there is the so-called rogue wave that surpasses any expectations a sailor might have from observing the waves that immediately preceded it.

In 1951-52, prior to Smith's arrival at Indiana University, Rickey made his most dramatic moving sculpture, *Silver Plume II*, which was the centerpiece of his exhibition in Indianapolis. This piece suggested the way Rickey's kinetic sculpture would develop over the next five years. The large piece, fashioned from a 3-by-8-foot plate of 18-gauge stainless steel and placed on a base made from a 3-by-8-foot sheet of 24-gauge stainless steel,[21] was completely nonobjective and unusually large compared to other works in the show. Its most singular characteristic was the long, curved blades or linear elements that rotated around a tripod that stood on the base. The blades were shiny but did not have a mirror finish, so that they caught the light but did not have reflections of other objects on them. The cost of the stainless steel for this piece was so high and it was so difficult to obtain that Rickey was unable to make others at that time, although making large outdoor moving works was something he was eager to do. Size was critical to Rickey's concept of using time as a dimension in his work. The larger the moving element, the slower the element moved. To achieve the slow, deliberate movements that would emphasize the passage of time, Rickey had to increase the size of his sculpture.

Almost all of Rickey's work at Bloomington was made with the techniques and equipment—soldering, cutting sheets of thin metal, enamel paint, for example—that could be found in the jewelry-making section of the university art department, but the structural limitations of the materials prevented Rickey from using them to make large pieces. The rigidity, strength, and durability of sheets of stainless steel provided the means for Rickey to make large works. New metal-working techniques, such as welding, were also necessary to making larger pieces in steel. Smith helped Rickey by giving him a welding lesson at Bloomington. Although *Silver Plume II* had been made without welding because it pivoted on a point, welding had to replace the solders Rickey had been using to construct his small work.

Smith had been employing steel welding techniques used in industrial production for at least some of his sculpture since the 1930s. His love affair with steel and welding really became intense in the 1940s. Not only Studebaker cars, but also boil-

ers, water towers, and farm machinery had been made in the Midwest from Indiana steel since the early part of the century and were symbolic of American know-how, the pioneering spirit, and industrial vigor. Steel remained a central material in Smith's work, although he continued to use many different materials throughout his life.

Rickey's interest in steel came from its use in architecture, particularly its association with Chicago architecture, the Institute of Design, and the Chicago Bauhaus. The radical steel and glass apartment buildings of 860-880 North Lake Shore Drive were completed by Mies van der Rohe in 1952. At the time, no other buildings celebrated the concept of modern technology so dramatically. Like Mies, Rickey felt that artists must learn to work with technology, using the materials of our times. Perhaps even more dramatic was Chicago's Inland Steel Building, completed in 1957. Like the Mies apartment buildings in concept, it was constructed by Skidmore, Owings & Merrill of steel and clad with sheets of stainless steel as well as glass. The interiors of these buildings echoed their exteriors with their stainless steel furniture and steel elevator doors. Stainless steel also found its way into the American kitchen in Revere pots and pans and utensils and sinks. What aluminum had been to the 1930s and as titanium was to the 1990s, stainless steel was to the 1950s. It embodied what the word *modern* meant in the 1950s. Rickey's term "machines of no use" for his early kinetic sculpture echoes the phrase Le Corbusier used to describe the modern house: a "machine for living."

So, while the essential artistic ideas for kinetic art were honed and developed at Indiana University, the facilities for handling and making the large, spare outdoor works like *Two Lines Oblique* become possible when Rickey moved permanently to East Chatham, New York. Only then did he achieve what *Silver Plume II* had hinted at.

For Smith and Rickey, the early 1950s was a time when each was able to take all the separate influences and experiences of his life and arrive at a conviction about the way his art must function as art. Although their esthetics, like their personalities, were quite different, and arrived at separately, there were shared areas of concern.

Rickey and Smith shared the idea of a sculpture as a spatial drawing active in space instead of confined to a piece of paper or to a sculptural mass. They both recognized the importance of steel, especially stainless steel, as the medium of modernity. Not only did it refer to twentieth-century machines and industrial methods, but it also provided enormous opportunity and freedom to use their new forms in large works. The comparison of *The Sitting Printer* with *Zig II* or *Sedge I* with *Two Lines Oblique I* makes the importance of the properties of steel manifest.

Both Smith and Rickey understood what it took and meant to be an artist

in the twentieth century. The financial sacrifice, the writing and speaking, the discipline necessary to produce art, the rebellion against artistic boundaries arbitrarily set by others, and finally the confidence to believe in yourself as an artist and your ideas were all necessary aspects of being an artist of the twentieth century.

Both Smith and Rickey found remote retreats in the hilly countryside of New York state, miles north of New York City and ideal for their work. Bolton Landing, Smith's choice, was a far cry from the flat terrain of Decatur, Indiana. For Rickey, East Chatham was not so different from Bloomington and its steep hills and woods, or the New England of his grandparents, or the Scotland of his childhood days, except that it was far not only from cities, but also from a town of any size. For Smith, the retreat came early in life. For Rickey, the move came later, not long after he left Bloomington to teach at Tulane University. For both men, despite their use of industrial materials, the rural setting was essential to the esthetic completion of their work.

While much has been written about Smith's fields of sculptures that march like personages across the land, each at home in the surrounding hills of Bolton Landing and at times reflecting the sky above them, less often mentioned are Rickey's wooded dales of kinetic sculptures. How different are the many works surrounding his home and studio. Stainless steel forms, looking like streaks of light against the dark green woods, move to different rhythms. In contrast to the sturdy physical presence of Smith's lively sculptures, Rickey's are driven by unseen but felt breezes. They echo in a stately manner the flutter of leaves in the trees or the wind-blown ripples in his small pond.

The work of these men enlivens the landscape in a way quite different from the way sculptures since ancient times have ornamented many a garden. Nor is the effect like the modern sculpture park, where objects of stone and wood nestle into the site or bright steel abstract forms boldly proclaim themselves against greenery.

Smith's forms, even in the most "non-objective" mode, seem rooted in both ancient history and in the late twentieth century because they celebrate the eternal relationship between man and the natural world he lives in. All of Rickey's mature work is carefully constructed from geometric elements and makes use of laws of physics that govern the world. These moving pieces stress the wonder and timelessness of the natural world and human fascination with it.

These two different approaches to sculpture by two Americans of the same generation show how the main tenets of European modernism could flourish and develop in the 1950s into new ideas, ideas that were quite different from each other and from those of the older Europeans whose work inspired them.

1 Diary entry for August 18, 1925, "Mediterranean Trip, 1925," Rickey Studio Archives.

2 Rickey to Ulfert Wilke, letter written at Lake Placid, N.Y., July 27, 1953, Rickey Studio Archives.

3 Ibid.

4 Ibid.

5 For example, *Parallel 42* (1953) and *ARK53* (1954).

6 "Thoughts on Sculpture" was published in *College Art Journal* 8, no. 2 (winter 1954): 97–100. "A Sculptor's Point of View" was published as "Second Thoughts on Sculpture" in *College Art Journal* 8, no. 3 (spring 1954), 203-207. In the first lecture, he said that "the contemporary artist stands in much the same position as primitive man. He accepts nature, intuitively. He becomes a part of nature. . . . He accepts it for its own statement as existence" (99). Earlier in the same talk, he said, "His (the artist's) act in art is an act of personal conviction and identity"(98). This view of man as nature and man guided by his instinctual being to make art is one Smith shared with other artists of his era. Compare Jackson Pollock's "I am Nature" and Barnett Newman's "The first man was an artist."

7 "Thoughts on Sculpture," 99.

8 "Second Thoughts on Sculpture," 205.

9 Ibid., 204.

10 Ibid.

11 Ibid., 206.

12 Ibid.

13 `"David Smith," *Arts* 30 (March 1956): 27. Although Goossen's description of the *Verticals* in the article is clearly a description of only the *Forging* series, one of the photographs in the article is identified as *Forging X*.

14 Stanley E. Marcus, *David Smith* (Ithaca, N.Y.: Cornell University Press, 1983), 95.

15 E. A. Carmean, Jr., "Introduction: David Smith at Work," *David Smith* (Washington, D.C.: National Gallery of Art, 1982) 17–64.

16 B. C. (Betty Chamberlain), review, *Art News* 55 (April 1956): 25.

17 After Moholy-Nagy died in 1946, the Institute of Design was combined in 1949 with Illinois Institute of Technology (IIT). It was relocated south of the Loop in 1995 at the campus designed by Mies van der Rohe. After the merger, IIT became less a school of design than an engineering and architectural school. But in the late 1940s and early 1950s, art was still a lively part of the curriculum under Moholy-Nagy's successor, Serge Chermayeff, especially in 1948 and 1949, when George Rickey was a student there.

18 *Cocktail Party*, a work where a cluster of small sheet-metal heads atop vertical wires bobbed and nodded with the air currents, was both a comment on the constant round of faculty cocktail parties that took place in the 1950s at Indiana University and a sculptural version of Paul Klee's *Twittering Machine* (1922), in the collection of the Museum of Modern Art.

[19] Nan Rosenthal, *George Rickey* (New York: Harry N. Abrams, Inc., 1977), 42.

[20] The term was first used for art by the brothers Naum Gabo and Antoine Pevsner in "The Realistic Manifesto" (1920): "We affirm *in these arts a new element the kinetic rhythms as the basic forms of our perception of real time." Art in Theory 1900–1990*, ed. Charles Harrison and Paul Wood (Cambridge, Mass.: Blackwell Publishers, 1993), 299. The "Manifesto" was originally translated by Gabo for Herbert Read, *Gabo* (London, 1957). Rickey heard Gabo speak at the Institute of Design and also saw his exhibition at the Museum of Modern Art in New York, according to Rosenthal (*George Rickey*, 49). In true Rickey fashion, he was well versed in the history of moving art even as he was making his early moving sculptures at Indiana University, and credits Marcel Duchamp's 1913 bicycle wheel mounted on a stool as the first mobile sculpture of the twentieth century. For a short history of moving art in the twentieth century, see George Rickey's article "The Morphology of Movement— A Study of Kinetic Art" in *Art Journal* 22, no. 4 (summer 1963), 220-230.

[21] On November 18, 1951, Rickey wrote in a supplement to an earlier grant application to Indiana University that he was "anxious to design some large outdoor mobiles of weatherproof materials." He was trying to obtain an extra $80 to purchase stainless steel from the university for this purpose as stainless steel could be "obtained in the general market only with a priority." Rickey Archives at Rickey Workshop, East Chatham, N.Y.

David Smith

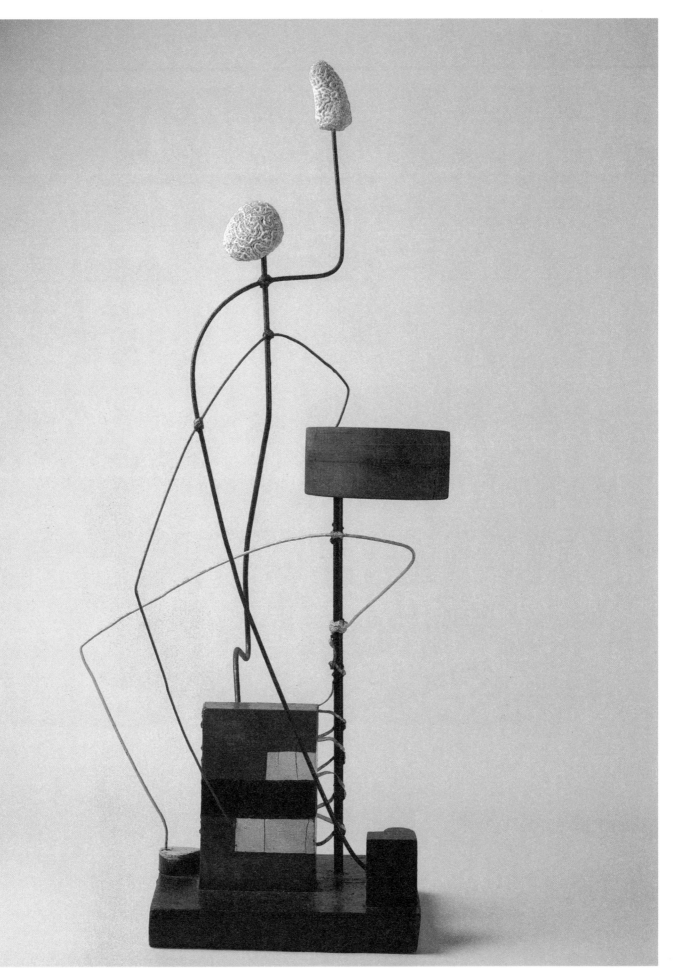

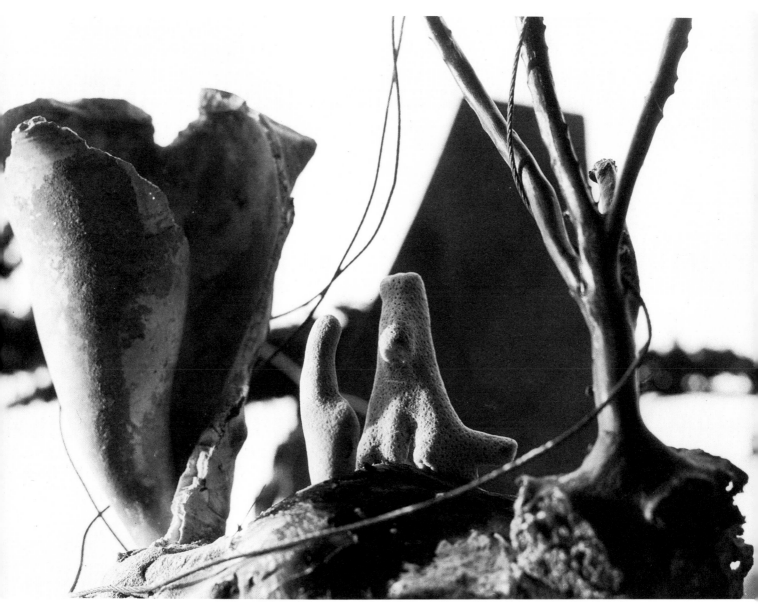

PAGE 77
CONSTRUCTION, ABOUT 1932
WOOD, WIRE, NAILS, 37 1/8 X 16 1/4 X 7 1/4 IN.;
ON WOOD BASE, 1 3/4 X 9 1/2 X 12 IN.
THE COLLECTION OF CANDIDA AND REBECCA SMITH, NEW YORK, N.Y.
©2000 ESTATE OF DAVID SMITH/ LICENSED BY VAGA, NEW YORK, N.Y.

ABOVE
UNTITLED (VIRGIN ISLAND TABLEAU), ABOUT 1931-32
EXHIBITION PRINT
GELATIN SILVER PRINT (WITH APPLIED VARNISH), 11 X 14 IN.
THE COLLECTION OF CANDIDA AND REBECCA SMITH, NEW YORK, N.Y.
©2000 ESTATE OF DAVID SMITH/ LICENSED BY VAGA, NEW YORK, N.Y.

OPPOSITE
MARKET-NEW YORK CITY, 1927
LINOCUT, 10 X 9 5/8 IN. (IMAGE SIZE)
INDIANAPOLIS MUSEUM OF ART
CARL H. LIEBER MEMORIAL FUND AND EMMA HARTER SWEETSER FUND 1991.45
©2000 ESTATE OF DAVID SMITH/ LICENSED BY VAGA, NEW YORK, N.Y.

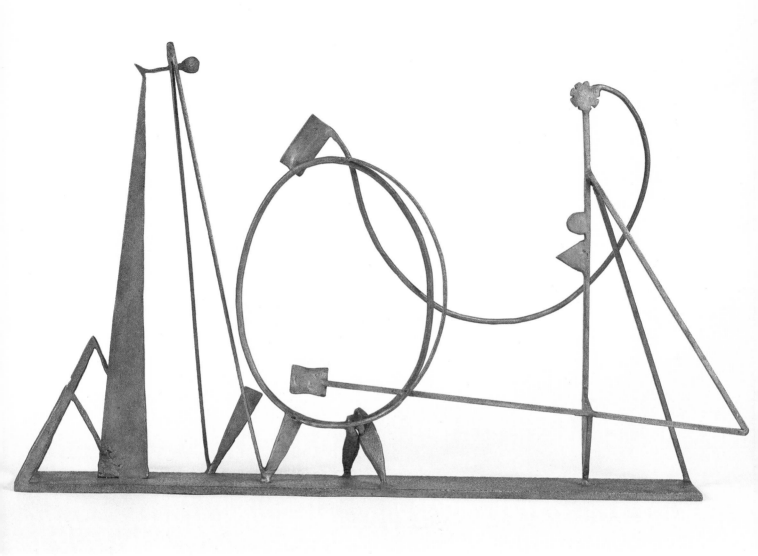

AMUSEMENT PARK, 1938
WELDED STEEL, 20 X 34 X 4 IN.
NEW ORLEANS MUSEUM OF ART:
GIFT OF MR. AND MRS. WALTER DAVIS,
JR. IN HONOR OF THE MUSEUM'S 75TH
ANNIVERSARY
©2000 ESTATE OF DAVID SMITH/
LICENSED BY VAGA, NEW YORK, N.Y.

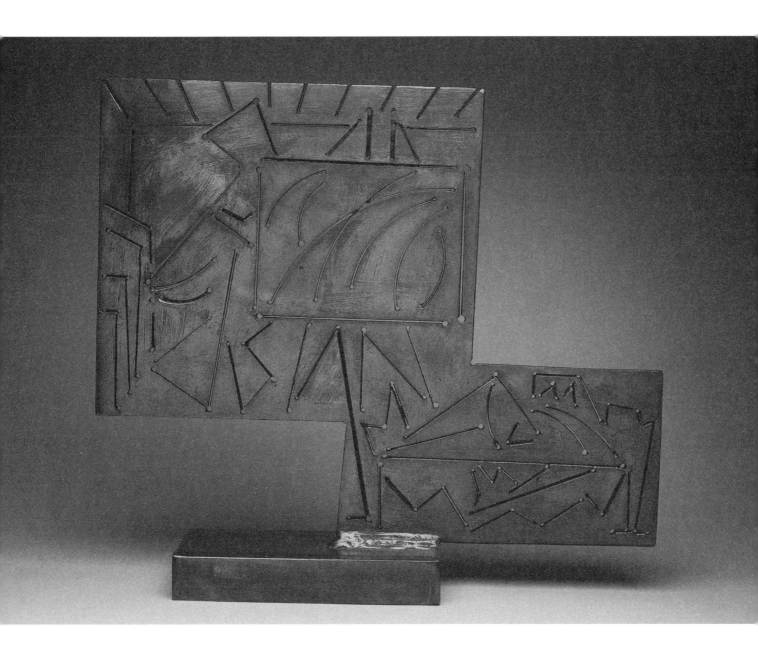

STEEL DRAWING I, 1945
STEEL, 22 1/4 X 26 X 6 IN.
HIRSHHORN MUSEUM AND SCULPTURE
GARDEN, SMITHSONIAN INSTITUTION
GIFT OF JOSEPH H. HIRSHHORN, 1966
©2000 ESTATE OF DAVID SMITH/
LICENSED BY VAGA, NEW YORK, N.Y.

DANCERS, 1952
GOUACHE ON PAPER, 15 3/4 X 20 1/4 IN.
BANK ONE ART COLLECTION
©2000 ESTATE OF DAVID SMITH/ LICENSED BY VAGA, NEW YORK, N.Y.

OPPOSITE
ADAGIO DANCERS, 1945
BRONZE, UNIQUE CAST, H: 13 1/4 IN.
ANN AND CHRIS STACK
©2000 ESTATE OF DAVID SMITH/ LICENSED BY VAGA, NEW YORK, N.Y.

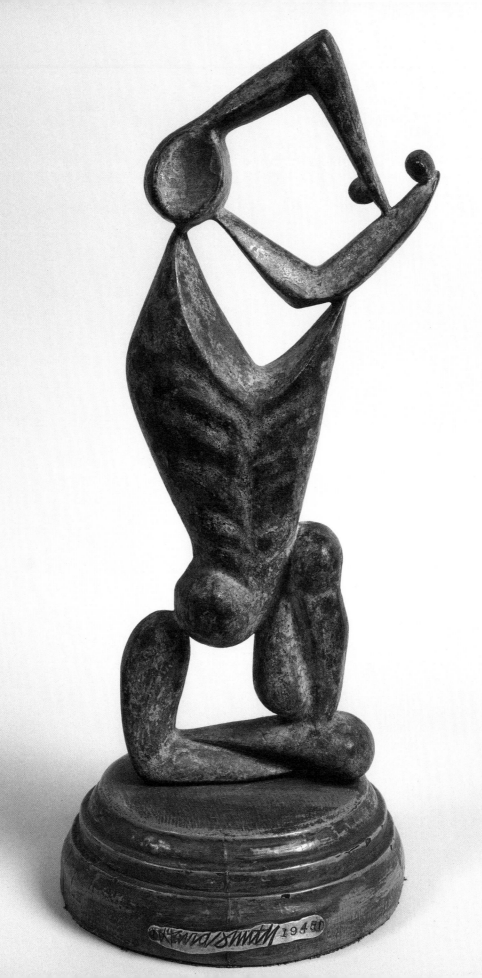

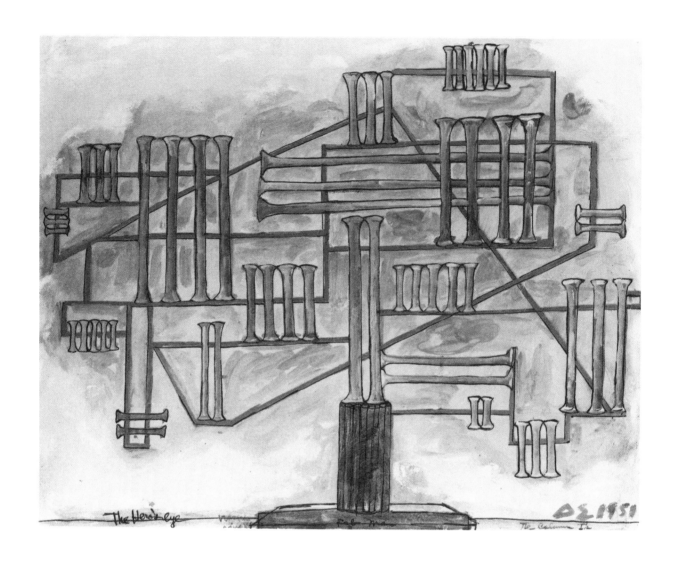

THE HERO'S EYE, 1951
INK AND WATERCOLOR ON PAPER, 18 1/4 X 22 3/4 IN.
TERESE AND ALVIN S. LANE
©2000 ESTATE OF DAVID SMITH/ LICENSED BY VAGA, NEW YORK, N.Y.

OPPOSITE
17 h'S, 1950
STEEL, PAINTED CADMIUM ALUMINUM RED, 44 1/2 X 28 1/2 X 12 IN. DIAMETER
THE COLLECTION OF CANDIDA AND REBECCA SMITH, NEW YORK, N.Y.
©2000 ESTATE OF DAVID SMITH/ LICENSED BY VAGA, NEW YORK, N.Y.

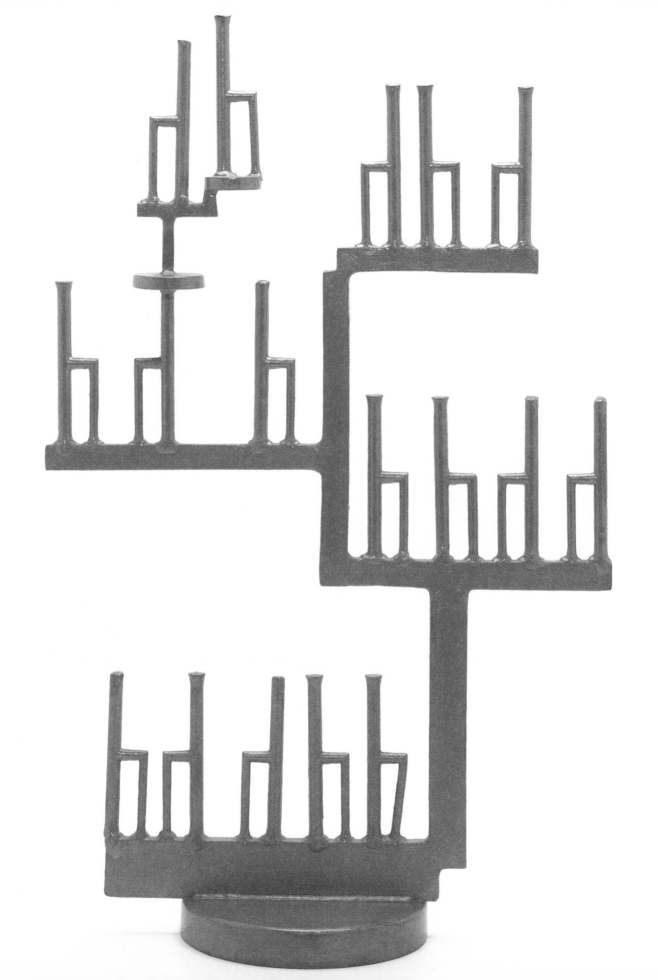

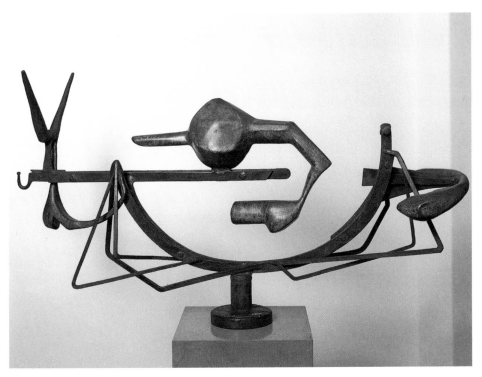

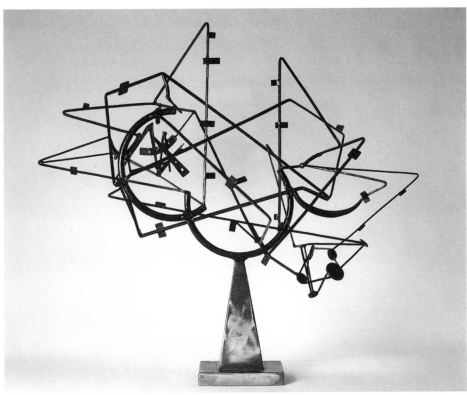

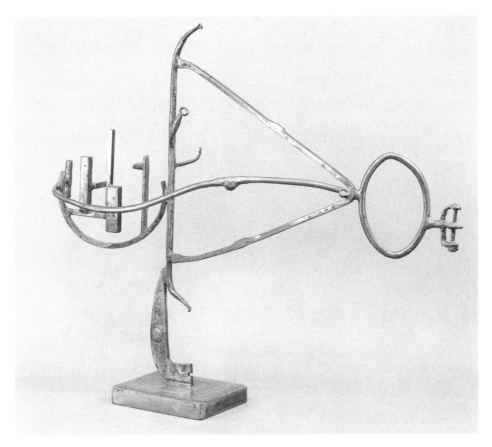

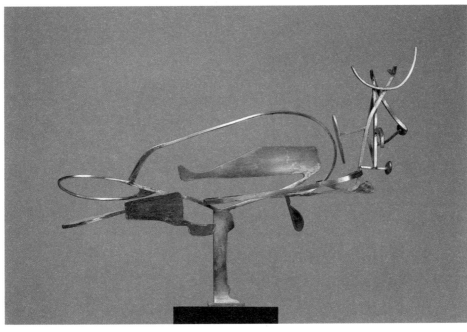

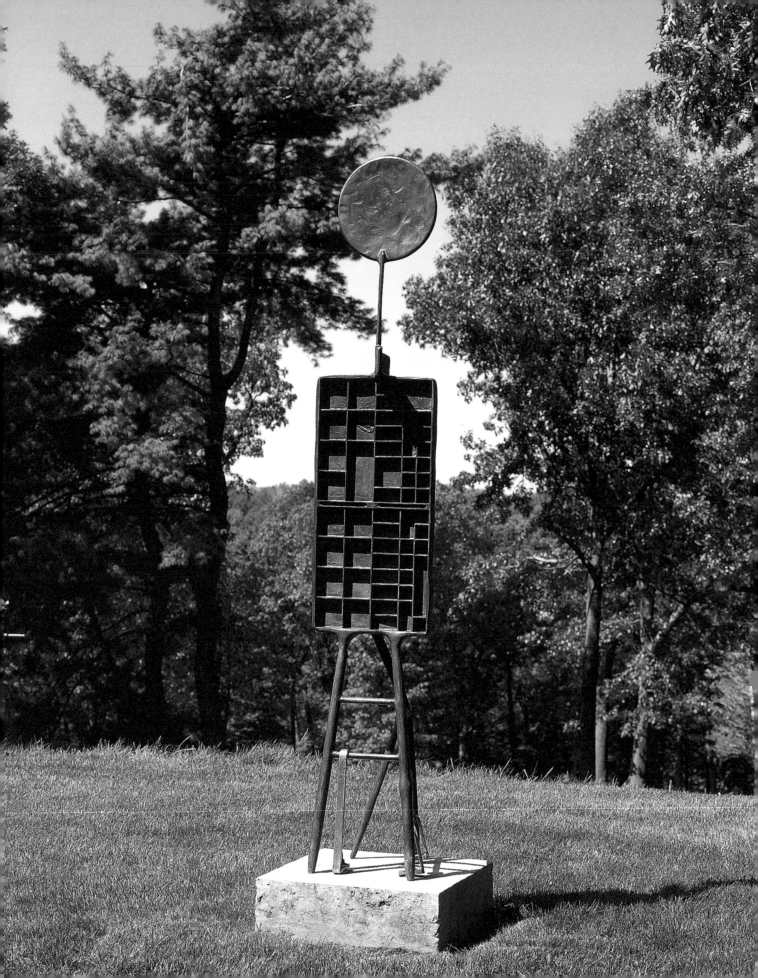

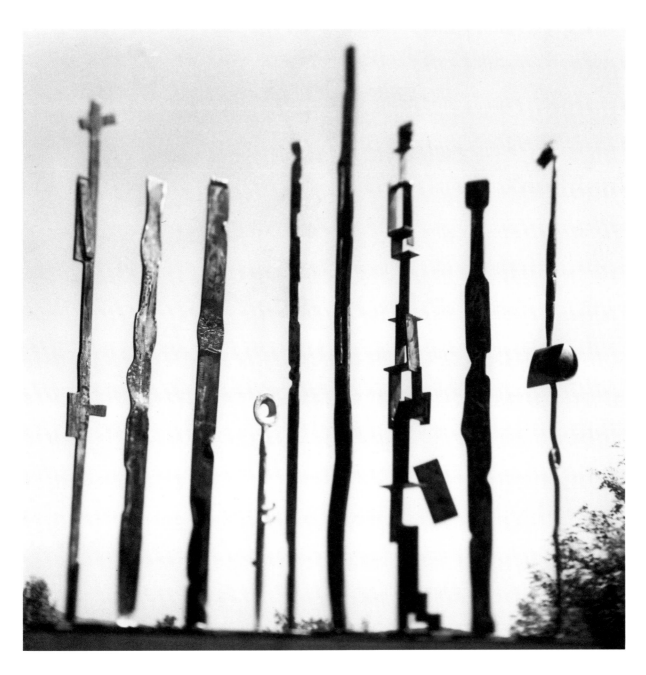

UNTITLED (FORGINGS), ABOUT 1955
EXHIBITION PRINT
BLACK AND WHITE PHOTOGRAPH , 11 X 14 IN.
THE COLLECTION OF CANDIDA AND REBECCA SMITH, NEW YORK, N.Y.
©2000 ESTATE OF DAVID SMITH/LICENSED BY VAGA, NEW YORK, N.Y.

OPPOSITE
THE SITTING PRINTER, 1954-56
BRONZE, 87 X 15 3/4 X 17 IN.
STORM KING ART CENTER, MOUNTAINVILLE, NEW YORK, GIFT OF THE RALPH E. OGDEN FOUNDATION, INC.
©2000 ESTATE OF DAVID SMITH/ LICENSED BY VAGA, NEW YORK, N.Y.

FORGING VII, 1955
STEEL, 87 1/4 X 4 1/2 X 5/8 IN.
COLLECTION LOIS AND
GEORGES DE MENIL
©2000 ESTATE OF DAVID SMITH/
LICENSED BY VAGA, NEW YORK, N.Y.

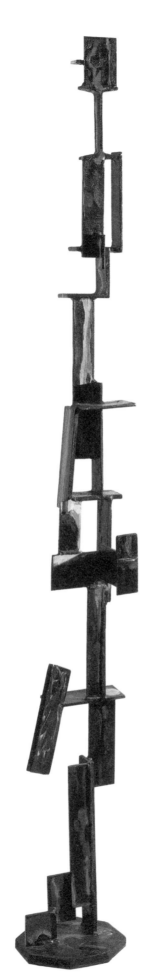

CONSTRUCTION IN RECTANGLES, 1955
PAINTED STEEL, 78 X 10 7/8 X 10 1/2 IN.
THE COLLECTION OF CANDIDA AND
REBECCA SMITH, NEW YORK, N.Y.
©2000 ESTATE OF DAVID SMITH/
LICENSED BY VAGA, NEW YORK, N.Y.

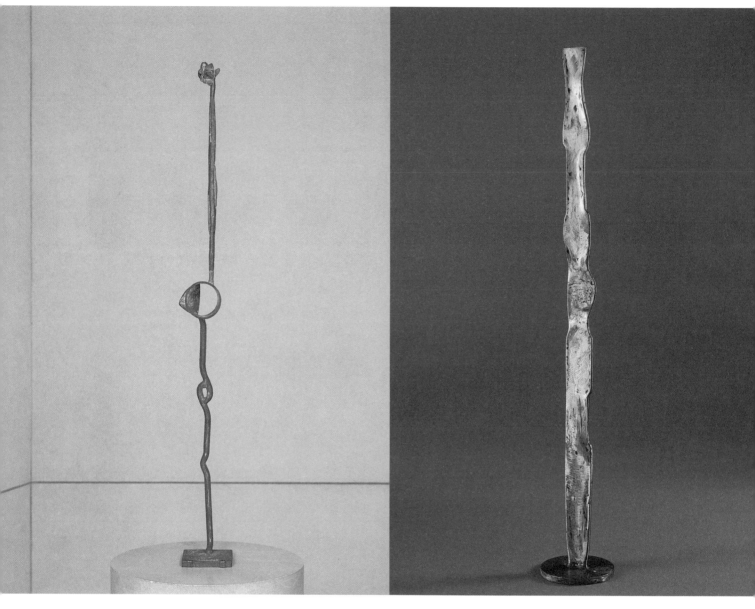

LEFT TO RIGHT
CONSTRUCTION WITH FORGED NECK, 1955
RUSTED STEEL, 76 1/4 X 13 X 8 5/8 IN.
THE COLLECTION OF CANDIDA AND REBECCA SMITH, NEW YORK, N.Y.
COURTESY OF THE NATIONAL GALLERY OF ART, WASHINGTON, D.C.
©2000 ESTATE OF DAVID SMITH/LICENSED BY VAGA, NEW YORK, N.Y.

FORGING III, 1955
STEEL, 67 X 3 7/8 X 5/8 IN.
THE MENIL COLLECTION, HOUSTON
©2000 ESTATE OF DAVID SMITH/LICENSED BY VAGA, NEW YORK, N.Y.

FORGING IV, 1955
STEEL, 81 7/8 X 8 3/8 X 7 7/8 IN.
THE COLLECTION OF CANDIDA AND REBECCA SMITH, NEW YORK, N.Y.
©2000 ESTATE OF DAVID SMITH/LICENSED BY VAGA, NEW YORK, N.Y.

FORGING V, 1955 (AND DETAIL)
STEEL, 74 1/2 X 8 1/2 IN. DIAMETER
THE COLLECTION OF CANDIDA AND REBECCA SMITH, NEW YORK. N.Y.
©2000 ESTATE OF DAVID SMITH/LICENSED BY VAGA, NEW YORK, N.Y.

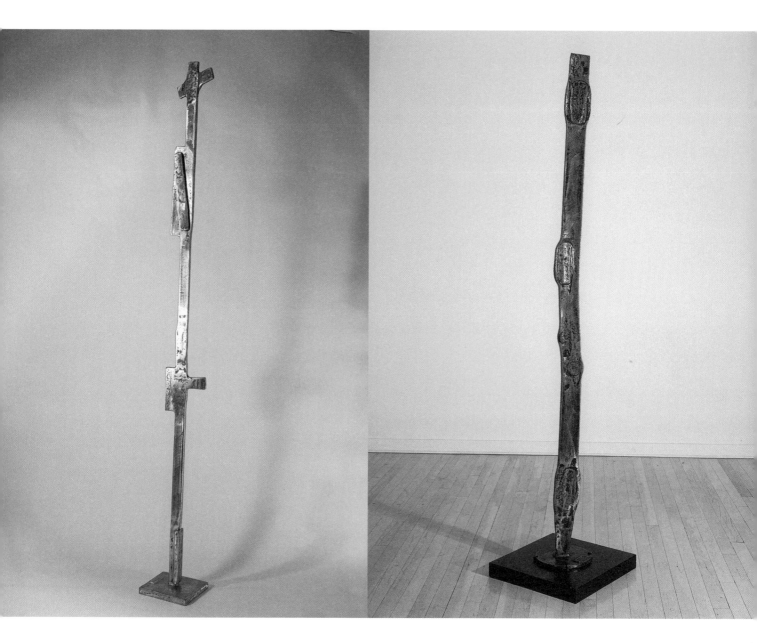

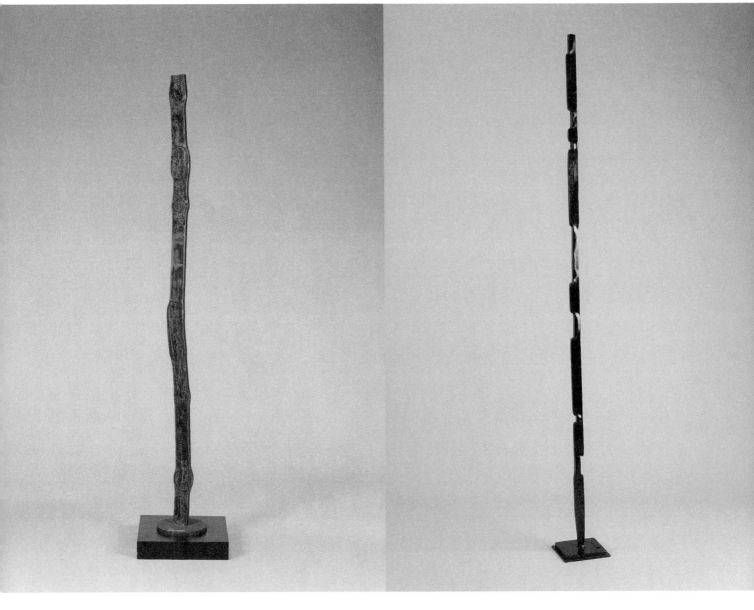

LEFT TO RIGHT
FORGING VI, 1955
STEEL, 79 X 9 X 9 IN.
COURTESY OF GAGOSIAN GALLERY
©2000 ESTATE OF DAVID SMITH/LICENSED BY VAGA, NEW YORK, N.Y.

FORGING VIII, 1955
PAINTED STEEL, 90 3/4 X 8 5/8 X 8 IN.
THE COLLECTION OF CANDIDA AND REBECCA SMITH, NEW YORK, N.Y.
COURTESY OF THE TATE GALLERY, LONDON
©2000 ESTATE OF DAVID SMITH/LICENSED BY VAGA, NEW YORK, N.Y.

FORGING IX, 1955
STEEL, 72 11/25 X 7 17/25 X 7 3/5 IN.
THE COLLECTION OF CANDIDA AND REBECCA SMITH, NEW YORK, N.Y.
COURTESY OF THE TATE GALLERY, LONDON
©2000 ESTATE OF DAVID SMITH/LICENSED BY VAGA, NEW YORK, N.Y.

UNTITLED, 1955
BRONZE, 36 X 7 7/8 X 7 5/8 IN.
THE COLLECTION OF CANDIDA AND REBECCA SMITH, NEW YORK, N.Y.
©2000 ESTATE OF DAVID SMITH/LICENSED BY VAGA, NEW YORK, N.Y.

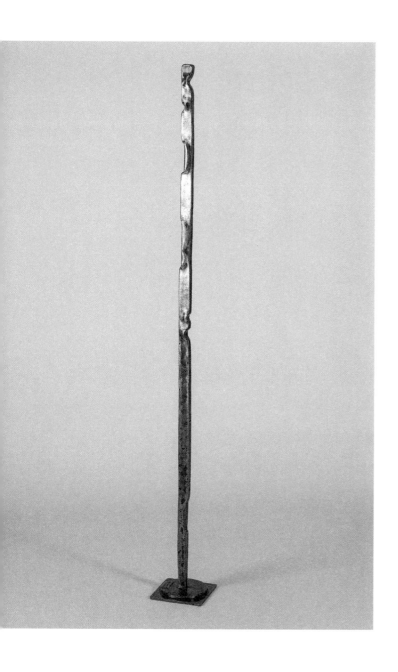

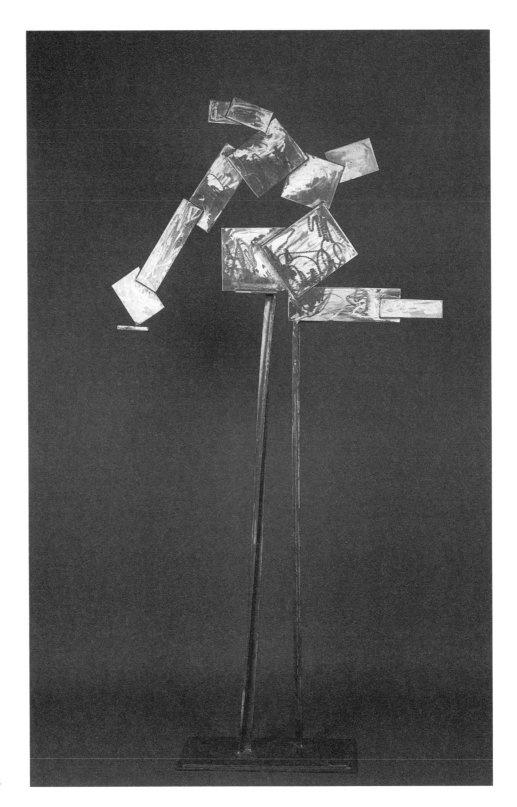

FIFTEEN PLANES, 1958
STAINLESS STEEL
113 3/4 X 59 1/16 X 16 IN.
SEATTLE ART MUSEUM, GIFT OF
THE VIRGINIA WRIGHT FUND
©2000 ESTATE OF DAVID SMITH/
LICENSED BY VAGA, NEW YORK, N.Y.

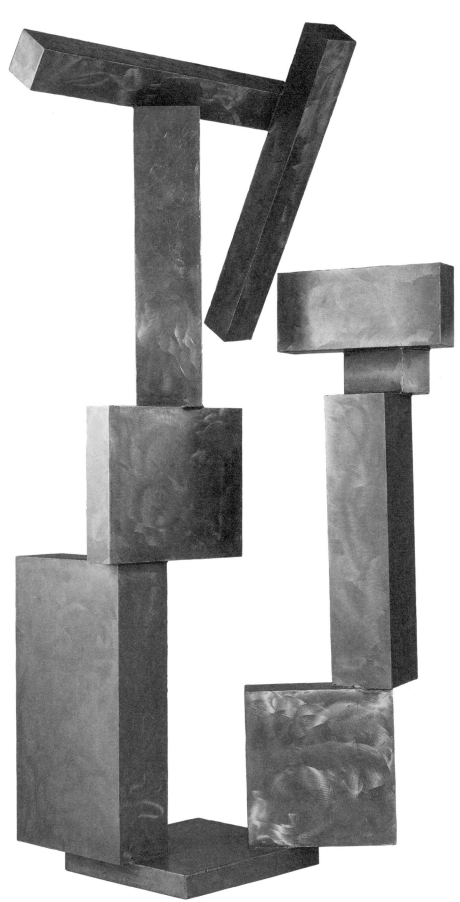

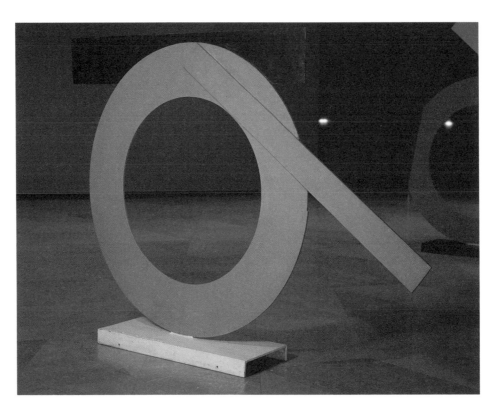

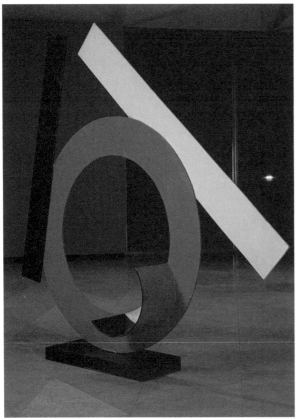

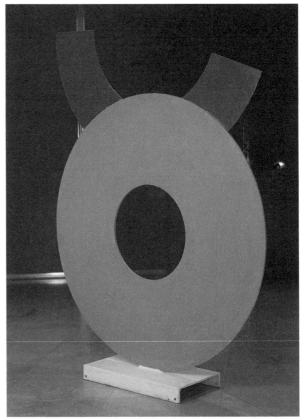

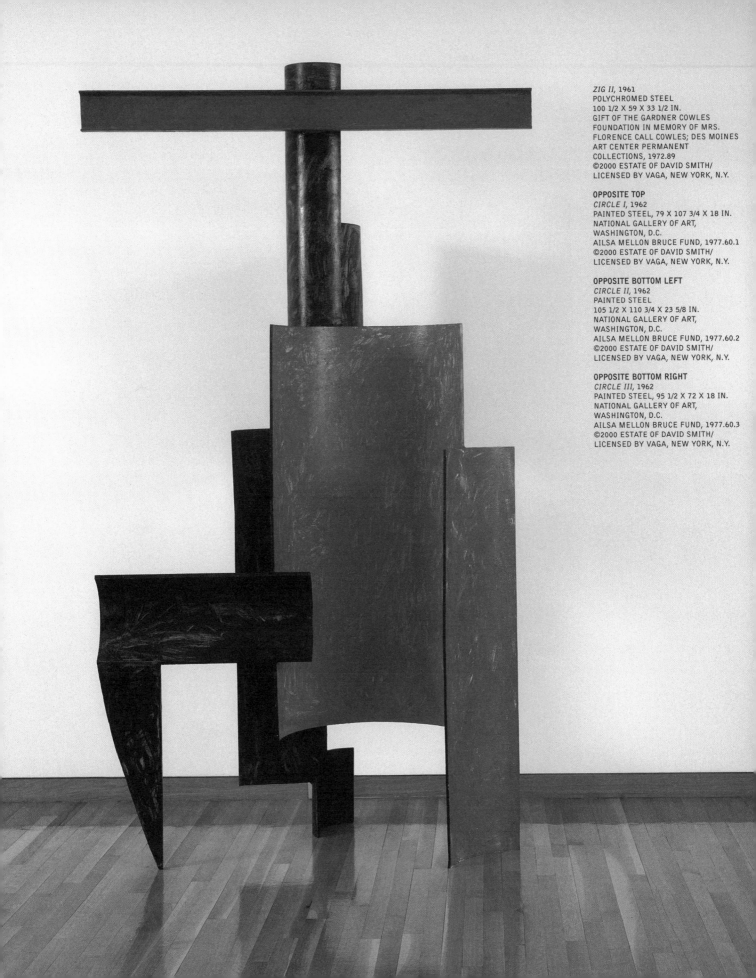

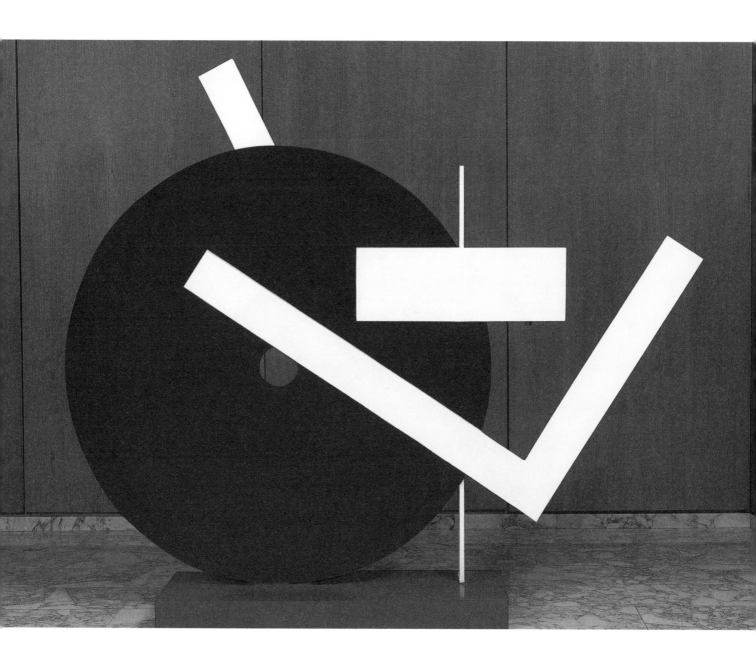

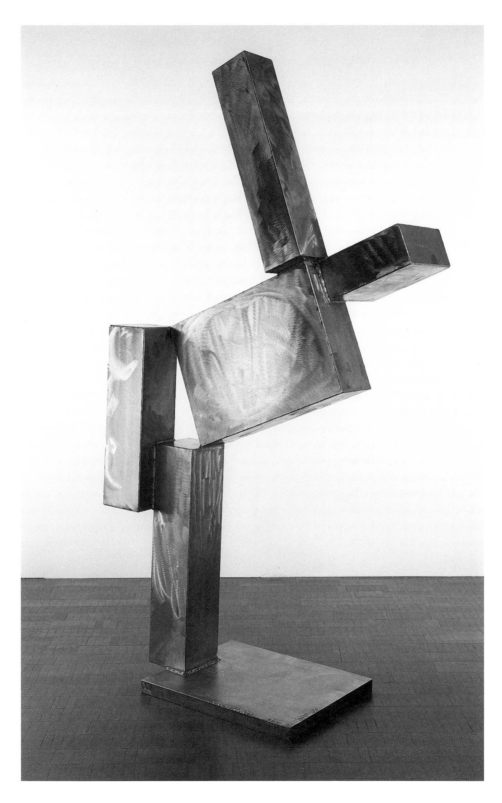

CUBI IV, 1963
STAINLESS STEEL
98 1/2 X 53 X 25 1/2 IN.
MILWAUKEE ART MUSEUM
GIFT OF MRS. HARRY LYNDE BRADLEY
©2000 ESTATE OF DAVID SMITH/
LICENSED BY VAGA, NEW YORK, N.Y.

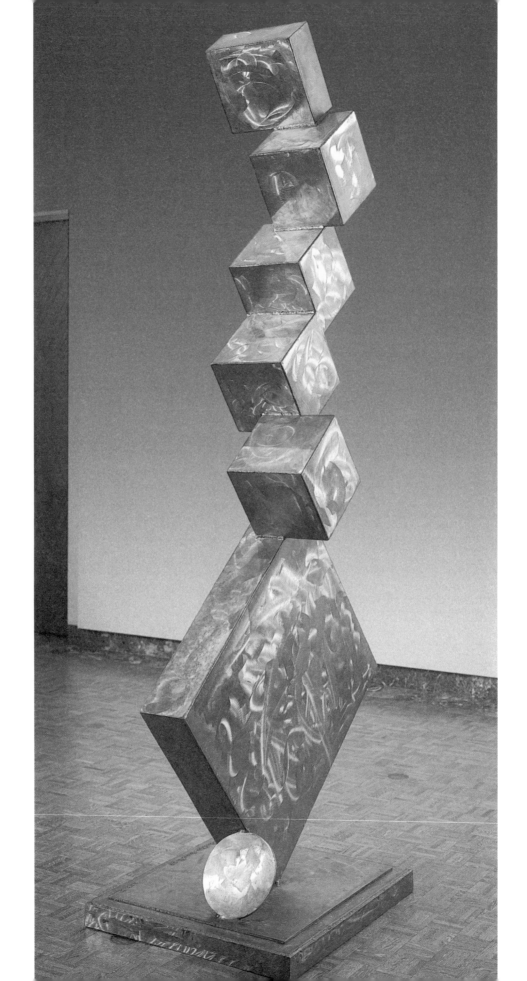

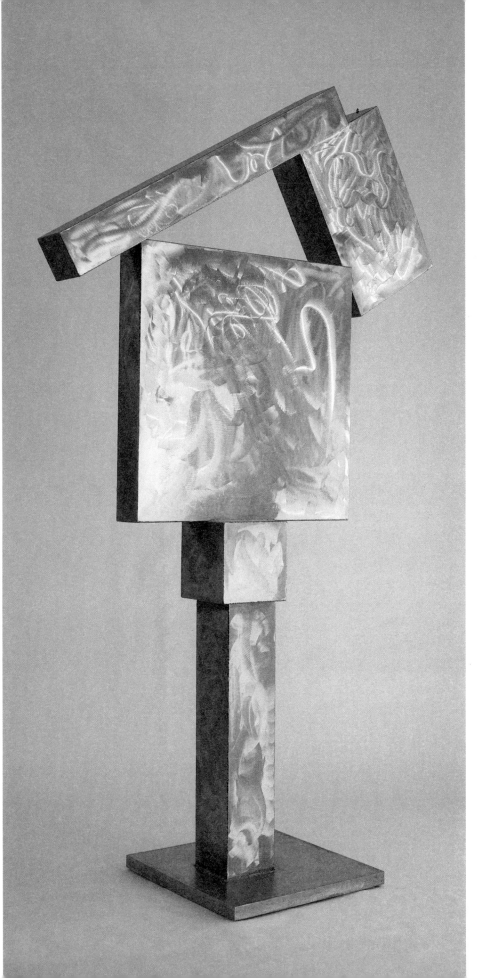

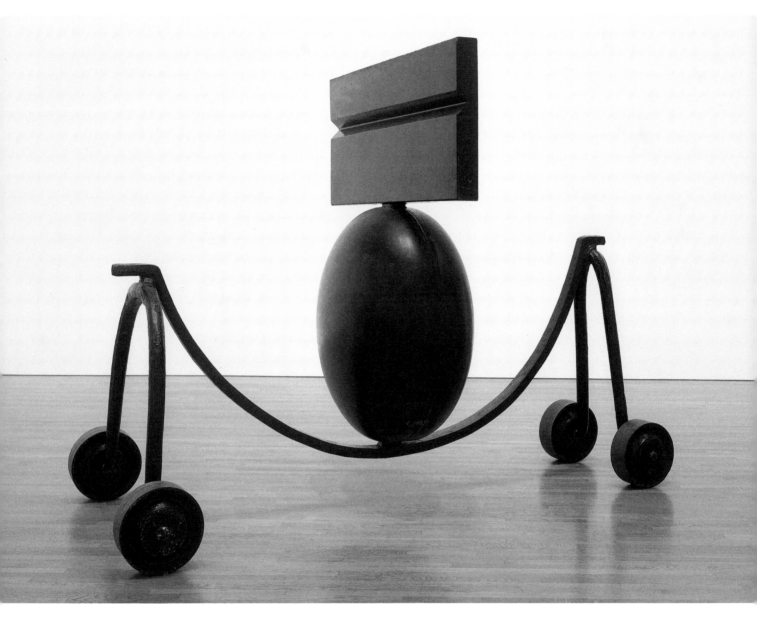

OPPOSITE
UNTITLED, 1962
ESTATE # 73-62.210
SPRAY ENAMEL ON PAPER, 19 X 26 IN.
THE COLLECTION OF CANDIDA AND REBECCA SMITH, NEW YORK, N.Y.
©2000 ESTATE OF DAVID SMITH/LICENSED BY VAGA, NEW YORK, N.Y.

WAGON I, 1963-64
STEEL WITH BLACK PAINT, 88 1/2 X 121 1/2 X 64 IN.
NATIONAL GALLERY OF CANADA, OTTAWA
©2000 ESTATE OF DAVID SMITH/LICENSED BY VAGA, NEW YORK, N.Y.

George Rickey

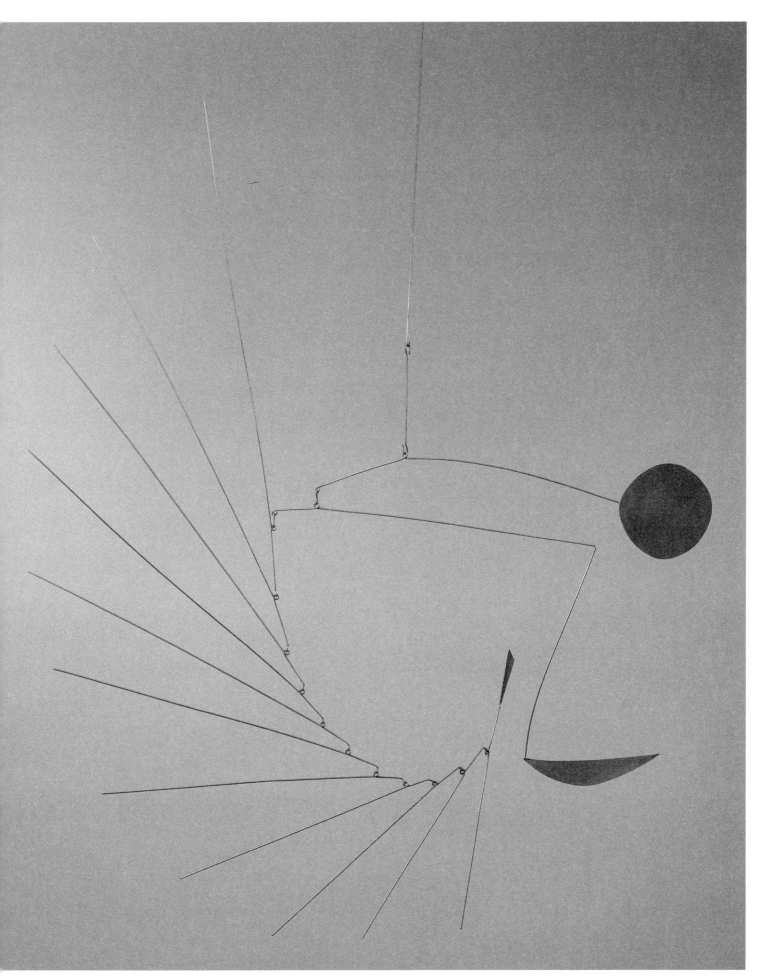

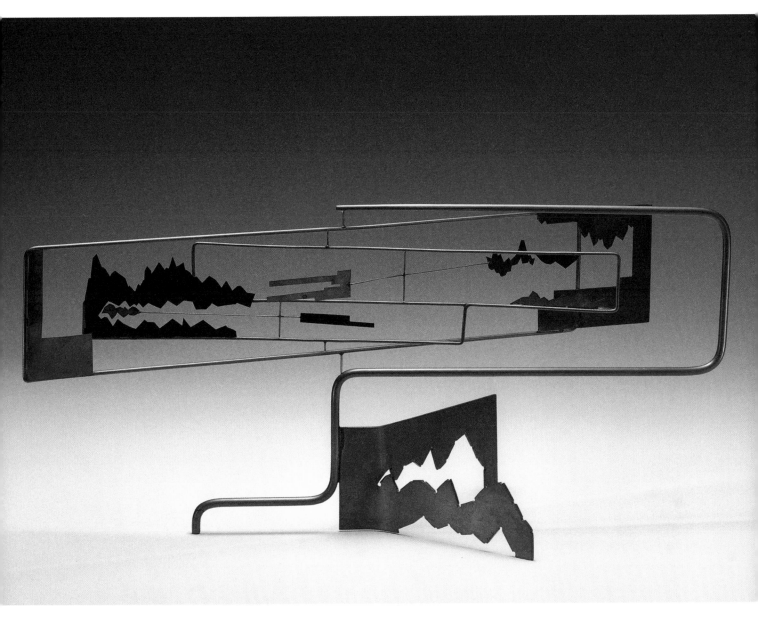

PAGE 113
SUN & MOON, 1951
STAINLESS STEEL AND BRASS, 33 X 28 IN.
COLLECTION OF THE ARTIST

OPPOSITE TOP
STUDY FOR NO CYBERNETIC EXIT, N.D.
INK ON PAPER (RECTO), 19 X 24 IN.
COLLECTION OF THE ARTIST

OPPOSITE BOTTOM
STUDY FOR NO CYBERNETIC EXIT, N.D.
INK ON PAPER (VERSO), 19 X 24 IN.
COLLECTION OF THE ARTIST

ABOVE
NO CYBERNETIC EXIT (OR) AN OVERVIEW OF COMPENSATORY RESERVES OF BITUMINOUS COAL, 1954
STEEL, BRASS, PAINT, 9 1/2 X 21 1/2 X 8 3/4 IN.
INDIANAPOLIS MUSEUM OF ART
GIFT OF CORNELIA V. CHRISTENSON
77.63

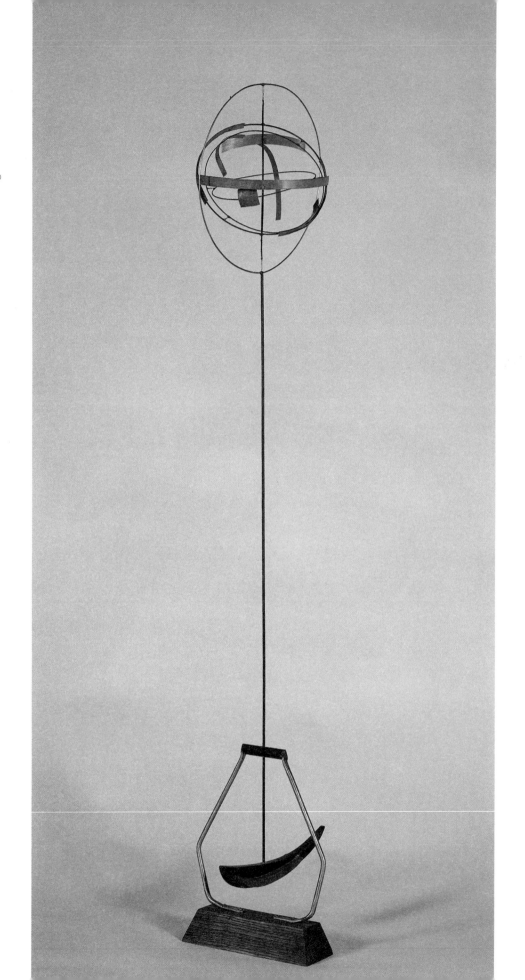

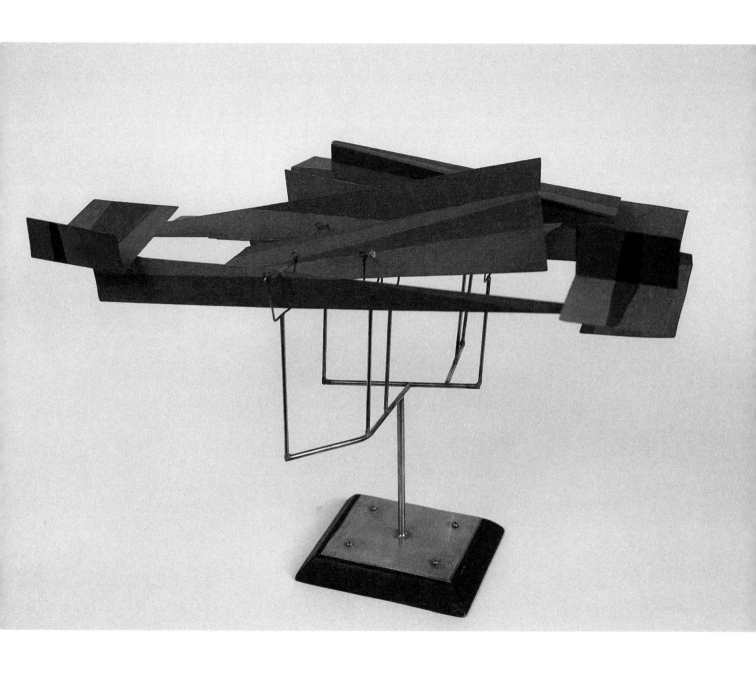

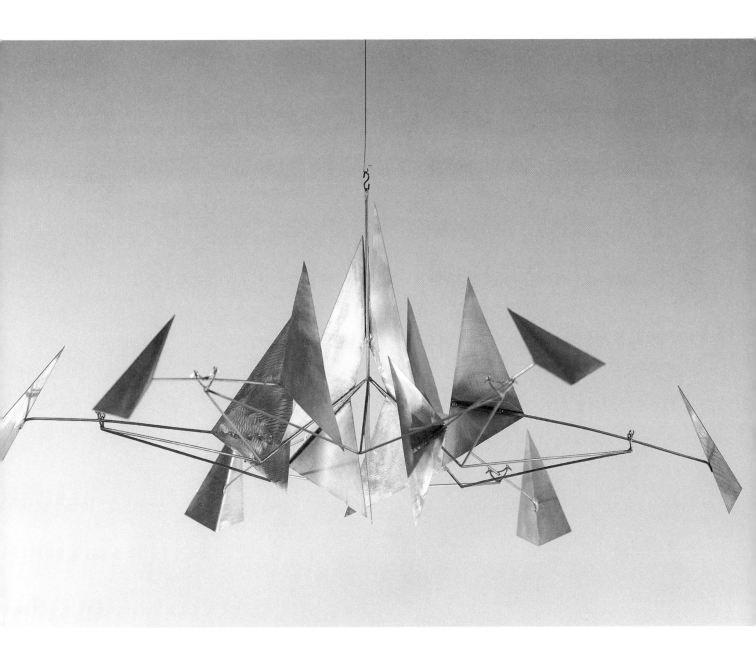

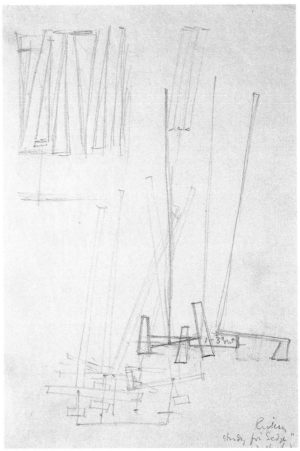

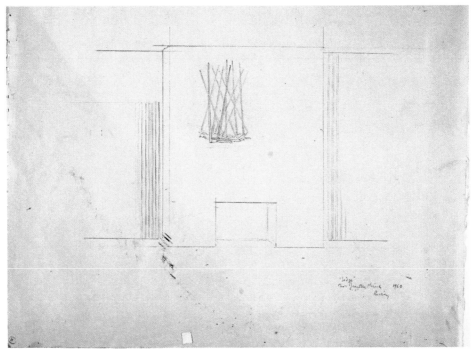

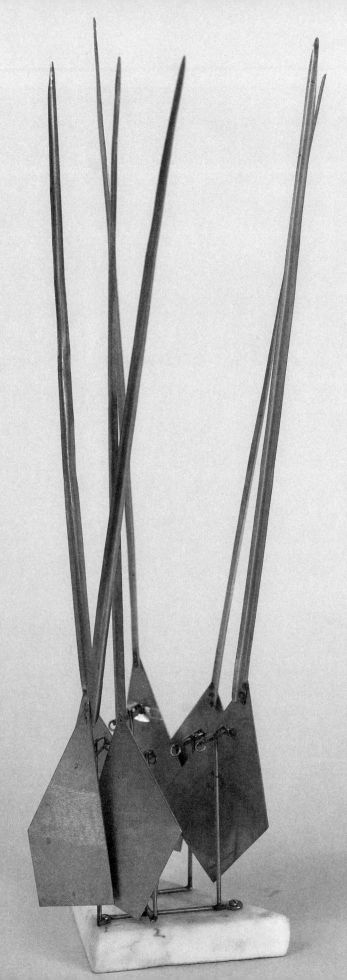

SEDGE I, 1961
STAINLESS STEEL
19 1/4 X 6 1/4 X 4 1/4 IN.
COLLECTION OF THE ARTIST

OPPOSITE TOP LEFT
STUDY FOR SEDGE, 1960
GRAPHITE ON OFF-WHITE PAPER,
17 X 11 1/2 IN.
COLLECTION OF THE ARTIST

OPPOSITE TOP RIGHT
STUDY FOR *SEDGE*, 1960
GRAPHITE ON PAPER
18 3/4 X 22 3/4 IN.
COLLECTION OF THE ARTIST

OPPOSITE BOTTOM
STUDY FOR SEDGE, 1961
GRAPHITE ON PAPER, 11 X 8 1/2 IN.
COLLECTION OF THE ARTIST

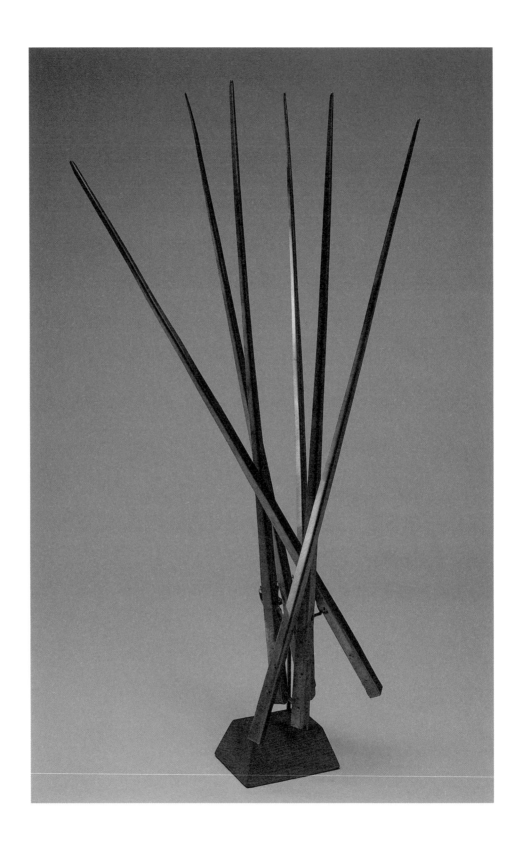

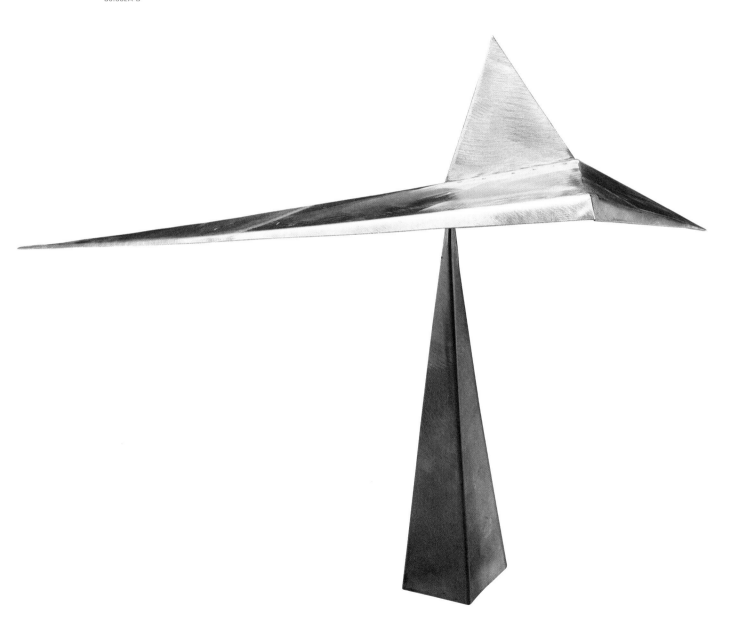

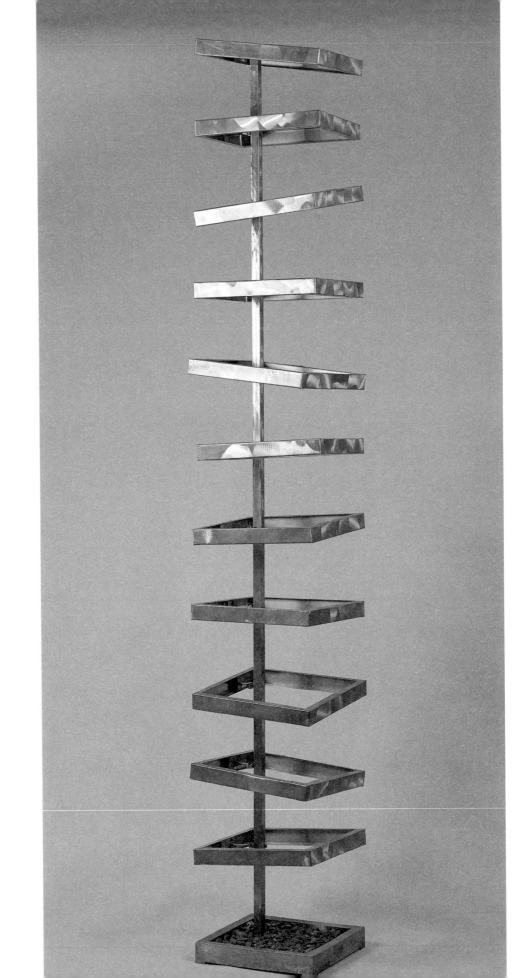

COLUMN OF SQUARES, 1970-71
STAINLESS STEEL
122 X 25 1/2 X 25 1/2 IN.
COLLECTION OF THE ARTIST

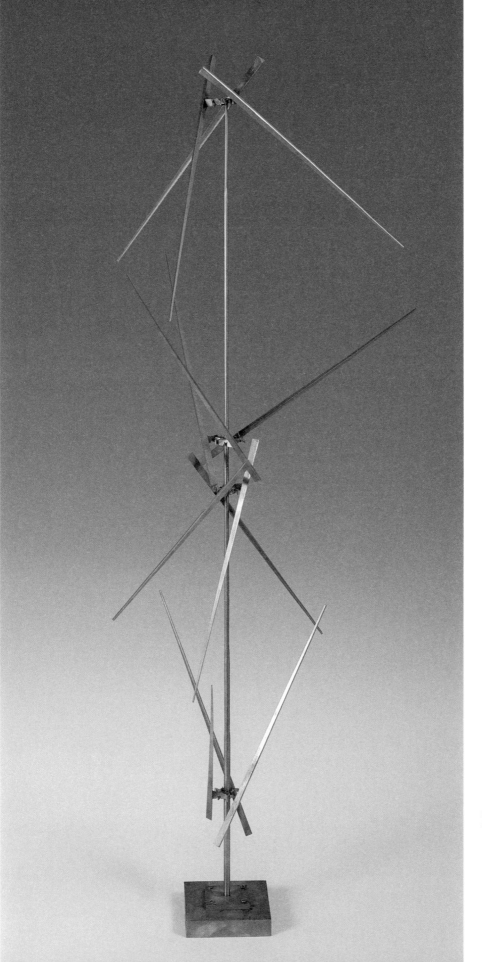

COLUMN OF TETRAHEDRA, 1972
STAINLESS STEEL
57 1/4 X 15 X 15 IN.
PRIVATE COLLECTION

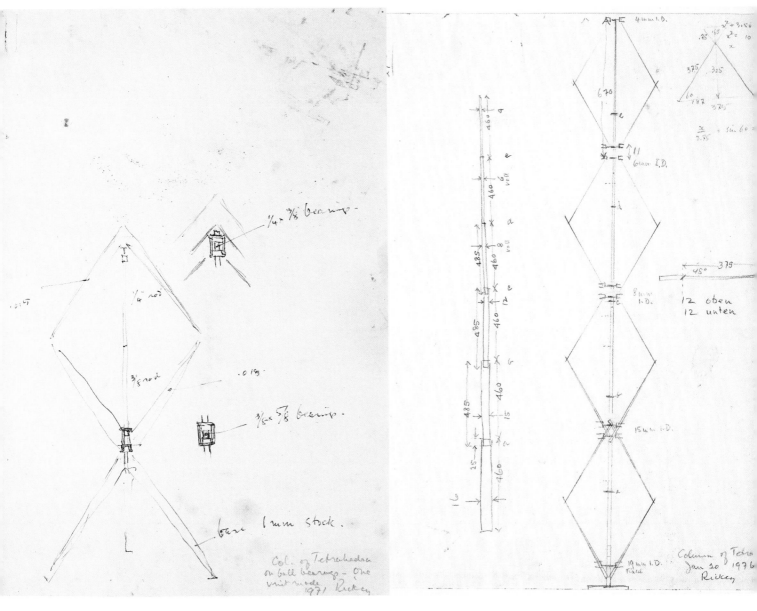

LEFT TO RIGHT
STUDY FOR COLUMN OF TETRAHEDRA, 1971
BLUE INK ON PAPER, 11 X 8 1/2 IN.
COLLECTION OF THE ARTIST

STUDY FOR COLUMN OF TETRAHEDRA, 1976
GRAPHITE ON WHITE PAPER , 11 X 8 1/2 IN.
COLLECTION OF THE ARTIST

STUDY FOR COLUMN OF TETRAHEDRA, 1968
BLUE INK ON PAPER, 11 X 8 1/2 IN.
COLLECTION OF THE ARTIST

STUDY FOR COLUMN OF TETRAHEDRA, 1968
BLUE INK AND GRAPHITE ON PAPER, 11 X 8 3/8 IN.
COLLECTION OF THE ARTIST

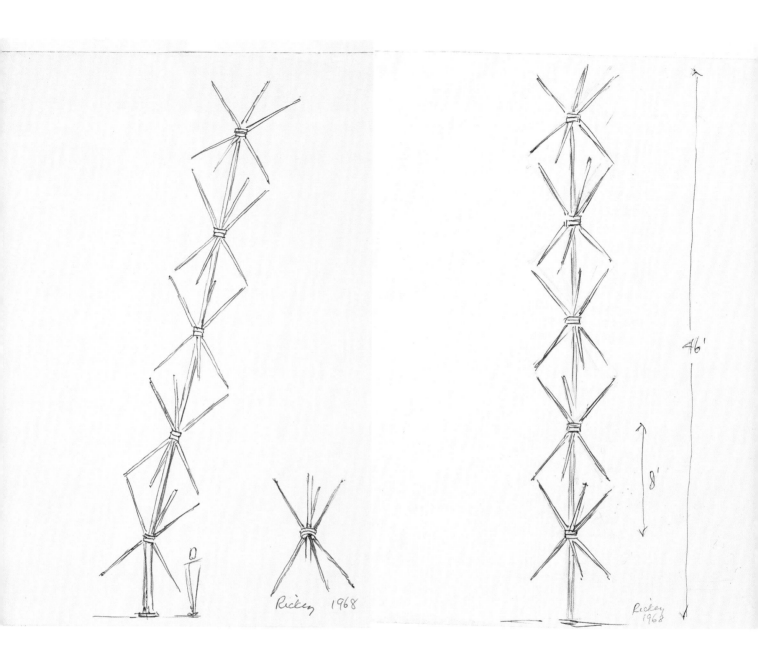

Rickey 1968

46'

8'

Rickey
1968

STUDY FOR COLUMN OF TETRAHEDRA,
N.D.
GRAPHITE ON PAPER
11 X 8 1/2 IN.
COLLECTION OF THE ARTIST

OPPOSITE
FIRST MOSAIC, 1986
ACRYLIC ON STAINLESS STEEL WITH
WOOD BASE, 18 X 9 X 8 IN.
WILLIAM AND BARBARA CRUTCHFIELD

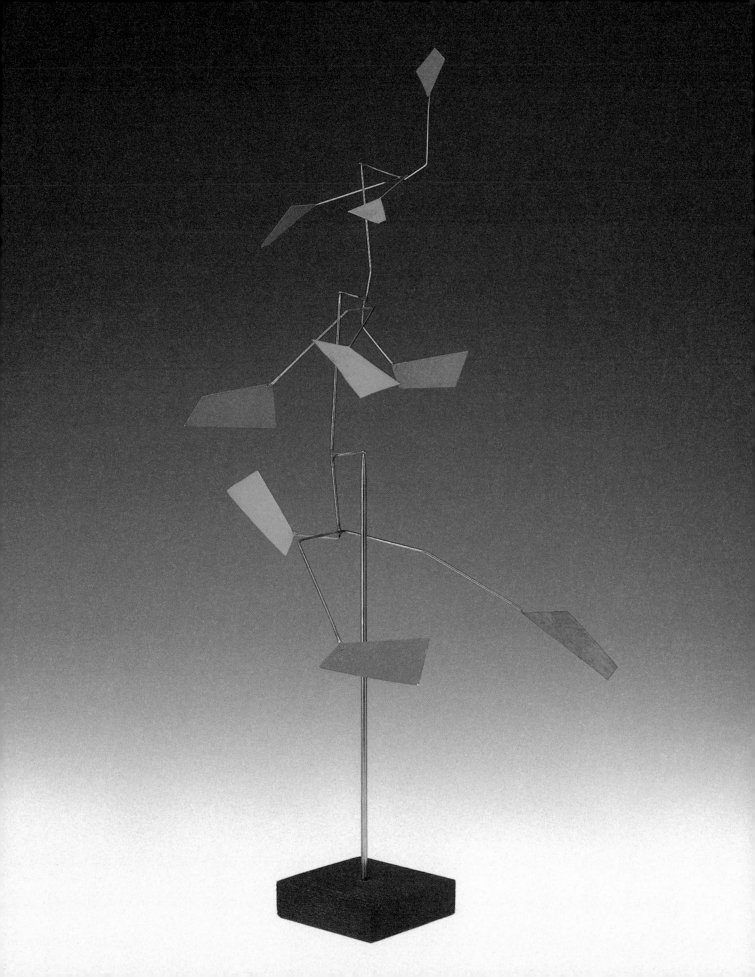

FACETED COLUMN, 1991-1995
STAINLESS STEEL
120 X 20 X 20 IN.
COLLECTION OF THE ARTIST

OPPOSITE
STUDY FOR FACETED COLUMN, N.D.
GRAPHITE, INK AND PHOTOCOPY ON
PAPER, 21 X 4 IN.
COLLECTION OF THE ARTIST

STUDY FOR FACETED COLUMN, N.D.
GRAPHITE ON PAPER, 11 X 8 1/2 IN.
COLLECTION OF THE ARTIST

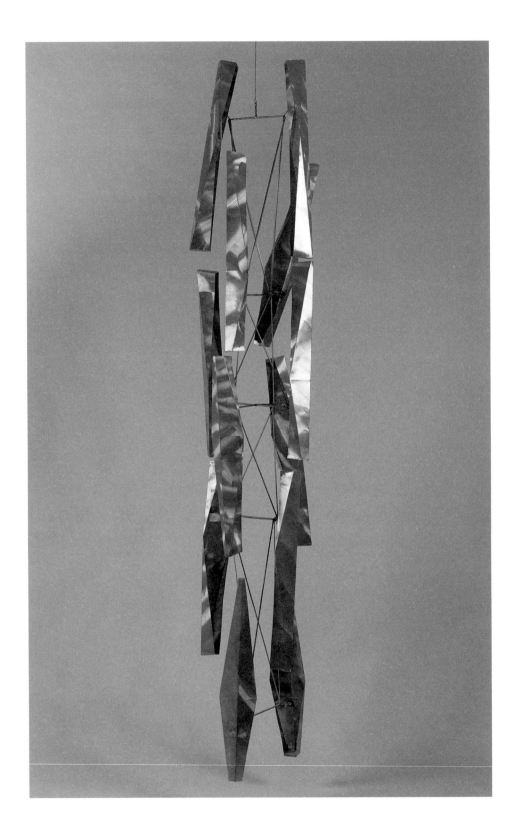

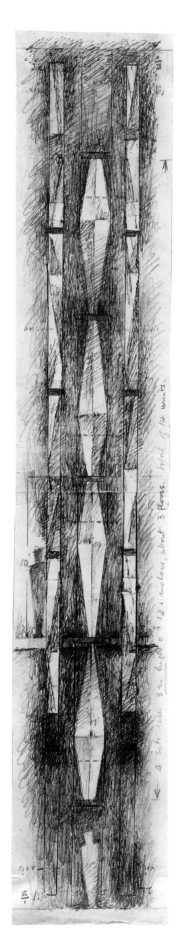

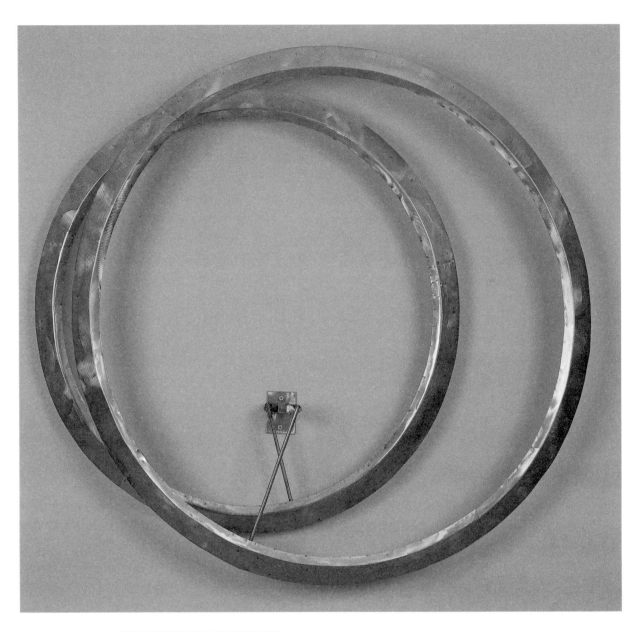

ANNULAR ECLIPSE WALL VARIATION V, 1999
STAINLESS STEEL, 43 X 43 X 6 IN.
COLLECTION OF THE ARTIST

John Chamberlain and Robert Indiana in Chicago in the early 1950s

CHICAGO HAD AN ENERGETIC, eclectic experimental atmosphere in the early 1950s. The Art Institute of Chicago and the School of the Art Institute (SAIC) shared a building, a front door, and a cafeteria. The place was infused by the seriousness of older war veterans attending the art school, and students, teachers, collectors, gallery owners, and curators mixed in a free and casual way. The dream was to make, collect, sell, and exhibit the best art possible.

In the 1950s, the Loop (the traditional heart of Chicago) was surrounded by decayed commercial buildings. The commercial building boom of the 1970s, 1980s, and 1990s had not begun. North of the Chicago River, one could live inexpensively only a few blocks from Michigan Avenue. State Street in the Loop, not North Michigan Avenue, was the main shopping area. The University of Illinois Chicago campus and the Museum of Contemporary Art had not yet been established. Trains brought people to Chicago and deposited them either in Union Station or Northwest Station in the Loop.

The Chicago Museum of Natural History, now the Field Museum, was a dark, cavernous building filled with dimly lit glass cases of artifacts of non-European cultures as well as dioramas of stuffed animals and bones of dinosaurs and mammoths.

The visitor to the Art Institute was still greeted at the door by the plaster casts of Greek and Roman sculptures. El Greco's imposing *Assumption of the Virgin* dominated the view at the head of the grand staircase leading to the painting galleries, and it was still possible to have a sense of the collection in a few hours.

Seeing the names of the great artists of the past chiseled in stone on a frieze around the outside of the museum or passing their works on the way to class, art students were reminded that making art was a serious goal, not to be confused with making a living or getting a diploma with "Bachelor of Fine Arts" written on it.

When Robert Clark, as Robert Indiana was then known, and John Chamberlain came to Chicago, or in the case of Chamberlain, returned, the city's artists and art students were divided into two camps: those who believed new art should be abstract and rational and those who felt the figurative and irrational were paramount.

Chicago's abstract art supporters were centered at the Institute of Design on the near north side, which had been founded by László Moholy-Nagy as the New Bauhaus in 1937, and at the Art Institute. Katharine Kuh, curator at the Art Institute, had close connections with the Museum of Modern Art in New York and in the 1930s had run a gallery in Chicago that exhibited abstract artists like Josef Albers.

At the Institute of Design, the training of the artist started with a basic course in which the student learned about the formal elements of art (line, color,

form, etc.) through experience and experimentation. By manipulating and combining blocks of wood, wire, and sheets of metal, students created new abstract objects. The aim was to learn and use a visual language common to all disciplines of art, not the techniques of drawing, painting or sculpting.

This approach was different from that of the School of the Art Institute (SAIC), where the art student was taught in the traditional way by drawing and studying the art of the past. Many of the older faculty members were strong advocates of the American Regionalism of Grant Wood and John Steuart Curry. The students and faculty of both art schools knew each other.

The students of the SAIC, mostly Midwesterners and often older veterans, like Chamberlain and Indiana, were an ambitious, energetic group eager to find their place in the world. Many of them saw for the first time the work of the New York Abstract Expressionists brought by Katharine Kuh to Chicago in annual exhibitions of American art. In these exhibitions, they saw Abstract Expressionism in its fully formed state. They did not have the advantage of observing the struggle that produced it. Consequently, many students did not find New York art any more satisfactory than American Regionalism, which they knew from personal experience did not reflect the Midwest they had experienced as children. Many of them, including Chamberlain and Indiana, held part-time jobs, lived in poor housing, and were despairing of their futures amid the growing prosperity of the new middle class. In many ways, Chicago in the early 1950s was the bleak place that A. J. Liebling described in his three-part essay in *The New Yorker*, "Second City."[1]

Both Indiana and Chamberlain were in their twenties, well-traveled, brought up in cities, and without formal education beyond high school.[2] They had survived the military, the poverty of the Depression, and their parents' divorces, and in Indiana's case, the death of his mother. The school of hard knocks had already provided part of their education, if not in art, in life. In art school, they were more influenced by their own experiences and their peers than by their teachers. They were used to finding their own way and trusting in themselves rather than in their teachers. Nevertheless, Chicago, a place they both wished to leave, provided a primitive map for the direction their art would eventually take. For Chamberlain, Chicago was his initiation into the world of art. Although he had returned to Chicago to study hairdressing, Chamberlain had the good fortune to meet a young woman who was taking art lessons. She encouraged him to try his hand and eventually to enroll at SAIC as a student in the fall of 1951.

In the 1950s, all SAIC students had to walk through the Art Institute of Chicago to get to the classrooms and studios, as there was no separate entrance to the school. The galleries were used as a teaching tool by the faculty as well. Consequently, the museum became for many students their formative experience. It was there that they were exposed to not only American and European art, but also Asian art. In addition to the Art Institute's own art collection, the museum held an annual exhibition of contemporary American art. Works from these exhibitions were purchased for or given to the museum.

Willem de Kooning's *Excavation* (1950) was purchased by the Art Institute in 1952, and David Smith's *Tanktotem I* (1952) was given to the museum in 1953. Smith's *Agricola IV* (1952) was exhibited at the Art Institute in its 1954 annual survey of American art. Both Smith's and de Kooning's work impressed Chamberlain.

Another famous work at the AIC was El Greco's *Assumption of the Virgin*. In retrospect, it appears that this El Greco was significant to Chamberlain as well. In this painting, the pictorial space is quite shallow, like a 20th-century Cubist painting, and dominated by numerous figures that are clothed in a drapery that appears to be made of crumpled sheet metal, not unlike Chamberlain's future sculptures.

The expressionistic handling of the paint, especially the broad areas of white paint added to the drapery, and the shifting planes of the drapery create a dynamic surface similar to that seen in de Kooning's *Excavation*.

In art history class, however, Chamberlain's admiration of one older work of art led to his expulsion from SAIC. He chose to write a paper about an Indian sculpture that depicted Hindu deities as lovers entwined around each other because of the way the forms interlocked with each other in an interesting sculptural way. According to Chamberlain,[3] the language he used in the paper was deemed inappropriate and too sexual by his teacher, and he was thrown out of the art school as a result. Chamberlain did not return to the school the following year. Unhappy with the traditional training of the school, he went back to styling hair to support himself while he continued to learn about and make art on his own from 1953 until the spring of 1955.

Joseph Goto (1920-1994), another young sculptor living in Chicago whom Chamberlain met at the SAIC, showed Chamberlain how to weld. Goto, who had attended the SAIC in the late 1940s and, like Chamberlain, had left without graduating, had come back to the school to use the welding equipment. By 1954, Goto had sold one of his steel rod sculptures to the Museum of Modern Art and several of his abstract pieces to local collectors and was enjoying a mild success as a sculptor, which may have encouraged Chamberlain. Chamberlain said that Goto's pieces of metal in

the sculpture made connections in a way that excited him. One piece of metal is just a thing; but when it is connected to another thing, not only is a new thing formed, but a new thing that is more than its parts, if it creates and activates the negative space between the two parts. For Chamberlain, these connections that Goto made were reinforced by his observance of Smith's sculpture at the museum. He was fascinated by the presence that an abstract sculpture could have. *Tanktotem I* is a slim vertical piece some 90 inches in height, while *Agricola IV* is an open "drawing in space," rising 60 inches above the floor, or more if it is placed on a low pedestal. Of the two, *Tanktotem I* is more figural in feeling than *Agricola IV*, although by the standards of the day both were very abstract. The presence that size gave to de Kooning's, El Greco's and Smith's work no doubt influenced Chamberlain to make his first two extant works, *Calliope* (1954) and *Clytie* (1954), 52 and 66 inches high. Placed on pedestals, both works have presence, but *Calliope*, in particular, activates a lot of space with its configuration, as its horizontal elements at the top extend nearly three feet to one side of the vertical element rising from the base. There is a sense that it is defying gravity.

Shortly after Chamberlain left SAIC, he met Chicagoan Robert Natkin, a recent SAIC graduate. Natkin and Chamberlain lived in the same building, a condemned warehouse at 56th and Lake Park heated by a pot-bellied stove. Natkin, like Chamberlain but unlike many SAIC graduates, such as Leon Golub and others in the Monster school, was committed to abstraction. Eventually, in 1957, a group of artists committed to abstraction began showing their work at the Wells Street Gallery in Old Town. It was founded by Natkin and Stanley Sourelis and run by Natkin's wife, Judith Dolnick. The group also included Gerald van der Wiele, Donald Vlack, Ann Mattling and Ernest Dieringer. In 1957, after Chamberlain had moved to New York City, he had his first exhibition there. One of the works, *Untitled* (1957), was sold to Paul R. Campagna, a Chicago collector.[4]

Those young artists, schooled at the SAIC, felt that art's meaning derived from expressive use of the language of the visual arts without reference to the visual world. They were at odds artistically with the prevailing mood of the other young artists in Chicago, who were interested in images that often reflected the seamier side of life in Chicago. Eventually, this interest in images became the dominant and homegrown esthetic of the Monster Roster and Chicago Imagists painters.

Chamberlain was unhappy with his life in Chicago and felt it was going nowhere. By chance, in 1955, he and Richard Bogart drove Gerald van der Wiele back to Black Mountain College in North Carolina, where van der Wiele had enrolled.

Black Mountain College, originally a progressive but unaccredited college where Josef Albers had taught for many years using Bauhaus methods, was on its last legs. The poet Charles Olson (1910-1970), who was rector of the college, persuaded Chamberlain to become a student there. Chamberlain and five other students were taught by six faculty members, three of whom were about Chamberlain's age. The curriculum had courses in literature, writing, weaving, painting, drama, and music, unlike its early days, when the arts were only part of a larger curriculum that included math, history, physics and other more traditional college subjects. In addition to these eleven men and one woman, the college had a special summer program for practicing avant-garde artists, musicians, and writers who came for a few weeks for workshops.

Although Josef Albers had left Black Mountain College in 1949, the teaching of the arts and writing still focused on the basic elements and materials of these disciplines. The faculty poets, like Robert Creeley, who was only a year older than Chamberlain, and the 45-year-old Charles Olson, were interested in the interaction of individual words and syllables, the nature of forms, and the structure and sounds of a poem's words and phrases, in the tradition of Ezra Pound and William Carlos Williams. Joseph Fiore, a former student of the geometric abstractionist Ilya Bolotoski,[5] taught painting. Fiore, like Natkin, was attracted to Abstract Expressionism and the lyrical use of color. Franz Kline was an advisor to Black Mountain College and friend of Olson's.

Black Mountain College was totally unstructured, in terrible physical condition, bankrupt and physically isolated. (It is not surprising that it closed the following fall, on September 27, 1956.) Yet, it was bound together in a way by the faculty's and students' commitment to their life as artists and poets and by a unified Modernist esthetic that was grounded in the ordinary things of life and by a love of learning. Here, Chamberlain found a soul mate in Robert Creeley, who suited his personality, and he began to develop the nascent ideas that had formed in Chicago but had never been brought together in a cohesive way before.

Robert Indiana took the opposite road from Chamberlain at the SAIC, where he was a graphic design student from 1949 to 1953. Fellow students, like Robert Natkin and Irving Petlin, remember him for his sweet manner and neatness, which was unusual at the SAIC, where a Bohemian lifestyle was the norm. Unlike Chamberlain, Indiana was not enamored with the Abstract Expressionism of Smith and de Kooning. Nor was Indiana interested in Social Realism, as many of his SAIC teachers were. He was attracted to an art about personal experience and dreams that engaged so many of

the non-abstract painters in Chicago who were fascinated by Surrealism. Neither the spontaneity of surrealistic dreams that attracted some SAIC students nor the expressionistic canvases of de Kooning that attracted Chamberlain suited Indiana's personality. He liked to plan everything carefully with drawings before building a sculpture or painting a canvas. At SAIC, Indiana listened and observed.

While dreams, images and personal metaphors appealed to Indiana, Surrealism did not. His fantasies were about the American dream that was never realized by his family, and he had his own dream of being an artist. He looked up to those modern artists like Picasso who had become mythical in their stature. Chicago was not the Shangri-La that perhaps he had thought it was when he moved from Indianapolis. It had very few galleries where artists could show or sell their work, and it was not unusual for artists to show their work in the restaurants, bars and nightclubs where they hung out on Chicago's bitterly cold winter nights.

In the spring of 1953 Indiana arranged to show his work in the Club St. Elmo with Claes Oldenburg and George Yelich. Oldenburg, whose father was a Swedish diplomat, was brought up exactly the way Indiana had not been. He was educated at Yale and came from a sophisticated, financially well-off family. The popular American culture seemed as strange and surreal to Oldenburg as it was personal and real to Indiana. Yet, Indiana and Oldenburg agreed on the importance of the possibilities of an image. Oldenburg wrote about his dreams in notebooks kept by his bedside. Indiana kept diaries of his life. Oldenburg was trying to draw as if he could go back to having the innocence of a child. Indiana was trying to come to grips with an American childhood that was not so innocent, one in which he experienced divorce and poverty.

Despite the seeming mismatch between Indiana's interests and the artistic interests of his teachers, the Art Institute of Chicago had a lasting impact on Indiana, as it did on Chamberlain. American Regionalism or American Scene Painting and Social Realism still held sway among some faculty at the SAIC, but these styles had an effect on Indiana even as he rebelled against them. One cannot look at Grant Wood's *American Gothic* at the Art Institute without seeing how much the crisp geometry of its stylized frontal forms coupled with the iconic and ramrod posture of the subjects infused Indiana's later work—not only such paintings as *Mother and Father*, but also in the sturdy totem-like herms that he built at Coentes Slip in New York City in the early 1960s.

The notion of herms may also have come from Kathleen Blackshear's art history classes, which included not only the history of European and ancient art, but

also explored art from other cultures. She often sent students to draw from ethnographic art at the Field Museum (then called the Museum of Natural History) as well as from the European art at the Art Institute. Drawings from Old Masters were not copying exercises; the student was to do the painting in his or her own style.[6] The art history text was Helen Gardner's *Art Through the Ages*. Unlike other texts of the period, it included sections on Mayan, Native American, Latin-American, Asian and African art, in addition to the sections on European and Egyptian art that are usually included in introductory art history texts. Indiana called his pillarlike, wood sculptures "herms," a term for a stone pillar surmounted by a bust (often of Hermes) that was used as a signpost in ancient Greece. Nevertheless, his herms—with their sexual body parts, wood materials, and metal nails and other objects that Africans often used to increase the potency or sacredness of the object—seem far more like the African art he was exposed to in the Field Museum by Blackshear than like Greek stone herms. Symbolically, though, they were like their Greek predecessors, signposts that carried messages. Instead of the winged feet of Hermes, Indiana often gave them wheels, the modern means of transportation. As with the Greek gods' messages, the messages Indiana placed on his herms were ambiguous.

Very early on in Indiana's life, he believed in the potency of numbers, or numerology. Street numbers where he lived and birth and death dates are to this day significant indicators or omens. For example, in 1963, when he first encountered Charles Demuth's *I Saw the Figure Five in Gold*, inspired by William Carlos Williams's poem, he immediately noticed that the painting was dated 1928, the year of his birth, and that the date of his encounter (1963) was the year of William Carlos Williams's death. Moreover, the three 5s in the painting suggested 35, the date of Demuth's death.[7] Occult signs—the star, the moon, the circle—were also seen as significant by Indiana. When, in 1961, Indiana said that he was an "American painter of signs,"[8] he was no doubt punning, referring to himself as a painter of letters and numbers, like a billboard painter, but also suggesting that he was a painter of omens. The feeling that one's life is governed by numbers and signs is understandable to many Americans, who choose lucky numbers to play lotteries, use nine-digit Zip Codes, PIN numbers, and computers to conduct their daily lives. But in the Midwest, numbers have imposed themselves upon the populace since the nineteenth century.

As in Indianapolis, Chicago's streets are laid out in a rectilinear grid. In Chicago, residents usually give an address by numbers rather than streets, as in "I live 2400 North and 800 West" rather than "I live at the corner of Fullerton Street and

CHICAGO
HOUSE NUMBER MAP

Halsted Street." The numbers correspond to miles from the loop. For example, 2400 North is three miles north and 800 West is one mile west of the intersection of Madison and State streets in the Loop (see map above). The same system is used in Indianapolis. The center of the grid is Monument Circle, which is centered in "the mile square," a square whose sides are each one mile long, bounded by North, East, South and West streets. Indiana has used the "star within the circle within the square" format repeatedly in his work since the 1960s. The street plan of downtown

Indianapolis, showing the circle in the square, is not only a striking image on city maps, but it is emblazoned on the city flag as well. It has given the city its nickname: Circle City. The flag also has a red star within the white circle to indicate the center of the city, as some gas station road maps do.

Indiana's father worked for Phillips 66,[9] and he lived at one time on English Avenue in Indianapolis, a few blocks from Route 40, a main east-west road. It is no wonder that the artist felt that his life was ordered and bounded by numbers, circles, and squares and that they became so much a part of his art forms and motifs. Even Chamberlain, whose work is not about signs, had some interest in numerology, as he once noted that his birth date (April 16) was a square root birthday (the square root of 16 is 4) and that he shared the day, April 16, not the year, with Charles Chaplin, Merce Cunningham, and Lew Alcindor.[10]

Like Chamberlain, Indiana never found in Chicago what he sought as an artist, and he left for New York upon graduation. Yet, the Midwest experience had left its stamp. His American Dream series, his "Autochronology" (important events in his life since birth, written by him in the third person), his development of graphic design into paintings and sculptures, and his personal iconography of numbers and signs were ideas whose seeds were planted long before they grew and blossomed into his distinct Pop Art style and imagery at Coentes Slip in the 1960s.

1 Vol. 27, nos. 48-50 (January 12, 19 and 26, 1952).

2 Chamberlain dropped out in 9th grade. Indiana graduated from Arsenal Technical High School, Indianapolis.

3 Julie Sylvester, *John Chamberlain: A Catalogue Raisonné of the Sculpture 1954-1985* (New York: Hudson Hills Press, 1986), 10.

4 Lynne Warren, ed., *Art in Chicago, 1945-1995* (New York: Thames & Hudson, New York, 1996) 34.

5 Chamberlain showed his work with Fiore in 1958 at Davida Gallery in New York.

6 Indiana used this technique between 1989 and 1994 to create the *Hartley Elegies* series of paintings.

7 *Robert Indiana* (Philadelphia: Institute of Contemporary Art with Falcon Press, 1968), 27.

8 Unpublished statement by Robert Indiana, 1961, curatorial files, Museum of Modern Art, New York.

9 Later, Indiana noted that his father died in June 1966.

10 Sylvester, *John Chamberlain*, 10.

John Chamberlain

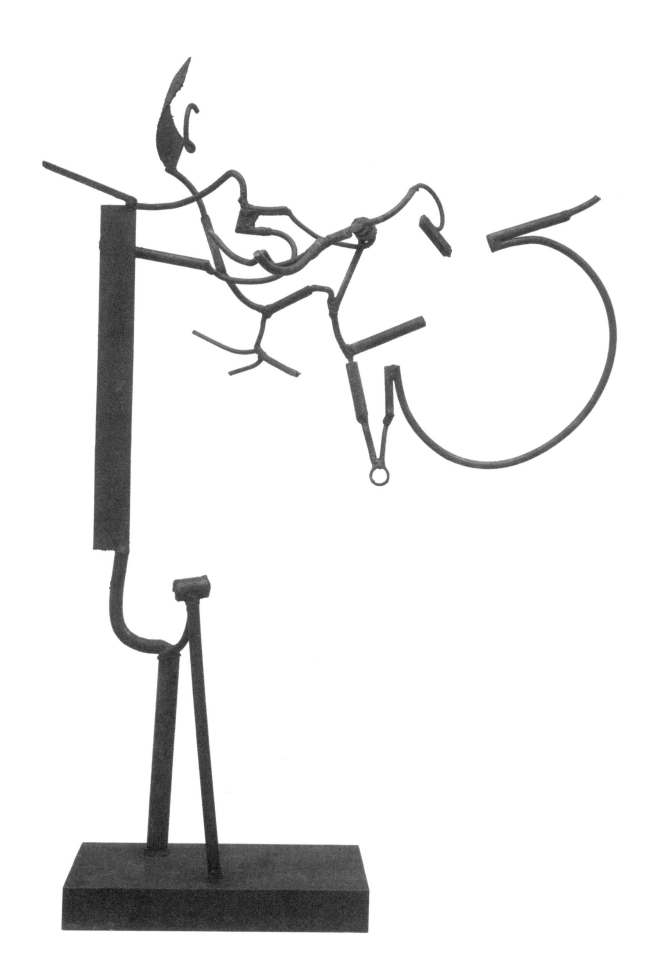

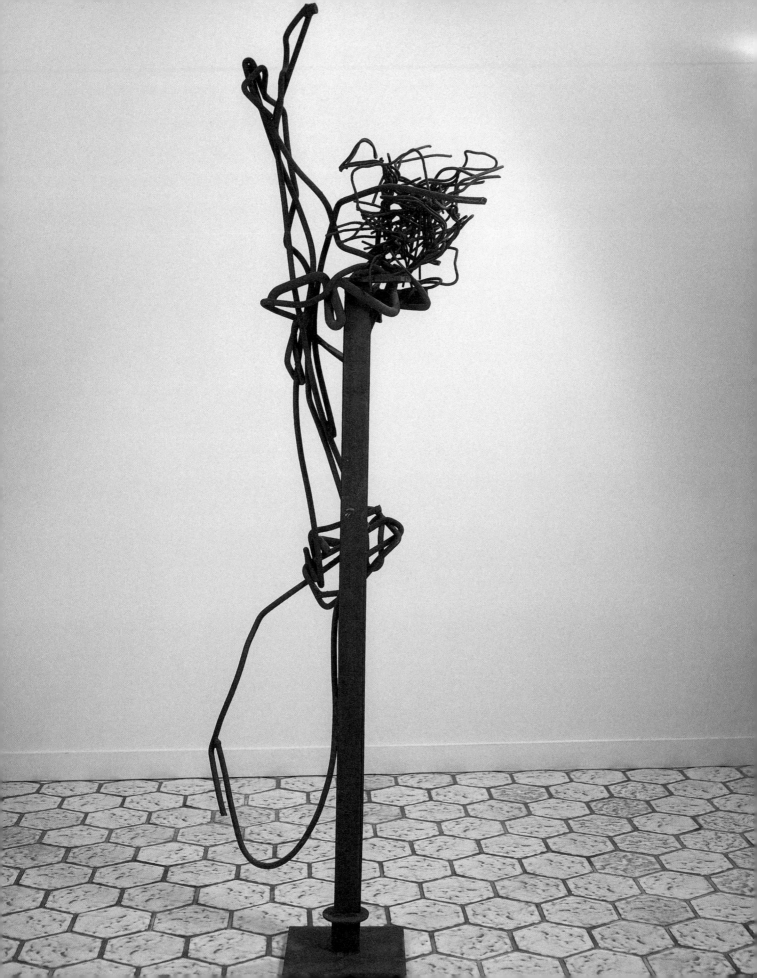

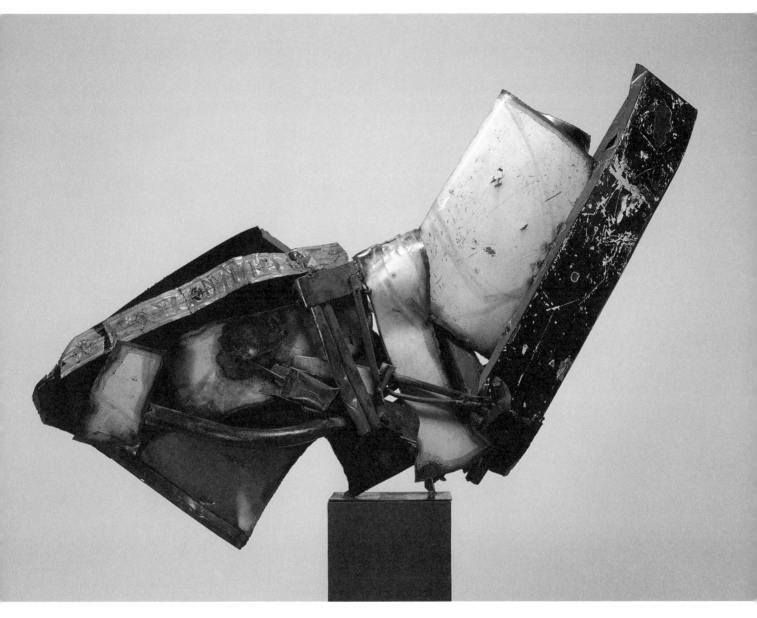

ZAAR, 1959
WELDED STEEL, PAINTED, 51 1/4 X 68 3/8 X 19 5/8 IN.
THE PATSY R. AND RAYMOND D. NASHER COLLECTION, DALLAS, TEXAS
©2000 JOHN CHAMBERLAIN/ARTISTS RIGHTS SOCIETY (ARS), NEW YORK

OPPOSITE
FOR ELAINE WITH LOVE, 1957
OIL PAINT ON PAPER, 9 X 10 IN.
COLLECTION OF THE ARTIST
©2000 JOHN CHAMBERLAIN/ARTISTS RIGHTS SOCIETY (ARS), NEW YORK

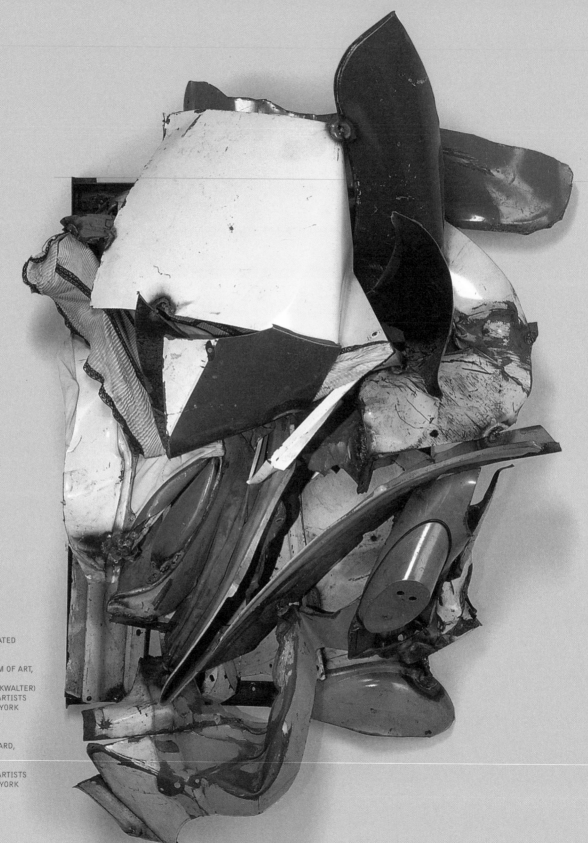

RIGHT
HUZZY, 1961
PAINTED AND CHROMIUM-PLATED
STEEL WITH FABRIC
54 X 33 X 21 IN.
THE NELSON-ATKINS MUSEUM OF ART,
KANSAS CITY, MISSOURI
(GIFT OF MRS. CHARLES F. BUCKWALTER)
©2000 JOHN CHAMBERLAIN/ARTISTS
RIGHTS SOCIETY (ARS), NEW YORK

OPPOSITE
TAOS DROP OFF, 1961
PAPER, FOIL, STAPLES ON BOARD,
COLLAGE, 13 X 7 IN.
COLLECTION OF THE ARTIST
©2000 JOHN CHAMBERLAIN/ARTISTS
RIGHTS SOCIETY (ARS), NEW YORK

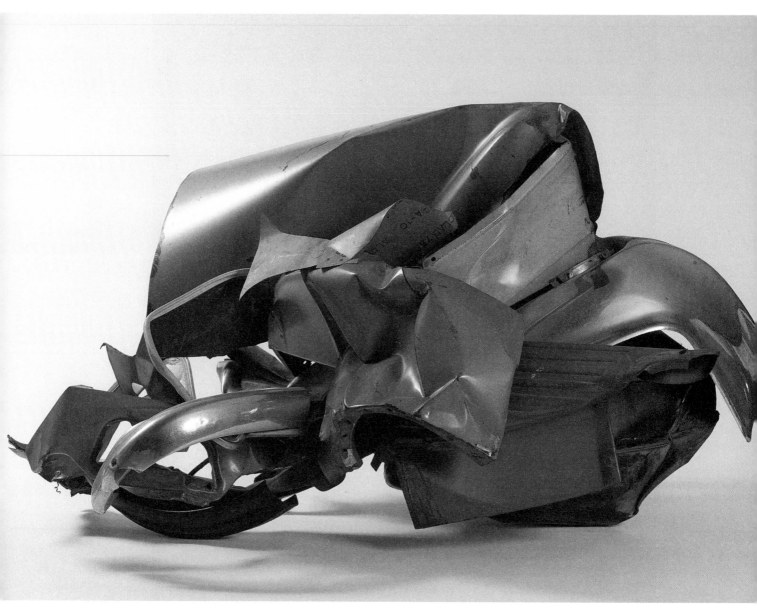

ABOVE
UNTITLED, 1963
WELDED, PAINTED, CHROMIUM-PLATED STEEL AUTOMOBILE BODY PARTS
36 X 50 X 53 IN.
THE DAVID AND ALFRED SMART MUSEUM OF ART, THE UNIVERSITY OF CHICAGO;
GIFT OF MR. AND MRS. RICHARD L. SELLE
©2000 JOHN CHAMBERLAIN/ARTISTS RIGHTS SOCIETY (ARS), NEW YORK

OPPOSITE
MADAME MOON, 1964
CHROME-PLATED STEEL, PAINT, 15 1/2 X 26 1/2 X 21 1/2 IN.
INDIANAPOLIS MUSEUM OF ART
KATHRYN A. SIMMONS CONTEMPORARY ART FUND
1993.239
©2000 JOHN CHAMBERLAIN/ARTISTS RIGHTS SOCIETY (ARS), NEW YORK

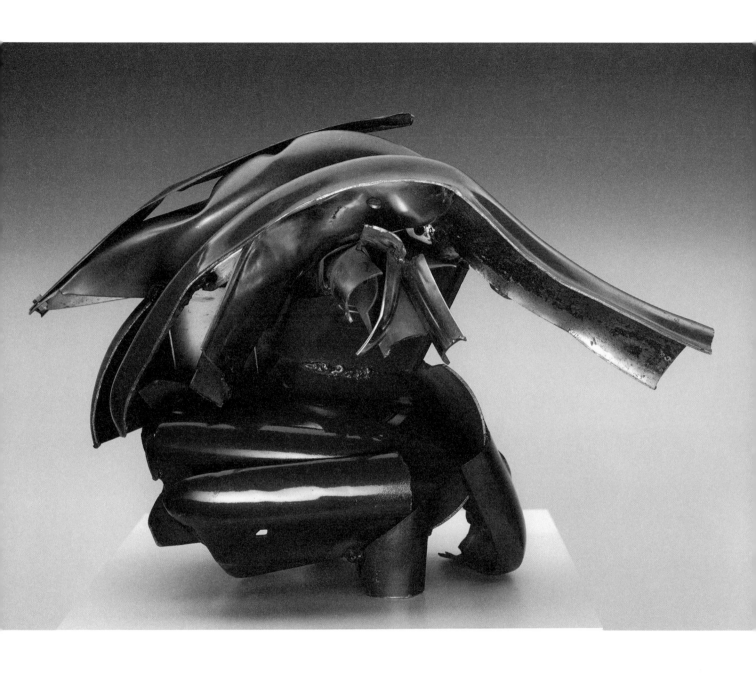

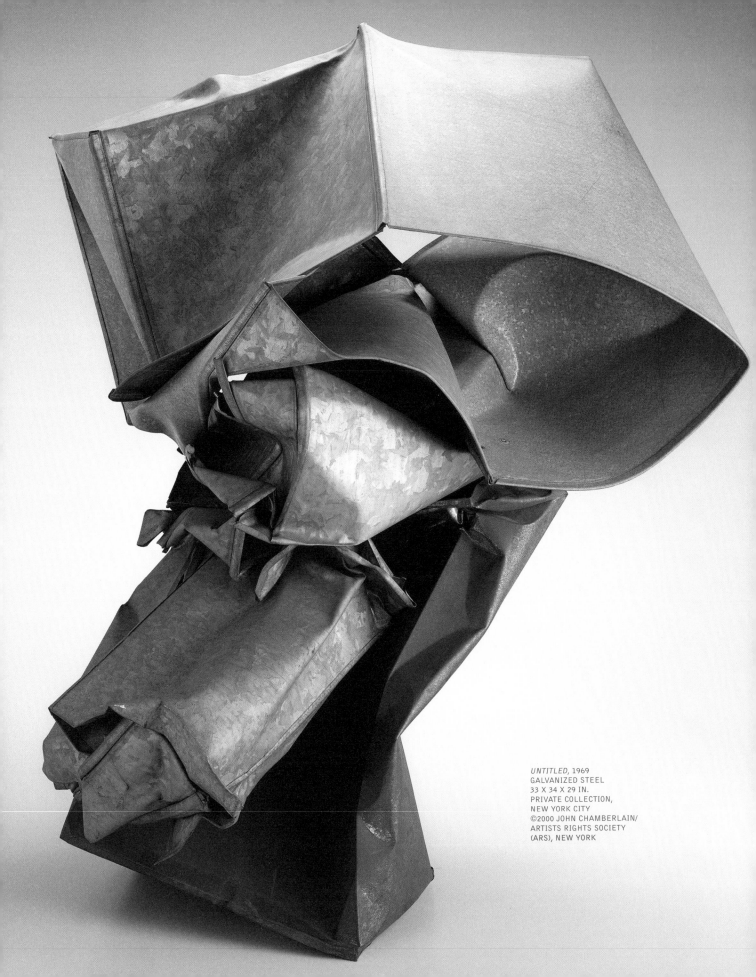

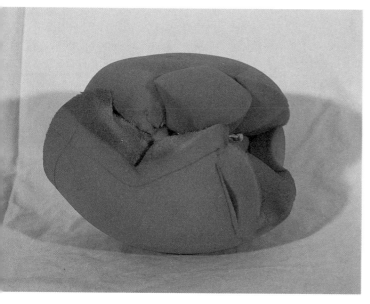

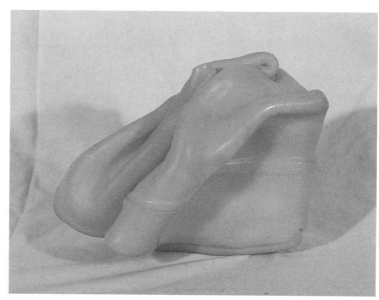

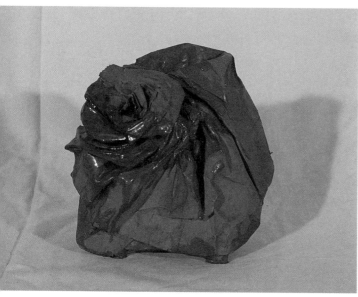

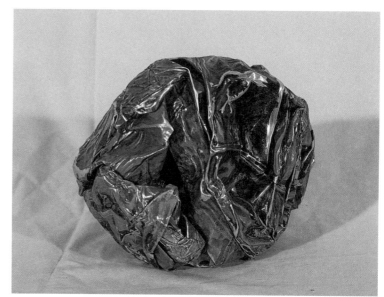

CLOCKWISE FROM TOP LEFT
UNTITLED, 1966
URETHANE FOAM, 5 1/2 X 7 1/2 X 6 3/4 IN.
COLLECTION OF THE ARTIST
©2000 JOHN CHAMBERLAIN/ARTISTS RIGHTS SOCIETY (ARS), NEW YORK

UNTITLED, 1979
PLASTIC, 6 1/2 X 5 1/4 X 5 3/4 IN.
COLLECTION OF THE ARTIST
©2000 JOHN CHAMBERLAIN/ARTISTS RIGHTS SOCIETY (ARS), NEW YORK

UNTITLED, 1973
FOIL WITH WATERCOLOR AND POLYURETHANE RESIN, 5 1/2 X 7 1/2 X 6 5/8 IN.
COLLECTION OF THE ARTIST
©2000 JOHN CHAMBERLAIN/ARTISTS RIGHTS SOCIETY (ARS), NEW YORK

UNTITLED, 1971
BROWN PAPER BAG AND POLYURETHANE RESIN, 5 1/2 X 5 X 4 3/4 IN.
COLLECTION OF THE ARTIST
©2000 JOHN CHAMBERLAIN/ARTISTS RIGHTS SOCIETY (ARS), NEW YORK

TO LAND FROM SEA, 1978
PAINT ON BOARD, COLLAGE, 10 X 17 IN.
COLLECTION OF THE ARTIST
©2000 JOHN CHAMBERLAIN/ARTISTS RIGHTS SOCIETY (ARS), NEW YORK

VIEW OF LAND FROM BOAT, 1978
PAINT ON BOARD, COLLAGE, 9 X 18 IN.
COLLECTION OF THE ARTIST
©2000 JOHN CHAMBERLAIN/ARTISTS RIGHTS SOCIETY (ARS), NEW YORK

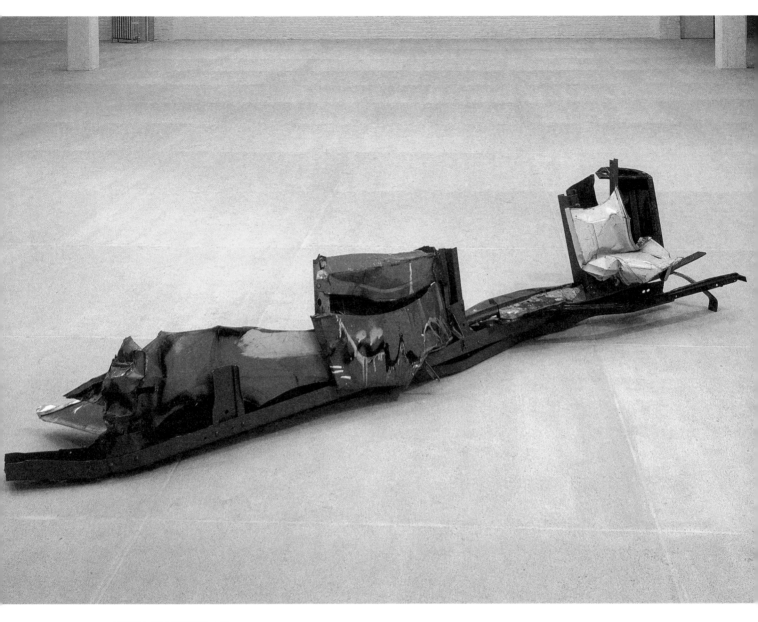

GONDOLA JACK KEROUAC, 1982
PAINTED AND CHROMIUM-PLATED STEEL, 34 X 151 X 30 IN.
PRIVATE COLLECTION, COURTESY OF PACEWILDENSTEIN
©2000 JOHN CHAMBERLAIN/ARTISTS RIGHTS SOCIETY (ARS), NEW YORK

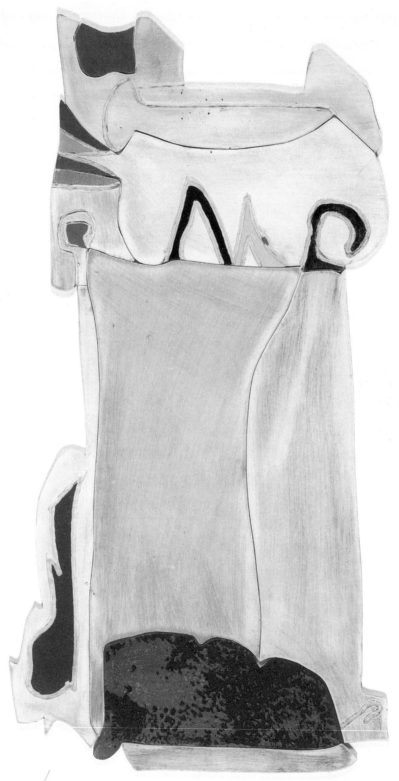

COLL/

/108-84

LEFT
LONGSLIDE, 1984
INK ON PAPER, 11 X 8 IN.
COLLECTION OF THE ARTIST
©2000 JOHN CHAMBERLAIN/ARTISTS RIGHTS SOCIETY (ARS), NEW YORK

RIGHT
SUPRIZE, 1984
INK ON PAPER, 12 X 8 IN.
COLLECTION OF THE ARTIST
©2000 JOHN CHAMBERLAIN/ARTISTS RIGHTS SOCIETY (ARS), NEW YORK

OPPOSITE
COLL/108-84, 1984
INK ON PLASTIC ON PAPER, 20 X 12 IN.
ANN AND CHRIS STACK
©2000 JOHN CHAMBERLAIN/ARTISTS RIGHTS SOCIETY (ARS), NEW YORK

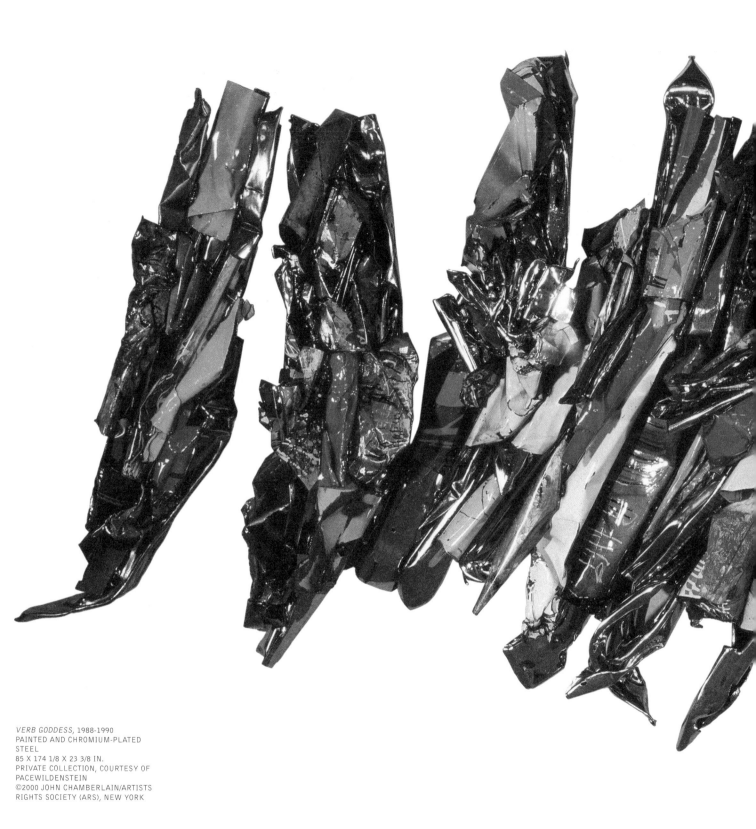

VERB GODDESS, 1988-1990
PAINTED AND CHROMIUM-PLATED
STEEL
85 X 174 1/8 X 23 3/8 IN.
PRIVATE COLLECTION, COURTESY OF
PACEWILDENSTEIN
©2000 JOHN CHAMBERLAIN/ARTISTS
RIGHTS SOCIETY (ARS), NEW YORK

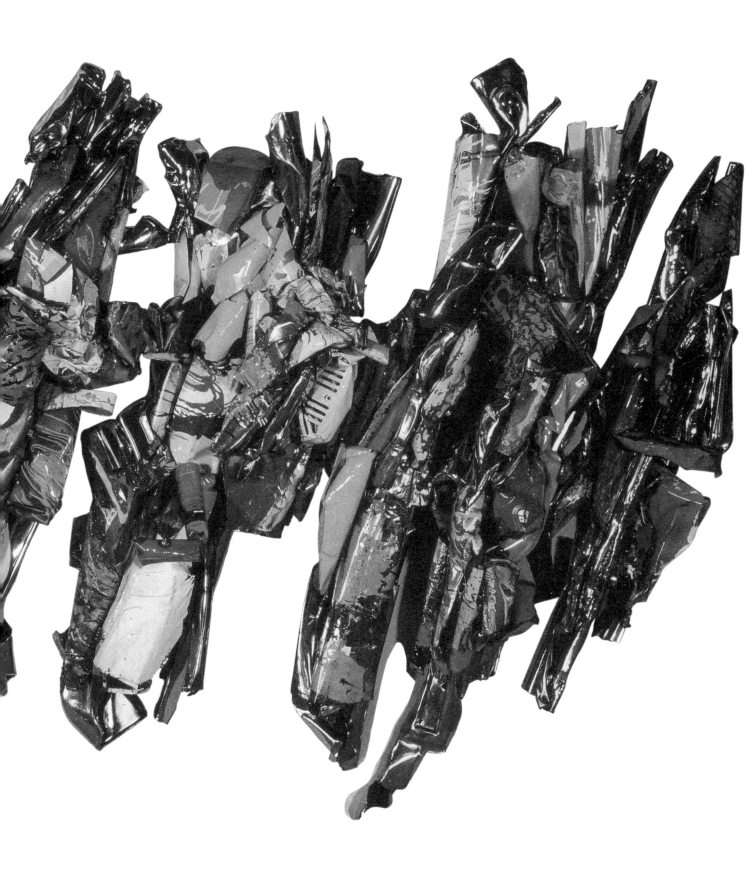

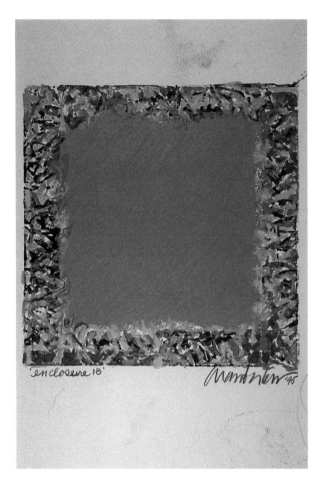

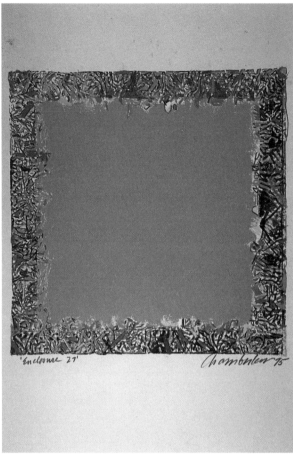

LEFT
ENCLOSURE 18", 1995
INK, OIL STICK ON PAPER
8 X 8 IN.
COLLECTION OF THE ARTIST
©2000 JOHN CHAMBERLAIN/ARTISTS RIGHTS SOCIETY (ARS), NEW YORK

RIGHT
ENCLOSURE 27', 1995
INK, OIL STICK ON PAPER
11 1/4 X 11 1/4 IN.
COLLECTION OF THE ARTIST
©2000 JOHN CHAMBERLAIN/ARTISTS RIGHTS SOCIETY (ARS), NEW YORK

OPPOSITE
THICKET, 1998
PAINTED MILD STEEL AND CHROMIUM-PLATED STEEL
96 X 96 X 96 IN.
COLLECTION OF THE ARTIST
©2000 JOHN CHAMBERLAIN/ARTISTS RIGHTS SOCIETY (ARS), NEW YORK

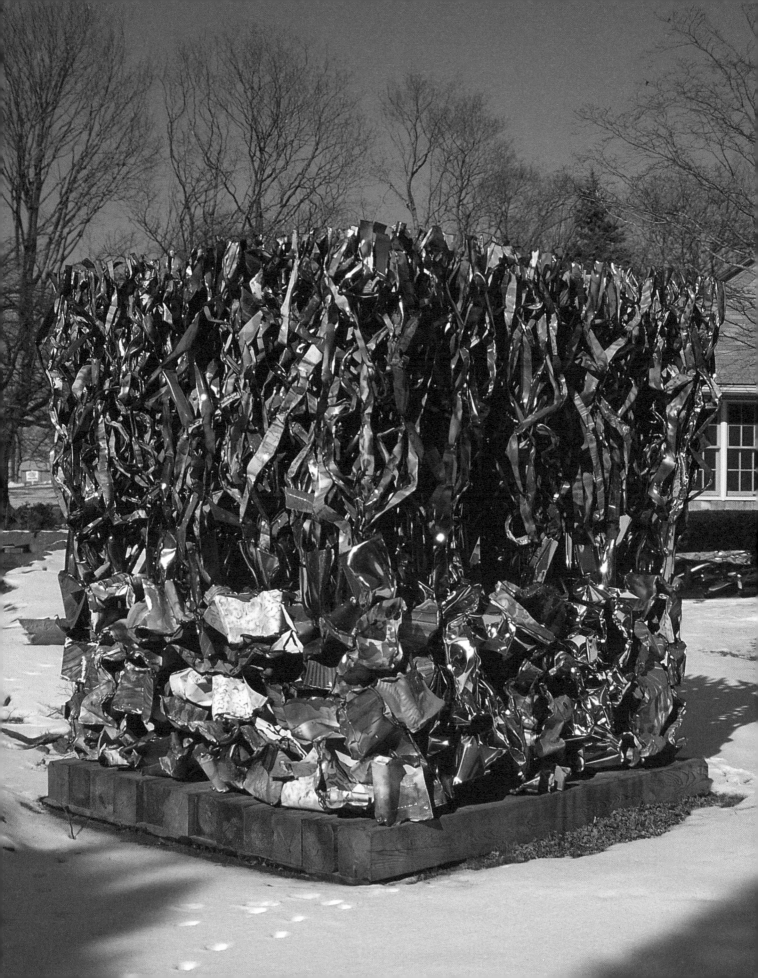

Robert Indiana

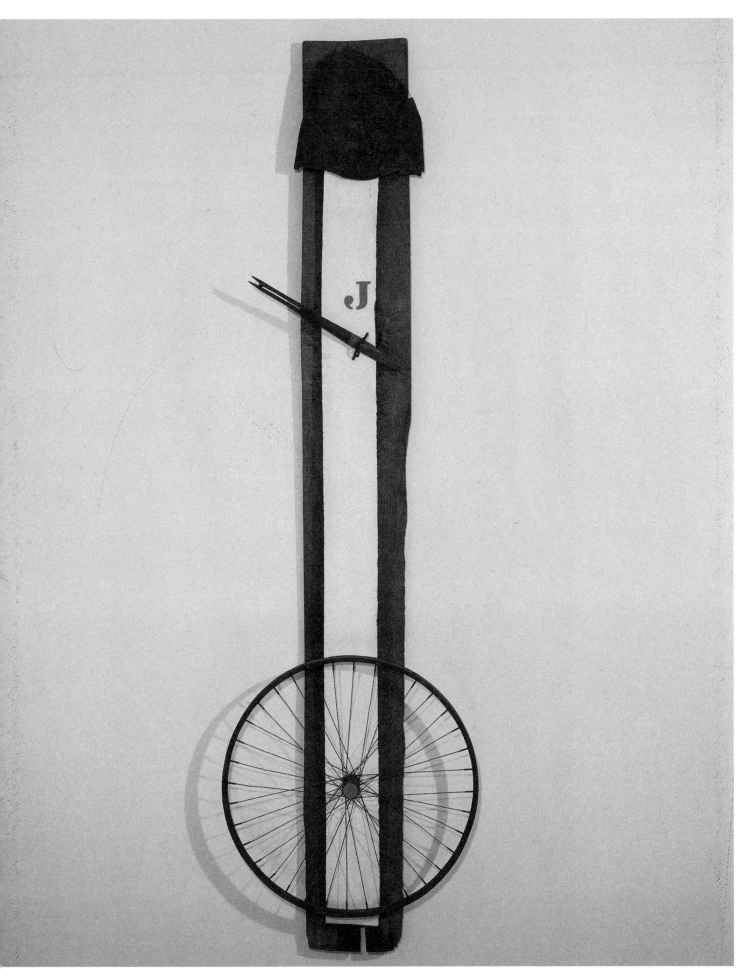

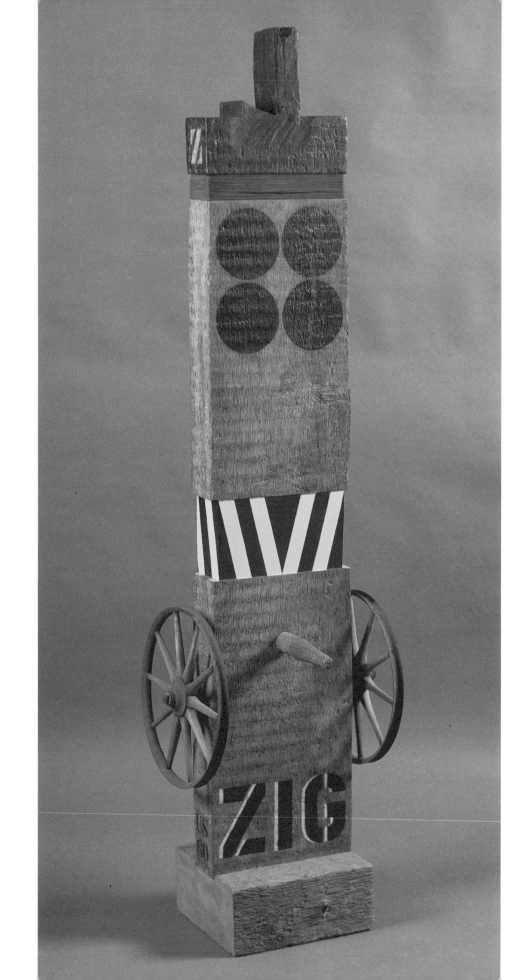

+ LENORE & CHARLESTON

THE >VLG FOR SUNDAY TIMES (*14TH)
PINKBOS ARE NOTICEABLY IN BUD NOW, THEIR
NEW GREENERY MAK'G A DEFINITE TRACERY IN
JEANNETTE.

BGIN >N CONSTRUCTION, DECIDING > FINISH
"MARINE WORKS" ONCE & FR ALL & EVEN
BRINGING WHAT WS ORIGINALLY >LONG "FOUR
WHITE ONES" INTO FOCUS W/ MY CURRENT DIRECTION.

"FOUR"
ADD >N GOTHIC
FOUR (4) >
>3 LOWER
84 >N WORD
"FOUR > 4
BOTTOM OF
CONSTRUCTION.

EACH 4 &

FOUR GESSO
WH.

IRON, GESSO & OIL
ON WOOD.

ROBERT INDIANA
NEW YORK
1959-1962

GBNED IN STENCIG ON
>N REVERSE

9'6" X 21 1/4"

+ CHARLESTON & LENORE VISIT JEUN'S HV'R CASES,
& FOR >N FORMER REESTABLISH'G A RAPPORT
LONG BROKEN & NEGLECTED: ALL WS PEACHES
& CREAM W/ ALL VARIOUS SLIGHTS & INCIVILITIES
APTLY PUT FR MEMORY & RECALL.

A COLLAGE FR RAY JOHNSON IN NMAIL 3 MORNING,
BRING COFFEE & CIGS > & ALOF? 3 MORNING.

CALL FR ART: HIS PARENTS ATTEND OPENING BASE-
BALL GAME TODAY. HIS DISENCHANTMENT WI
FIRE ISLAND CONTINUES.

VISIT LENORE > PICK UP SOME MONEY > PAY NEROUS
LIGHT BILL> TAKE KIM A PAIR A ELECTRICAL PLIERS
>FLOOR N > 3RD FLR IS ALMOST ALL PAINTED. A
NEW SEAMAN WORK'G IS PAINTING >N HALLWAY ALL
>WAY DOWN >N STREET.

AGAIN Y>N CONST'NS: "FOUR" & "JOAN A ARC"

>N 4 & FOUR BECOME
BLACK FR >N WHITE THEY
WERE YESTERDAY.

WHICH >N "J" > WS ALWAYS IN
PENCIL-STENCIL OUTLINE
A CAD. RED. Z7R.

> CALL FR CAMPBELL: HE HAD DINK LATELY W/ >N
DUCHAMPS & STEMPFLI'S.
CALL FR ANN STEINBROKER—! PUT HER ON STONE'S
DOORSTEP.

GOUVERNEUR LANE.
OGDEN REID GETS HIS PONTICAL WISH: 36 YRS OLD.

GOUVERNEUR SLIP.

PAGE 165
JEANNE D'ARC, 1960-62
GESSO, OIL, IRON, WOOD, AND WHEEL, 83 X 24 X 6 IN.
ON LOAN FROM MORGAN ART FOUNDATION LIMITED, COURTESY SIMON SALAMA-CARO, NEW YORK
©2000 MORGAN ART FOUNDATION LIMITED/ARTISTS RIGHTS SOCIETY (ARS), NEW YORK

ABOVE
PAGES FROM JOURNAL FROM 1962-63
HARDBOUND LEDGER , 15 3/4 X 10 3/8 X 2 1/4 IN.
COLLECTION OF THE ARTIST
©2000 MORGAN ART FOUNDATION LIMITED/ARTISTS RIGHTS SOCIETY (ARS), NEW YORK

OPPOSITE
ZIG, 1960
WOOD, WIRE, IRON, OIL PAINT, 65 X 18 X 16 IN.
MUSEUM LUDWIG, KÖLN, LUDWIG DONATION
©2000 MORGAN ART FOUNDATION LIMITED/ARTISTS RIGHTS SOCIETY (ARS), NEW YORK

PAGES FROM JOURNAL FROM 1959-60
HARDBOUND LEDGER, 17 1/2 X 11 1/4 X 2 3/8 IN.
COLLECTION OF THE ARTIST
©2000 MORGAN ART FOUNDATION LIMITED/ARTISTS RIGHTS SOCIETY (ARS), NEW YORK

OPPOSITE TOP
WALL OF CHINA, 1960-61
METAL, WOOD, GESSO, OIL , 48 X 54 1/4 X 8 IN.
PRIVATE COLLECTION, COURTESY SIMON SALAMA-CARO, NEW YORK
©2000 MORGAN ART FOUNDATION LIMITED/ARTISTS RIGHTS SOCIETY (ARS), NEW YORK

OPPOSITE BOTTOM
ZENITH, 1960
METAL, WOOD, GESSO
12 1/2 X 8 3/4 X 4 1/2 IN.
PRIVATE COLLECTION, COURTESY SIMON-SALAMA CARO, NEW YORK
©2000 MORGAN ART FOUNDATION LIMITED/ARTISTS RIGHTS SOCIETY (ARS), NEW YORK

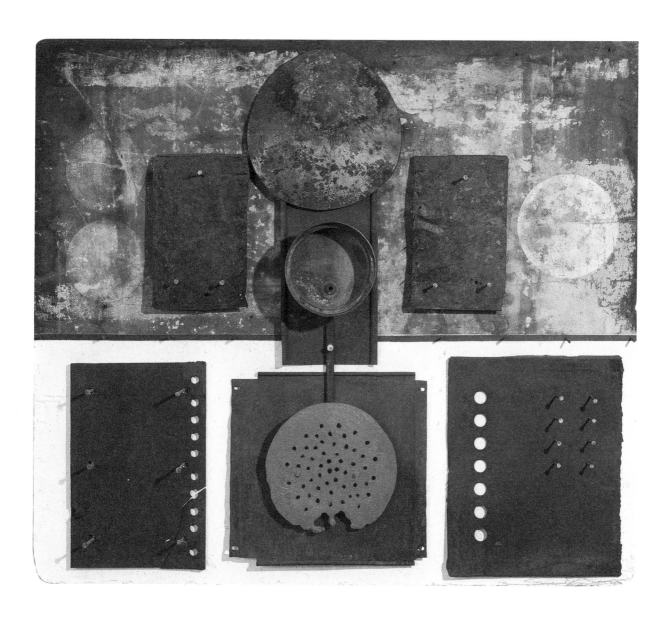

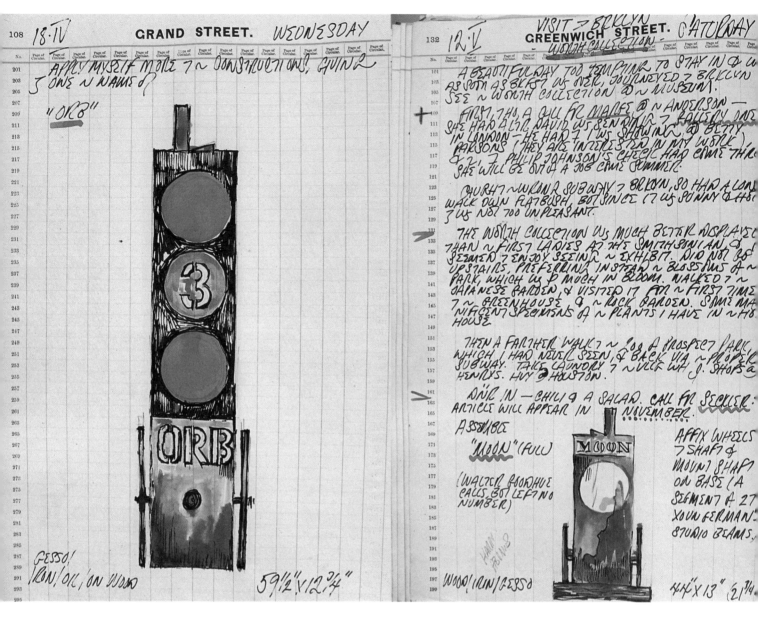

ABOVE
PAGES FROM JOURNAL FROM 1962-63
HARDBOUND LEDGER, 15 3/4 X 10 3/8 X 2 1/4 IN.
COLLECTION OF THE ARTIST
©2000 MORGAN ART FOUNDATION LIMITED/ARTISTS RIGHTS SOCIETY (ARS), NEW YORK

OPPOSITE
ORB, 1960-1991
CONSTRUCTION IN PAINTED BRONZE, 61 1/2 X 19 X 18 1/2 IN.
PRIVATE COLLECTION, COURTESY SIMON SALAMA-CARO, NEW YORK
©2000 MORGAN ART FOUNDATION LIMITED/ARTISTS RIGHTS SOCIETY (ARS), NEW YORK

MOON, 1962
FOUND OBJECT CONSTRUCTION, H: 44 IN.
ROBERT E. ABRAMS
©2000 MORGAN ART FOUNDATION LIMITED/ARTISTS RIGHTS SOCIETY (ARS), NEW YORK

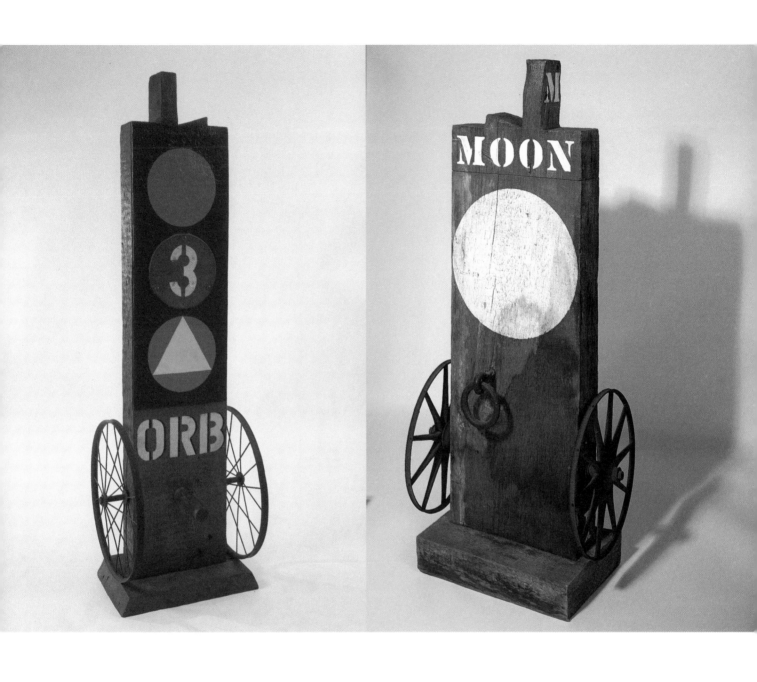

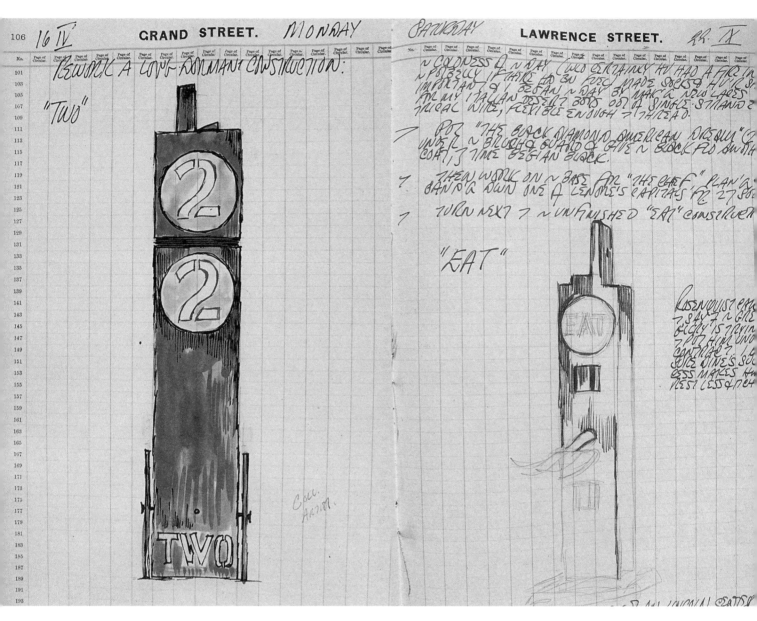

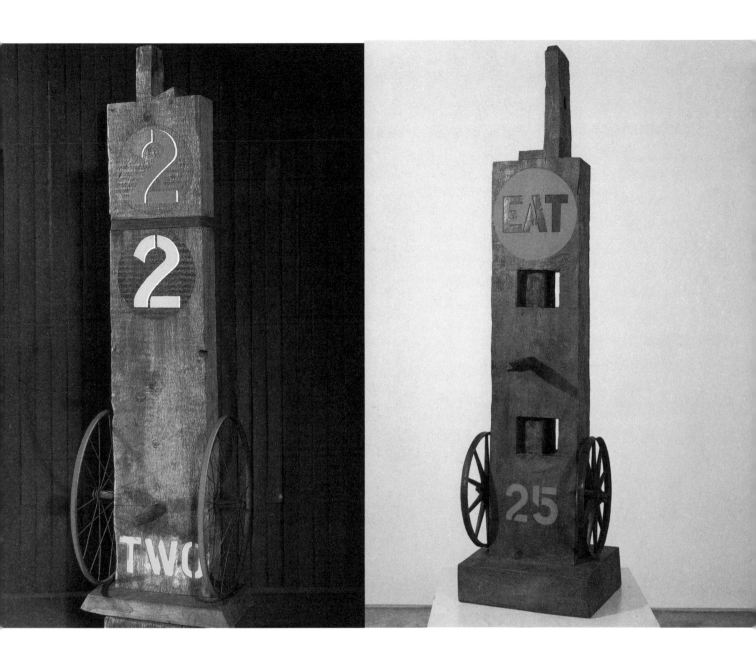

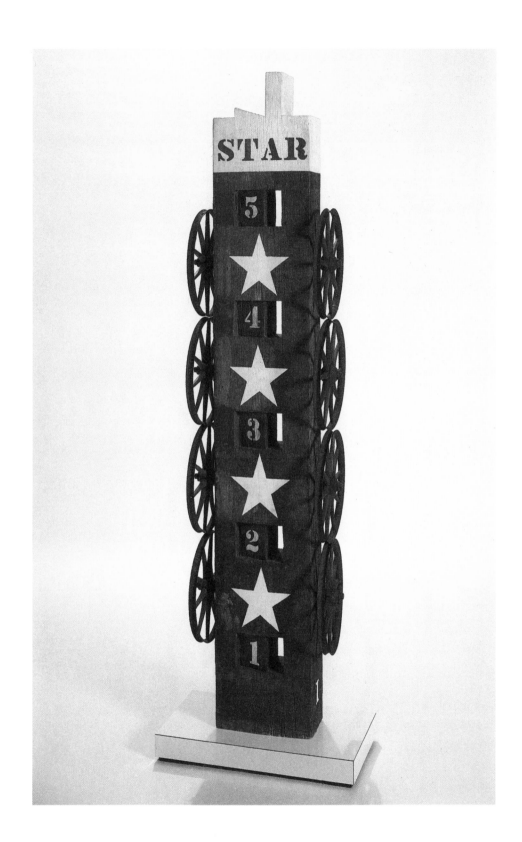

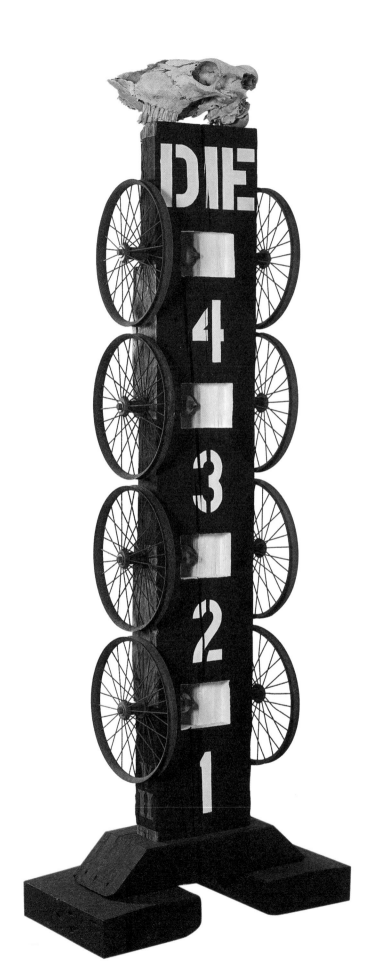

DIE, 1962-84
WOOD, IRON, OIL, WHEELS, FOUND
OBJECTS, H: 79 3/4 IN.
COLLECTION OF THE ARTIST
COURTESY OF PORTLAND MUSEUM OF
ART, MAINE
©2000 MORGAN ART FOUNDATION
LIMITED/ARTISTS RIGHTS SOCIETY
(ARS), NEW YORK

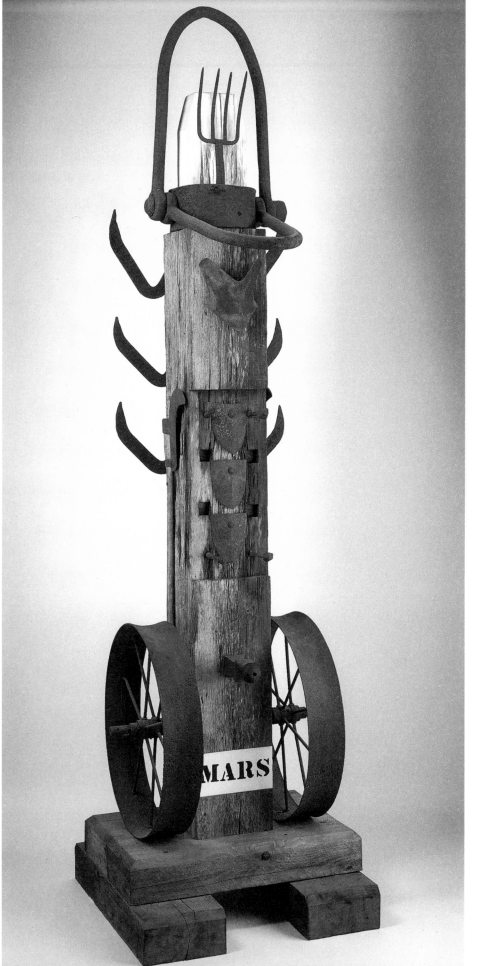

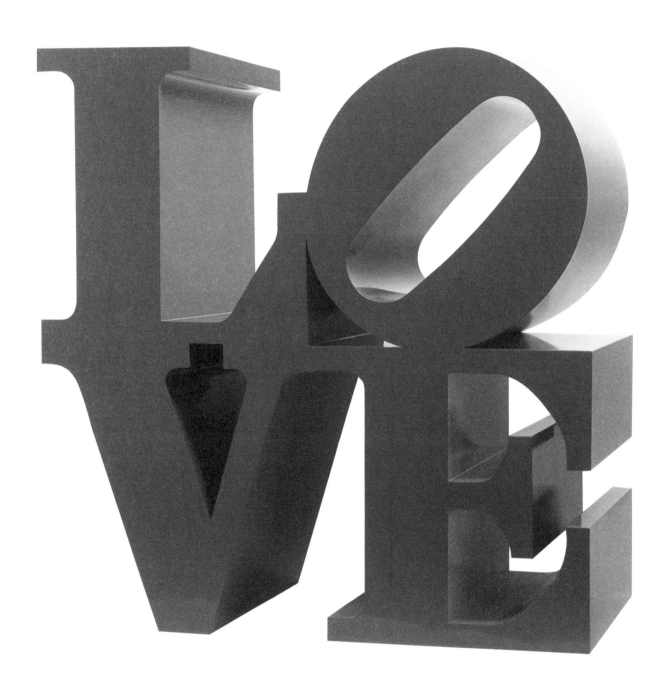

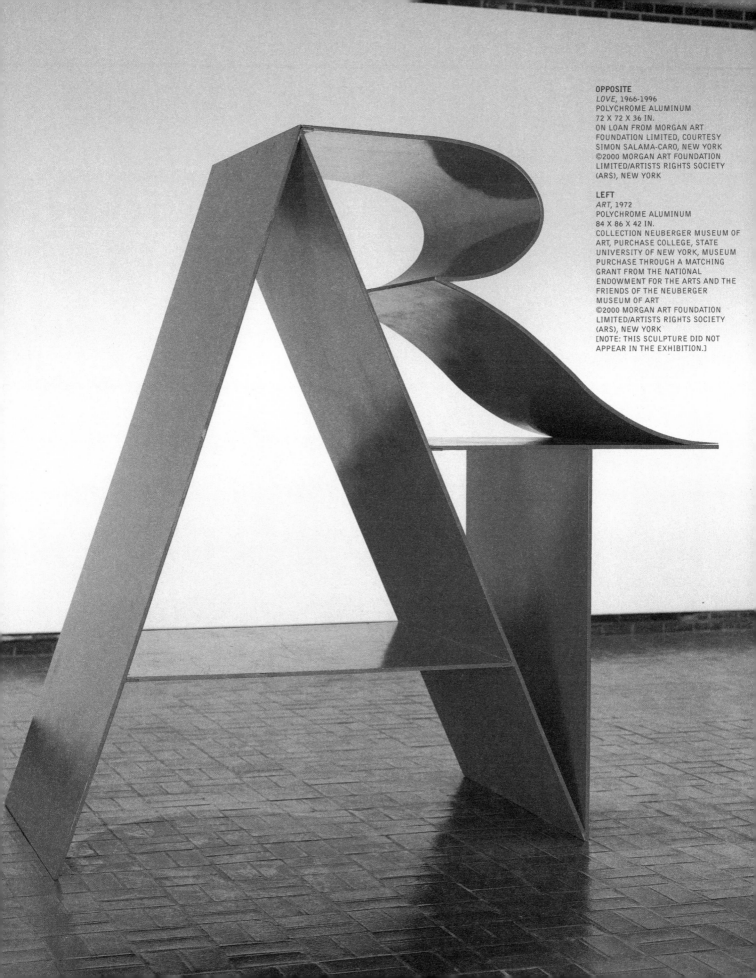

LOVE, 1964
COLORED PENCIL ON PAPER, 9 X 9 IN.
SPENCER MUSEUM OF ART, THE UNIVERSITY OF KANSAS, THE GENE SWENSON COLLECTION
©2000 MORGAN ART FOUNDATION LIMITED/ARTISTS RIGHTS SOCIETY (ARS), NEW YORK

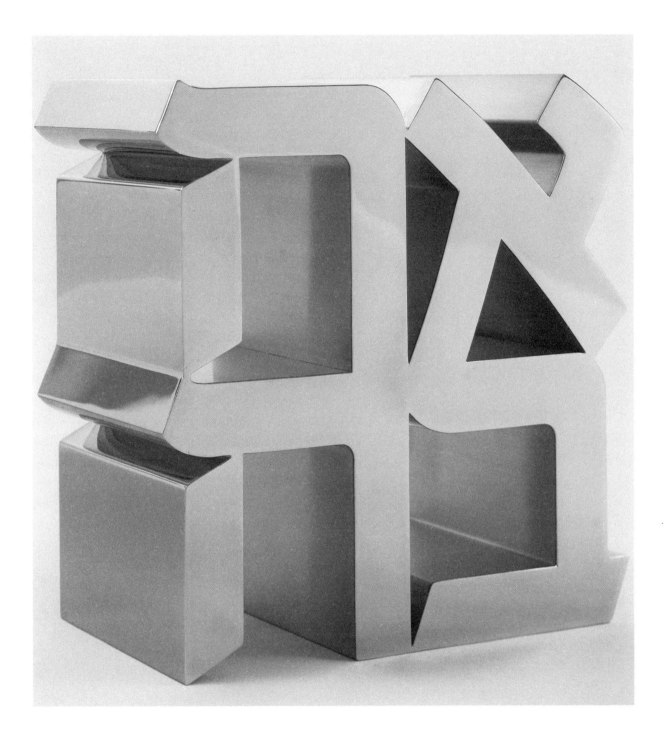

AHAVA, 1972-1998
STEEL
18 X 18 X 9 IN.
COLLECTION OF YESHIVA UNIVERSITY MUSEUM, GIFT OF JEFFREY LORIA
©2000 MORGAN ART FOUNDATION LIMITED/ARTISTS RIGHTS SOCIETY (ARS), NEW YORK

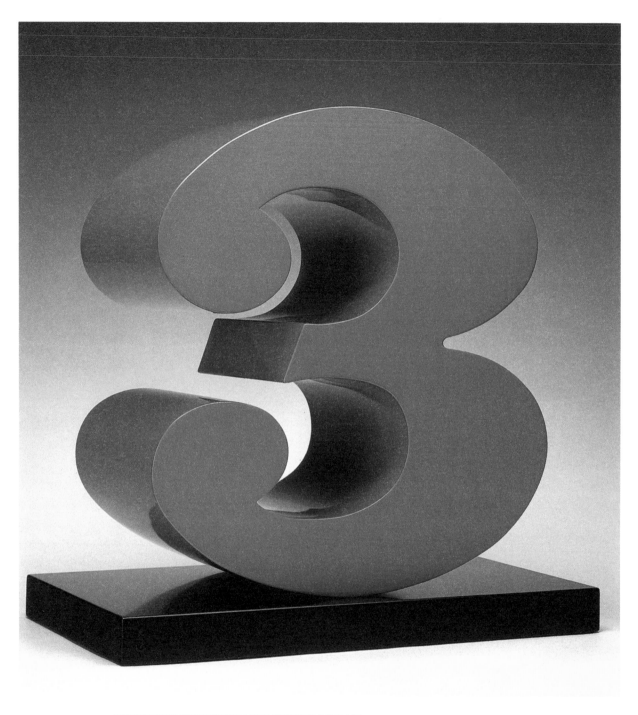

NUMBER 3 FROM *MAQUETTES FOR LARGE NUMBERS 1-0*, 1980-1996
PAINTED ALUMINUM ON STEEL BASE
18 X 18 X 10 IN. EACH
PRIVATE COLLECTION, COURTESY SIMON SALAMA-CARO, NEW YORK
©2000 MORGAN ART FOUNDATION LIMITED/ARTISTS RIGHTS SOCIETY (ARS), NEW YORK

OPPOSITE
2000, 2000
STAINLESS STEEL, 18 X 8 X 9 IN.
ON LOAN FROM MORGAN ART FOUNDATION LIMITED, COURTESY SIMON SALAMA-CARO, NEW YORK
©2000 MORGAN ART FOUNDATION LIMITED/ARTISTS RIGHTS SOCIETY (ARS), NEW YORK

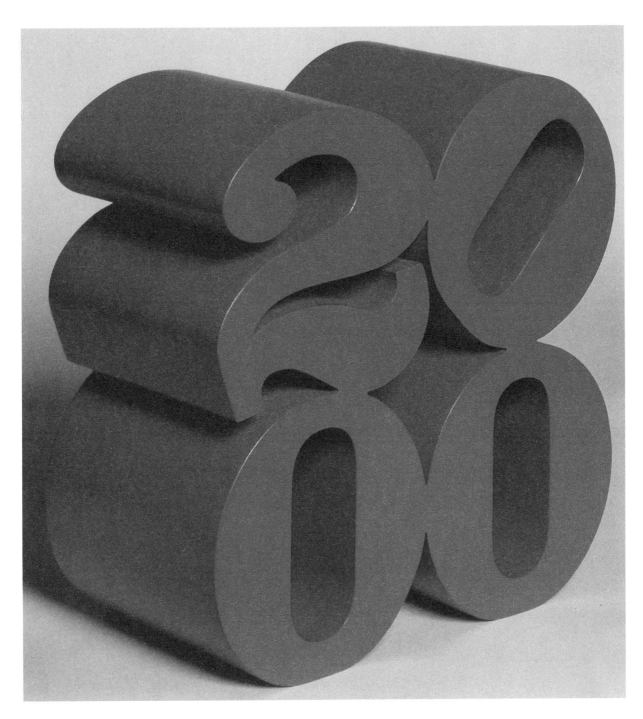

THESE WORKS BY ROBERT INDIANA ARE IN THE EXHIBITION BUT DO NOT APPEAR IN THIS CATALOGUE:

SUN AND MOON, 1960, OIL AND IRON ON WOOD PANEL, 34 3/4 X 12 X 4 IN.
ON LOAN FROM MORGAN ART FOUNDATION LIMITED, COURTESY SIMON SALAMA-CARO, NEW YORK

SIX, 1960-62, WOOD, IRON, OIL, H: 61 3/4 IN., COLLECTION OF KIMIKO AND JOHN POWERS

EAT SIGN, 1964, METAL WITH ELECTRIC BULBS, D: 6 FT., COLLECTION OF THE ARTIST

ART, 2000, POLYCHROME ALUMINUM, 72 X 72 X 36 IN.
ON LOAN FROM MORGAN ART FOUNDATION LIMITED, COURTESY SIMON SALAMA-CARO, NEW YORK

JOURNAL FROM 1961 , SOFTBOUND SKETCHBOOK, 8 1/8 X 5 1/4 X 1 1/4 IN., COLLECTION OF THE ARTIST

William T. Wiley and Bruce Nauman in California in the early 1960s

When Bruce Nauman came to the University of California, Davis, in 1964, it is not surprising that the education of an artist in that time and place was vastly different from what it had been in Chicago in the early 1950s or New York in the 1930s and '40s. The goals that New Yorkers had—of eclipsing European art or of making the best painting or sculpture possible, whether based on Bauhaus methods or Surrealist dreams—seemed antiquated. New York had already eclipsed Paris as the center of art, and making art for art's sake seemed too self-serving in the 1960s. Both art students and teachers were concerned with art's moral function in society. Although earlier artists like David Smith were certainly concerned with social and political issues, they nevertheless thought that art was a discipline and that the purpose of a work of art was its esthetic value. In the '60s, artists demanded that art be more than esthetic objects. Art should be a means of investigating moral issues.

In the early 1960s, California artists were in the process of both breaking art apart to examine its fundamental premises and of making art inclusive. Performance, music, dance, film, literature came to be seen as parts of a seamless artistic endeavor rather than separate disciplines. While visual artists have always been interested in other disciplines, like poetry, in the past they saw them as parallel disciplines whose ideas and philosophies could be translated into art objects. Wiley and Nauman came to see them as materials for art "investigations."

The concept that art was an investigation had several consequences. First, the process was more important than the craftsmanship of the object, if the idea was clear. Second, a small or temporary art object was just as valid as a large (and sometimes pretentious) permanent one. These experimental attitudes were encouraged not only by the social climate, but also by the limited opportunities in California for artists to show and sell the work they made. An artwork could be unpretentious, jokey, and perishable,[1] if the artist was not trying to make art with a capital A. Such a concept of art was in direct contrast to the New York idea that bigger was better and to the large-scale public outdoor sculptures that were being built by many older artists at that time.

Wiley's role as a teacher and artist was central to the directions San Francisco artists took in the 1960s. He had an inquiring mind and an inclusive attitude about art. Word play, music, and performance were naturally part of his personality. Anything a student wanted to do was basically art. He encouraged artists to think about all manner of subjects that might or might not be art topics.

Words in particular held a fascination for Wiley, not just as formal shapes or graphic symbols, but as a means to convey meaning, and he used both visual and ver-

bal puns in his art. Robert Arneson, another of Nauman's teachers, and Wiley frequently used phrases that were made literally visible in the art. In *Eating My Words*, an early work by Nauman, the artist photographed himself eating food shaped like the letters of the word "WORDS."

Music was another interest Wiley and Nauman shared, and both could play instruments. Nauman had played in a band at the University of Wisconsin, and Wiley was an accomplished guitar player. Wiley felt at ease performing not only music, but also as an art performer. Eventually, he developed a character, Mr. Unatural, who took part in various art events and who appears in numerous works. Nauman, not as comfortable as a performer in public, recorded various of his performances on video or film. His graduate artwork at Davis was a performance in which he manipulated a fluorescent light bulb with various body movements. Another studio performance involved playing a violin tuned to the notes D.E.A.D. Nauman also made four films in 1966 with William Allan, who was then teaching art at the University of California, Davis. One depicted Allan fishing for Asian carp, and an unfinished one recorded the two artists building a new Slant Step.

While both Wiley and Nauman had inquiring minds that allowed them to delve into many subjects not traditionally thought of as art, their approaches and personalities were quite different. Wiley's inclusive approach often led to his making quite complex sculptures and paintings with multitudinous things happening in the same work. Nauman, trained in mathematics and physics at the University of Wisconsin, initially took a conceptual reductive approach to making art. He tended to mask himself off from his work and create distance between himself and the viewer. Even in works where he used his own body, his body was a stand-in for a generic body rather than a personal autobiographical form. He used it as a metaphor for human activity rather than his personal activity.

Both artists were interested in the opposition of two ideas in the same work of art or paradoxes that arose when two opposing ideas were brought together. For Wiley, this interest in paradox naturally followed his interest in Zen philosophy, where truth is revealed through the study of paradoxes. Nauman, on the other hand, was exposed to paradoxes through his study of quantum theory and other areas of modern physics where two apparently contradictory exclusive events can both be true.[2]

In both physics and Asian philosophy, these paradoxes or oppositions are not resolvable into a cohesive whole by applying a unifying theory. They forever remain paradoxes, and they demand a new, inclusive way of thinking. Such thinking doesn't resolve

the paradox, but rather allows one to understand the world in terms of the paradox. For example, an electron can behave both like a particle and like a wave at the same time.

Certainly central to Wiley and Nauman was the work of Marcel Duchamp. Duchamp's art activities raised questions about art that were interesting, rather than providing a way to make art. For example, Duchamp's bicycle wheel inverted on a stool or his bottle rack raised a question more fundamental than whether appropriated objects—either altered or unaltered—could be turned into art by their content. These objects, for San Francisco artists, questioned the function of art for the American culture by opposition. Could art be useful, like a tool, or was it something of no conceivable use to society? What gave art its social value and made it worth saving? Duchamp's objects were useful objects or tools that had been turned into "useless" sculptures. Perhaps artists were "spinning their wheels," as they sat on their painting stools making art.

This question was played out in real life when Wiley and Nauman became interested in a small homemade object, possibly a step stool or a chair, in a junk store. It was slanted in such a way that it could not be used for either purpose. Immediately, the question of social value entered into the picture when the artists tried to buy this strange object they called the "slant step." At first, the owner couldn't fix the price. If the slant step was useful, the owner wanted $20, but after the artists showed him it had no conceivable use, the price became 50 cents.

The philosophical ramifications of the slant step were immediately obvious to the Davis group of artists, and they arranged an exhibition around it. A number of artists made works about the step, and these were arranged in the gallery in the traditional way. Somehow, according to Wiley, they didn't "look right" until they were "arranged" in the corner to be pawed through by visitors, much as they might be at a resale shop.

The essence of this gesture was to emphasize the art as useless while the original slant step was displayed in the gallery as if it had value and was useful. Another work, a cement slant step, was displayed outside, chained to the building. The cement slant step was stolen during the show. This chance occurrence again raised the question of the value of art to society.

At the time of the exhibition, critics saw the show as a funky Dada happening, a meaningless spoof by artists—an interpretation quite different from the fundamental question being raised by the artists themselves. Their humor did not mean that the exhibition was only fun and games. Humor was a way to get the viewer to pay attention to serious, moral issues about art.

Wiley and Nauman did not think that the purpose of art was fun and games or, perhaps more accurately, an end game like Marcel Duchamp's chess games. For them, art had to have a moral purpose. Art was not to be about morality, as in the Victorian sense of a picture or story having a moral. Art was not about something; it was that something itself. Nor was art's purpose to create an esthetic object in the Modernist sense. Art should provide a concrete experience for the viewer rather than suggest one through analogy. Art was an experience grounded in daily life in the sense that a guitar was an instrument or tool that directly produced the experience of sound. In this sense, art could be useful and a real tool to investigate life, not just an abstraction like beauty.

Despite the San Francisco artists' rejection of Duchamp's practice of art as a game, they did engage in a type of game—fishing. The difference between fishing and chess is that fishing is useful, unlike chess. The end game is something to eat. Fish were literally game as well as pawns in a game. Nauman's video of William Allan fishing ends when the fish is caught. Wiley, who is an avid fisherman, continues to use fishing imagery in many of his works as metaphors for life's experiences.

Following Nauman's graduation from Davis, he went to teach at the San Francisco Art Institute in 1966. During 1966, Wiley and Nauman, no longer in the teacher-student role, collaborated on several projects, including the aforementioned "Slant Step Show" at Berkeley Gallery in San Francisco, and engaged in a brief correspondence that could be called "Dada mail art" with H. C. Westermann, a sculptor who greatly influenced Chicago artists in the 1950s.[3] Wiley also took the letters from a temporary installation by Nauman, Untitled (*The True Artist is a Luminous Fountain*), and reused them as part of one of his sculptures.

Wiley's energy, teaching style, and open-ended views about art created an atmosphere in the Bay Area that was particularly suited to Nauman's inquiring mind. Wiley, however, was not just known on the West Coast. He had connections in New York, where he had shown regularly since 1962. Similar ideas were developing in New York and Europe. By 1967, New York artists like Eva Hesse, Richard Tuttle, and Robert Morris were making art that was antiform, process-oriented, and conceptual, as opposed to formal, in nature. A number of exhibitions there included Nauman's amorphous objects of the late 1960s. Early conceptual exhibitions in Europe, like *When Attitudes Become Form* (which opened in Bern in 1969), included works by both Nauman and Wiley.

In contrast to Smith and Rickey's generation, who had absorbed European movements like Cubism and Constructivism years after their conception, Wiley's and Nauman's generation was, from the beginning, part of an international movement

that was investigating and rethinking traditional ideas about art in San Francisco, New York, and all over Western Europe. Art magazines, like *Artforum*, founded in San Francisco in 1962, had an international audience. Television sped the transmission of popular culture. Art exhibitions and dance performances traveled more frequently. Artists in smaller cities had opportunities to see art from all over the world almost as soon as it was made. Artists like Smith, who saw their first art, either new or old, only as adults, were increasingly rare. Wiley, for example, was aware even in high school of Arp, Klee, Mark Tobey and other twentieth-century artists; Smith on the other hand had no concept of Picasso in high school. Art in the form of mail art and conceptual sentences provided another almost instantaneous distribution of ideas internationally. High-quality recordings made a wide variety of music available. The most esoteric of books could be obtained in an inexpensive paperback edition. Crisscrossing the continent and the ocean by jet plane became commonplace in the 1960s, allowing artists from California, New York and Europe to know each other personally without extended time away from home.

In the twenty-first century, the transmission of ideas has become even speedier with the Internet, e-mail and CNN news. Exactly how these changes will affect art over the next hundred years we don't know, but perhaps one can say it will be as different and perhaps as unrecognizable as art to artists living in 2100 as Nauman's installations or Wiley's constructions would have been to French artists living during the last of the nineteenth century.

1 Joe Raffaele and Elizabeth Baker, "The Way Out West: Interviews with 4 San Francisco Artists," *ArtNews* 66, no. 8 (Summer 1967), 39.

2 For a lengthy discussion of the relationship of modern physics to various Asian philosophies, see Fritjof Capra's book *Tao of Physics* (Berkeley, Calif.: Shambhala, 1975).

3 Joan Simon, "Catalogue Raisonné," in Neal Benezra et al., *Bruce Nauman* (Minneapolis: Walker Art Center, 1994), 218.

William T. Wiley

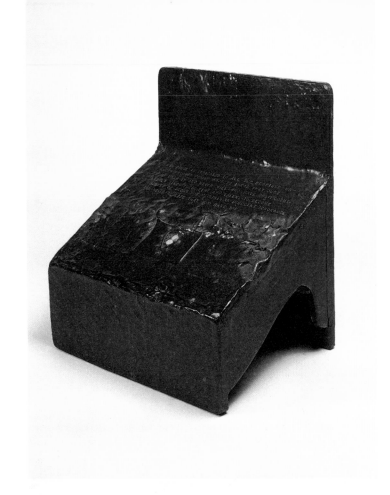

OVERLEAF
ENIGMA DOGGY, 1965-66
WOOD, LEAD, CANVAS, LATEX,
CHAIN, PAINT
23 1/2 X 26 X 6 IN. (IRREGULAR)
C. S. SPROULE

ABOVE RIGHT
SLANT STEP, 1966
LEAD, WOOD, GLASS, ASPIRIN, NAILS
17 X 15 X 11 IN.
INSCRIPTION: THIS PIECE IS DEDICAT-
ED TO ALL THE DESPISED, UNKNOWN,
UNLOVED PEOPLE OBJECTS IDEAS
THAT JUST DON'T MAKE IT AND NEVER
WILL WHO HAVE SO THOUGHT LESSLY
GIVEN THEIR TIME AND TALENT TO
BECOME OBJECTS OF SCORN BUT
MAINTAIN AN INNOCENT IGNORANCE
AND NEVER REALIZE YOU HATE THEM
MR. AND MRS. MATTHEW D. ASHE

RIGHT
*SLANT STEP BECOMES RHINO/RHINO
BECOMES SLANT STEP*, 1966
PLASTER, ACRYLIC, PAINT, CHAIN
22 X 12 X 12 IN.
RON WAGNER AND BONNIE RUDER

OPPOSITE
BEATNIK METEOR, 1970
WOODEN BOX WITH FOUND OBJECTS
AND STUDIO DUST
24 1/2 X 22 X 18 IN.
THE DI ROSA PRESERVE

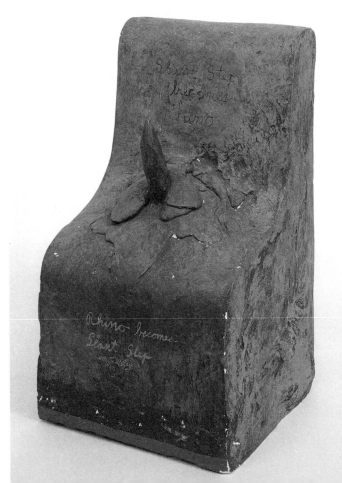

MICHAEL ROW THE BOTHA SOUL, 1987
WATERCOLOR ON PAPER, 30 X 22 IN.
COLLECTION OF ETHAN WILEY

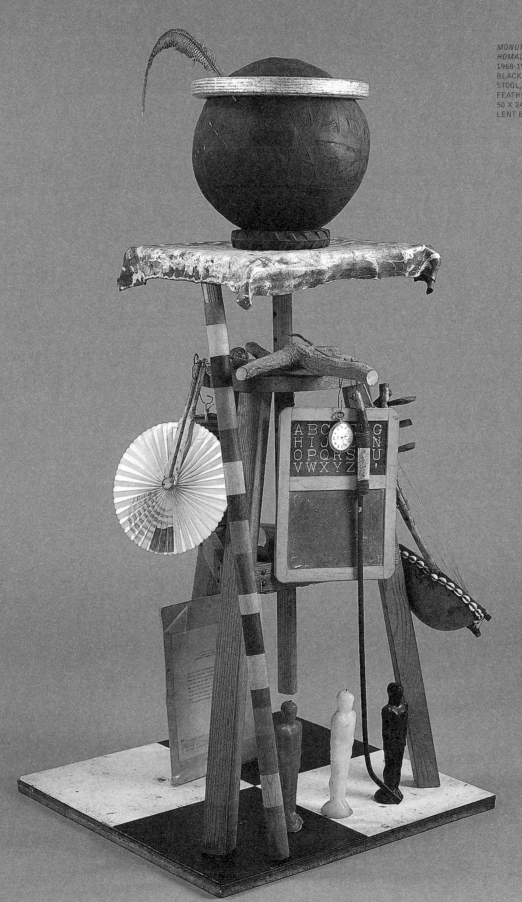

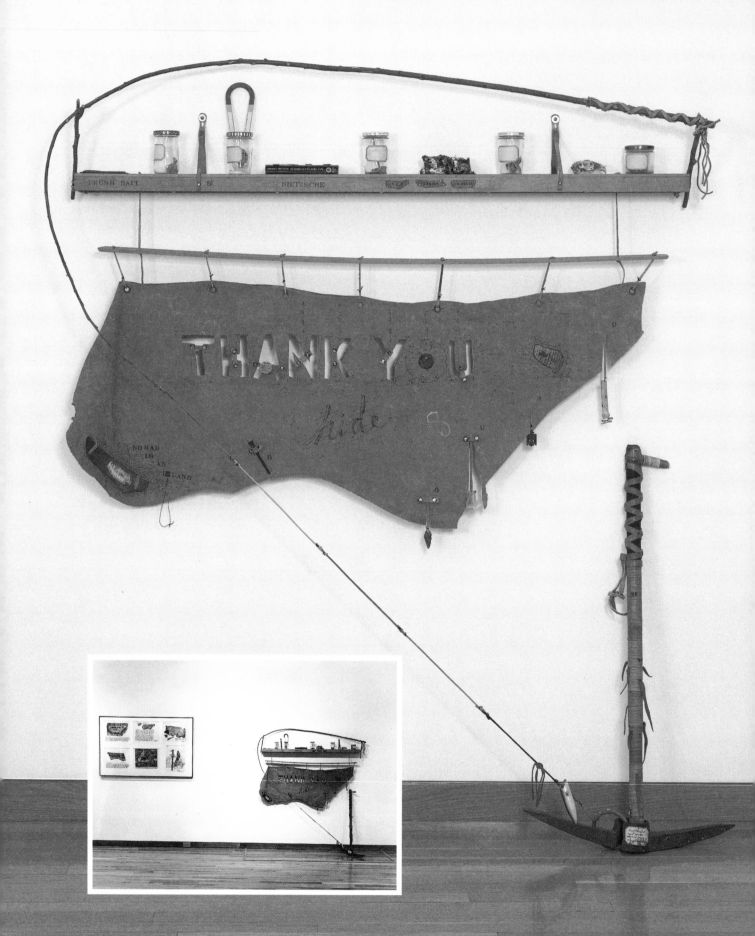

B.L.O.T., 1977
MIXED MEDIA CONSTRUCTION, 11 X 13 X 12 IN.
DIANA BURGESS FULLER

OPPOSITE
THANK YOU HIDE, 1970-71 (DETAIL, ENTIRE INSTALLATION SHOWN IN INSET)
WOOD, LEATHER, INK AND CHARCOAL ON COWHIDE, WITH PICKAXE, FOUND OBJECTS,
AND SIX WATERCOLOR-ON-PAPER DRAWINGS, 74 X 160 1/2 IN.
PURCHASED WITH FUNDS FROM THE COFFIN FINE ARTS TRUST;
NATHAN EMORY COLLECTION OF THE DES MOINES ART CENTER, 1977.9

STUDEASE FOR POST OOWII (MR.
UNATURAL CONFRONTSELF), 1975
WATERCOLOR, COLORED PENCIL, CHAR-
COAL AND WAX ON PAPER
24 1/2 X 36 IN.
COLLECTION OF LOUIS A. HERMES

MR. UNATURAL TAKES A BOW, 1975/76
WATERCOLOR ON PAPER
21 1/2 X 30 IN.
COLLECTION OF GLENN M.
BUCKSBAUM

OPPOSITE
NOMAD IS AN ISLAND, 1981
WOOD, COR-TEN STEEL, STAINLESS
STEEL, COPPER, LEAD, PAINT
114 X 216 X 240 IN.
WILLIAM T. WILEY, COURTESY L.A.
LOUVER, VENICE, CALIF.

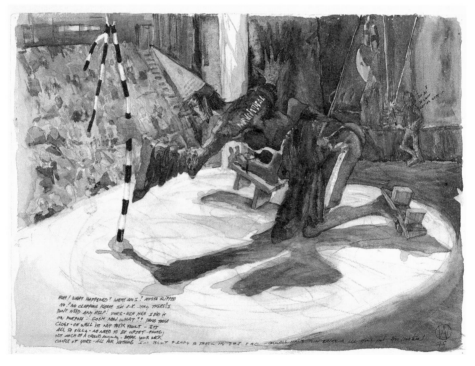

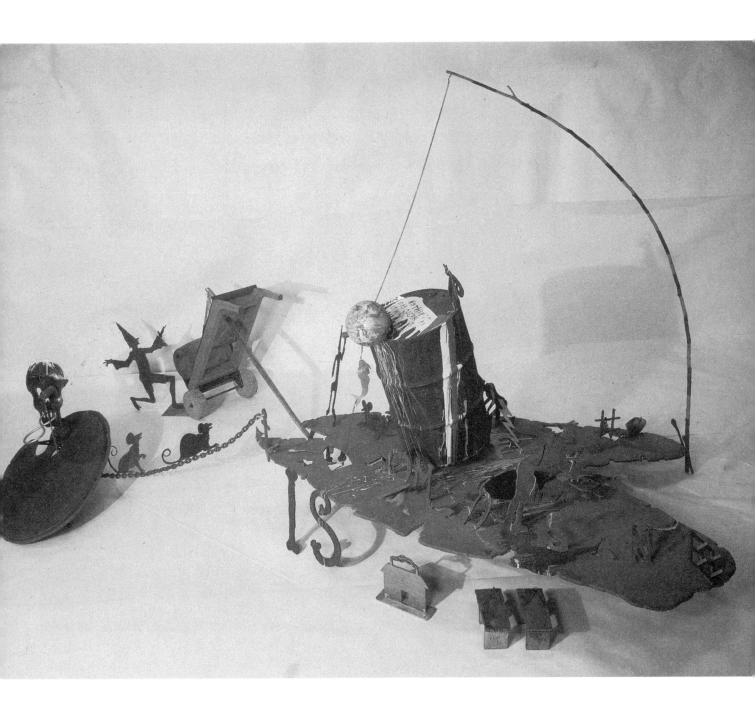

THE ANVIL, 1992
ACRYLIC AND CHARCOAL ON CANVAS, 28 1/2 X 32 1/4 IN.
WILLIAM T. WILEY, COURTESY MORGAN GALLERY, KANSAS CITY, MO.

OPPOSITE
O. T. P. A. G. FOR E. T. S. , 1982
CERAMIC, STEEL, PAINT, BRASS
105 X 53 X 23 IN.
COLLECTION: STEPHANE JANSSEN, ARIZONA

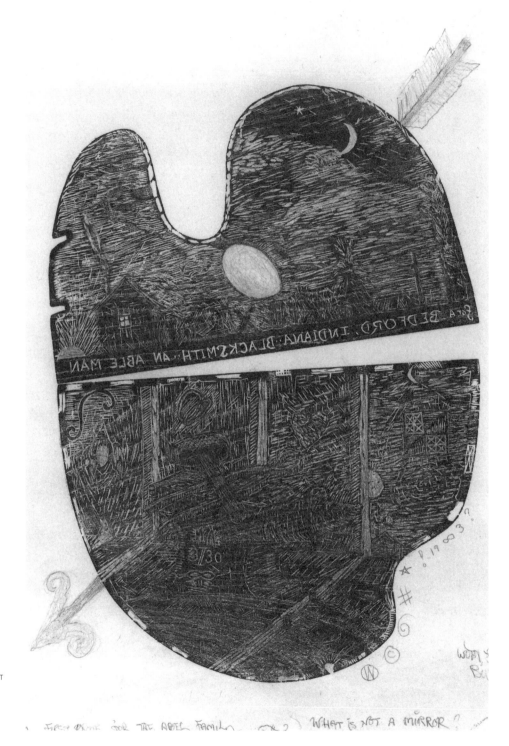

TO THE BRIDGE (FOR GRANDFATHER ABEL AND HIS CHILDREN), 1987
HAND-COLORED WOODCUT ON PAPER,
29 X 20 1/4 IN.
COLLECTION GENE ABEL

OPPOSITE
THE ANVIL, 1988
BRONZE, STEEL, BRASS, COPPER,
LEAD, NICKEL, WOOD
41 X 32 X 11 IN.; BASE: 33 1/2 X ABOUT
23 IN. DIAMETER
INDIANA UNIVERSITY ART MUSEUM
GIVEN IN HONOR OF TOM AND ELLEN
EHRLICH BY THE I.U. FOUNDATION
BOARD OF DIRECTORS

CORNER GONG, 1998
PLUM WOOD, CANVAS, GLASS CONE,
SAKI JUG, CATCHER'S MITT, WIRE,
HAMMER
33 X 8 X 24 IN. (APPROXIMATELY)
WILLIAM T. WILEY, COURTESY LOCKS
GALLERY, PHILADELPHIA, PENN.

OPPOSITE
THE GOOD AND THE GRUBBY, 1985
WATERCOLOR ON PAPER
30 1/4 X 22 1/2 IN.
COLLECTION OF MR. AND MRS.
GRAHAM GUND

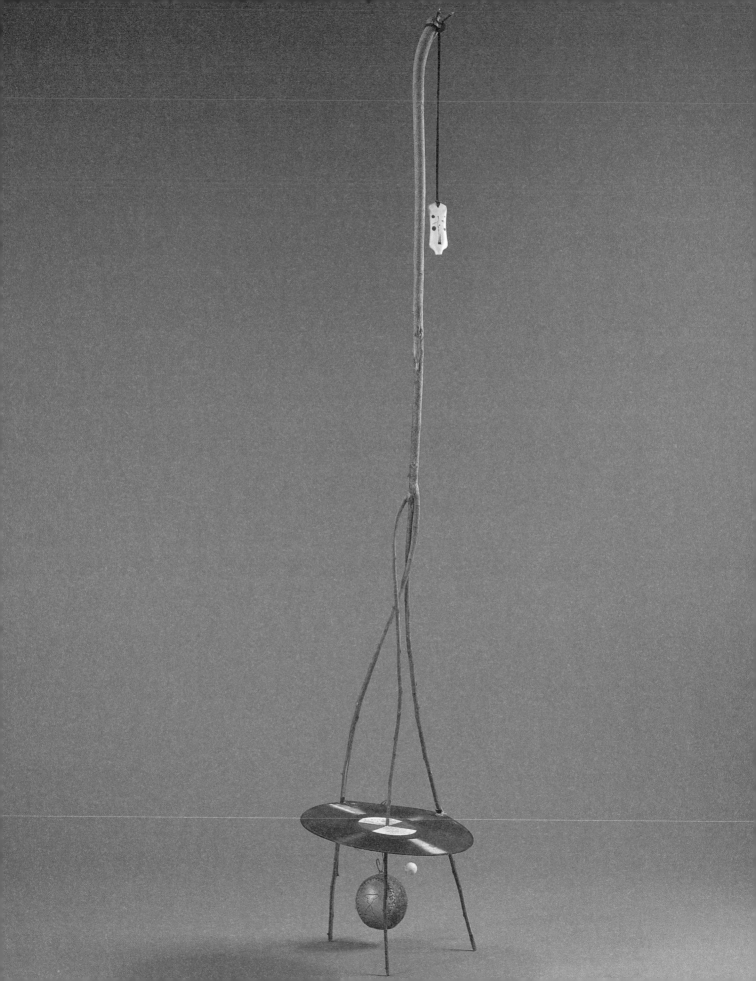

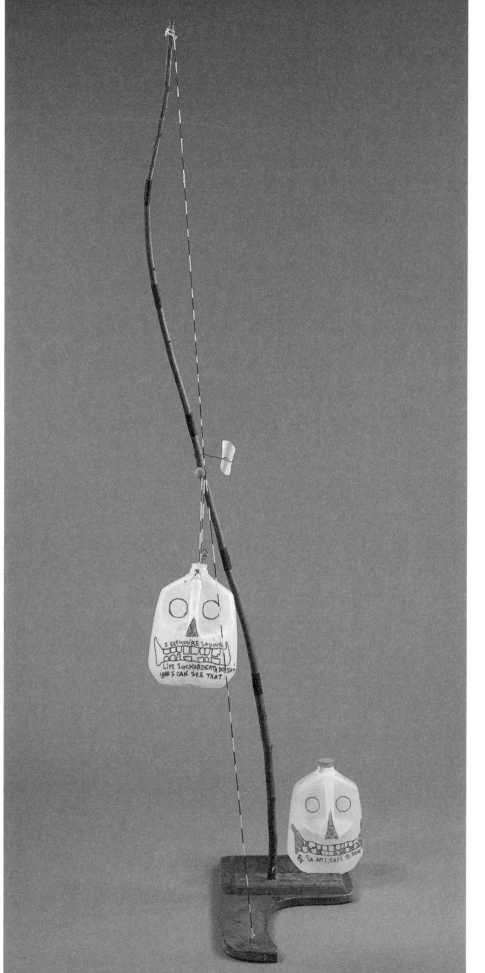

ONE DESK BASE, 1998
PLUM WOOD, STRING, PLASTIC WATER
JUG, WIRE, CORK, WOODEN DESK TOP
73 X 24 X 12 IN.
WILLIAM T. WILEY, COURTESY RENA
BRANSTEN, SAN FRANCISCO, CALIF.

OPPOSITE
FLUTE FOR A.G., 1998
PLUM WOOD, VINYL RECORD, CORK
SOFTBALL, WIRE, PORCELAIN FLUTE
62 X 13 X 13 IN.
WILLIAM T. WILEY, COURTESY MARSHA
MATEYKA, WASHINGTON, D.C.

Bruce Nauman

OVERLEAF
UNTITLED, 1965
FIBER GLASS, POLYESTER RESIN, 84 X 3 1/2 X 1 1/2 IN.
COURTESY CHRISTOPHE VAN DE WEGHE FINE ART
©2000 BRUCE NAUMAN/ARTISTS RIGHTS SOCIETY (ARS), NEW YORK

ABOVE
*PLAN FOR AN OBJECT TO BE MADE OF FOLDED CARDSTOCK OR SHEET METAL - TIN ALUMINUM
GALVANIZED IRON OR WHATNOT -*, 1965
GRAPHITE ON PAPER, 11 X 8 1/2 IN.
COLLECTION ELISABETH CUNNICK AND PETER FREEMAN, NEW YORK
©2000 BRUCE NAUMAN/ARTISTS RIGHTS SOCIETY (ARS), NEW YORK

ABOVE LEFT
DRAWING OF A MODEL OF A PLASTIC ROOM WITH A RUBBER WALLPIECE, 1966
COAL ON PAPER (VERSO) , 24 X 19 IN.
EMANUEL HOFFMANN FOUNDATION, PERMANENT LOAN
TO THE KUPFERSTICHKABINETT BASEL, SWITZERLAND
©2000 BRUCE NAUMAN/ARTISTS RIGHTS SOCIETY (ARS), NEW YORK

ABOVE RIGHT
STUDY FOR A RUBBER SCULPTURE, ABOUT 1966
PENCIL ON PAPER, 22 X 18 1/8 IN.
EMANUEL HOFFMANN FOUNDATION, PERMANENT LOAN
TO THE KUPFERSTICHKABINETT BASEL, SWITZERLAND
©2000 BRUCE NAUMAN/ARTISTS RIGHTS SOCIETY (ARS), NEW YORK

Bruce Nauman 66

the original slant-step
wood and linoleum

ABOVE LEFT
STUDY FOR "SLANT STEP," 1966
PENCIL ON PAPER, 24 X 18 IN.
EMANUEL HOFFMANN FOUNDATION, PERMANENT LOAN
TO THE KUPFERSTICHKABINETT BASEL, SWITZERLAND
©2000 BRUCE NAUMAN/ARTISTS RIGHTS SOCIETY (ARS), NEW YORK

ABOVE RIGHT
THE ORIGINAL SLANT-STEP/WOOD AND LINOLEUM, 1966
PASTEL AND PENCIL ON PAPER, 22 X 18 1/4 IN.
EMANUEL HOFFMANN FOUNDATION, PERMANENT LOAN
TO THE KUPFERSTICHKABINETT BASEL, SWITZERLAND
©2000 BRUCE NAUMAN/ARTISTS RIGHTS SOCIETY (ARS), NEW YORK

OPPOSITE
MOLD FOR A MODERNIZED SLANT STEP, 1966
PLASTER, 22 X 17 X 12 IN.
COLLECTION MUSEUM OF CONTEMPORARY ART, CHICAGO, GERALD S. ELLIOTT COLLECTION
©2000 BRUCE NAUMAN/ARTISTS RIGHTS SOCIETY (ARS), NEW YORK

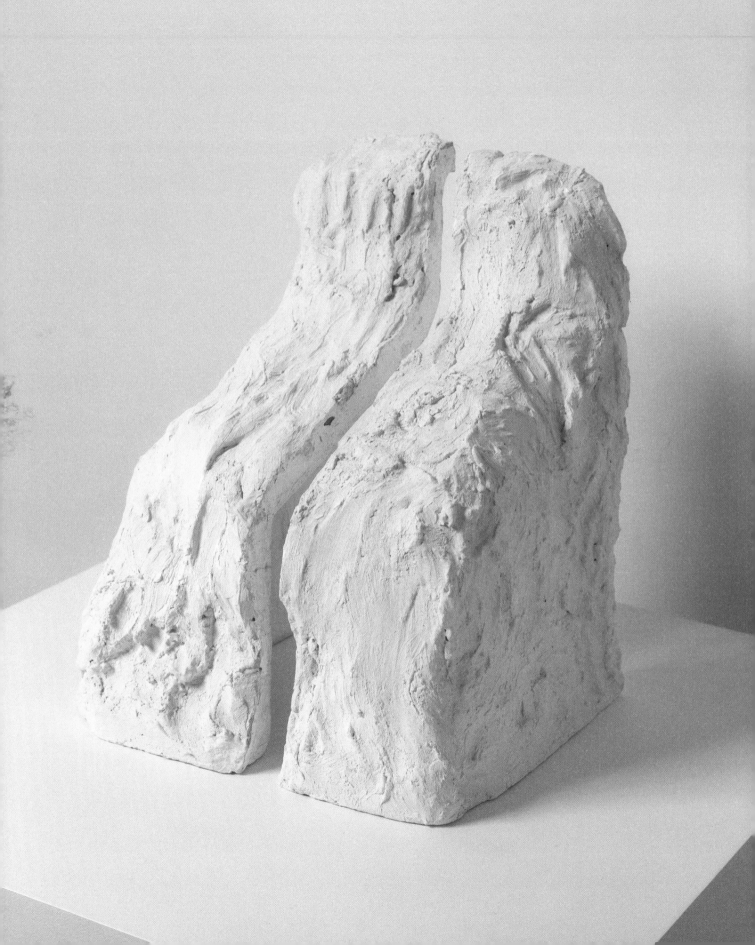

DRILL TEAM
FROM THE PORTFOLIO *ELEVEN COLOR PHOTOGRAPHS*, 1966-67
EXHIBITION COPY, 20 X 23 7/8 IN.
COLLECTION MUSEUM OF CONTEMPORARY ART, CHICAGO, GERALD S. ELLIOTT COLLECTION
©2000 BRUCE NAUMAN/ARTISTS RIGHTS SOCIETY (ARS), NEW YORK

*LETTER TO BILL ALLAN: THREE WELL-
KNOWN KNOTS (SQUARE KNOT, BOW-
LINE AND CLOVE HITCH)*, 1967
THREE COLOR PHOTOGRAPHS AND
ONE ENVELOPE
1 3/4 X 3 IN. EACH (APPROXIMATELY)
WILLIAM GEORGE ALLAN PAPERS,
ARCHIVES OF AMERICAN ART, SMITH-
SONIAN INSTITUTION
©2000 BRUCE NAUMAN/ARTISTS
RIGHTS SOCIETY (ARS), NEW YORK

OPPOSITE
HENRY MOORE BOUND TO FAIL,
1967/1970
CAST IRON, 25 1/2 X 24 X 2 1/2 IN.
COLLECTION OF MR. AND MRS. RONALD
K. GREENBERG, ST. LOUIS
COURTESY GREENBERG VAN DOREN
GALLERY
©2000 BRUCE NAUMAN/ARTISTS
RIGHTS SOCIETY (ARS), NEW YORK

FLESH TO WHITE TO BLACK TO FLESH, 1968
VIDEOTAPE, BLACK AND WHITE, SOUND
60 MIN., REPEATED CONTINUOUSLY
COURTESY OF ELECTRONIC ARTS INTERMIX, NEW YORK
©2000 BRUCE NAUMAN/ARTISTS RIGHTS SOCIETY (ARS), NEW YORK

PACING UPSIDE DOWN, 1969
VIDEOTAPE, BLACK AND WHITE, SOUND
60 MIN., REPEATED CONTINUOUSLY
COURTESY OF ELECTRONIC ARTS INTERMIX, NEW YORK
©2000 BRUCE NAUMAN/ARTISTS RIGHTS SOCIETY (ARS), NEW YORK

THE · TRUE · ARTIST · IS · AN · AMAZING · LUMINOUS · FOUNTAIN

design for around the edges of a window ... in well B
true proportions.

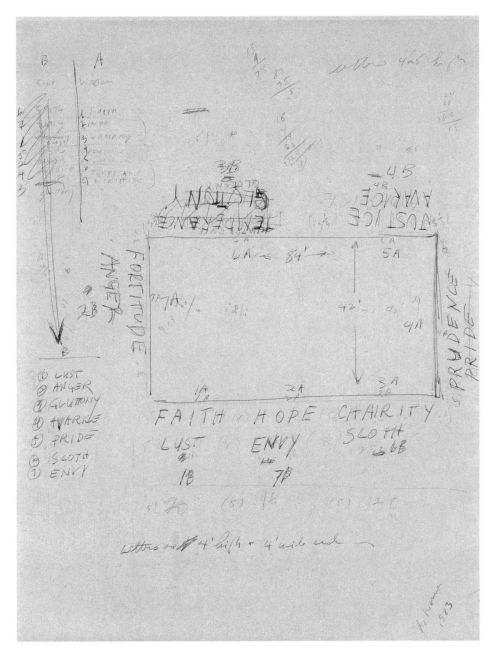

*STUDY FOR "SEVEN VIRTUES AND
SEVEN VICES,"* 1983
PEN AND INK AND GRAPHITE ON
PAPER, 30 X 24 IN.
COLLECTION ELISABETH CUNNICK AND
PETER FREEMAN, NEW YORK
©2000 BRUCE NAUMAN/ARTISTS
RIGHTS SOCIETY (ARS), NEW YORK

OPPOSITE
*THE TRUE ARTIST IS AN AMAZING
LUMINOUS FOUNTAIN,* 1966
PENCIL AND INK ON PAPER
24 X 19 IN.
PRIVATE COLLECTION, COURTESY OF
SONNABEND GALLERY
©2000 BRUCE NAUMAN/ARTISTS
RIGHTS SOCIETY (ARS), NEW YORK

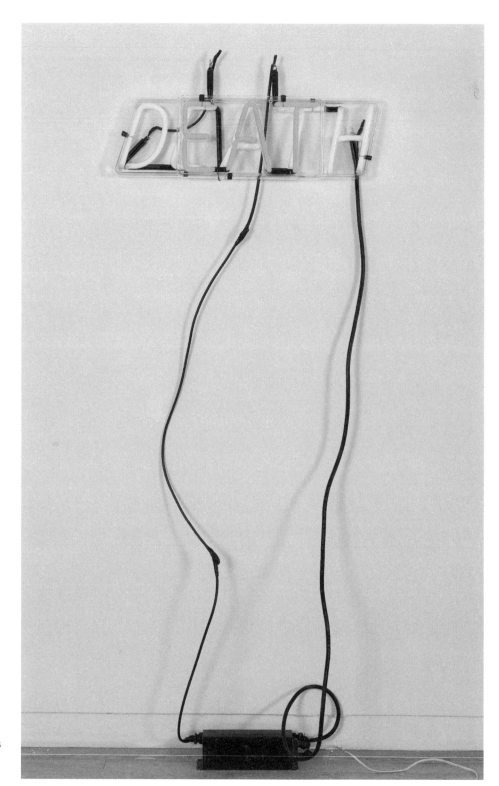

EAT/DEATH, 1972
NEON TUBING WITH CLEAR GLASS
TUBING SUSPENSION FRAME
7 1/2 X 25 1/4 X 2 1/8 IN., EDITION 2/6
PRIVATE COLLECTION, COURTESY OF
SONNABEND GALLERY
©2000 BRUCE NAUMAN/ARTISTS
RIGHTS SOCIETY (ARS), NEW YORK

FOX WHEEL, 1990
ALUMINUM
15 X 71 X 72 IN.
MUSEUM MODERNER KUNST STIFTUNG
LUDWIG, VIENNA, AUSTRIA
©2000 BRUCE NAUMAN/ARTISTS
RIGHTS SOCIETY (ARS), NEW YORK

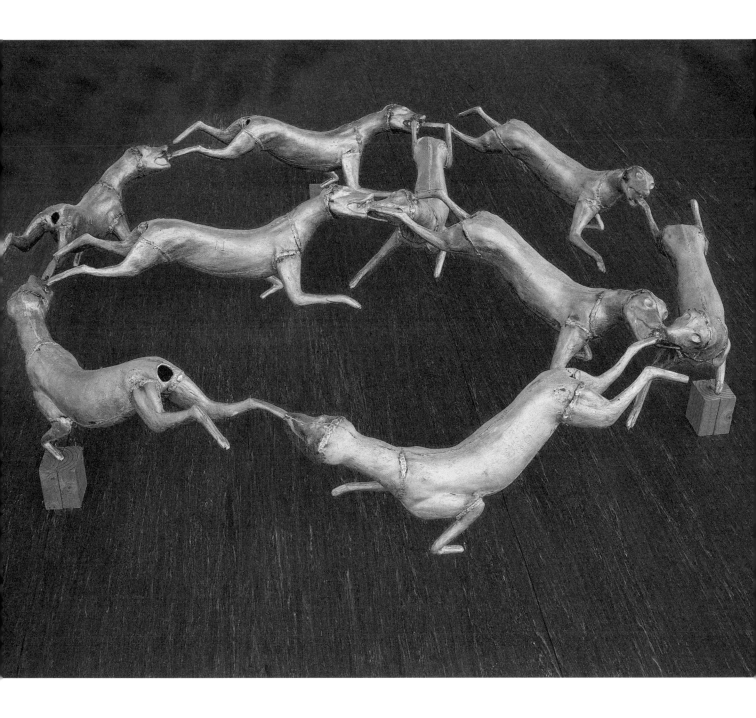

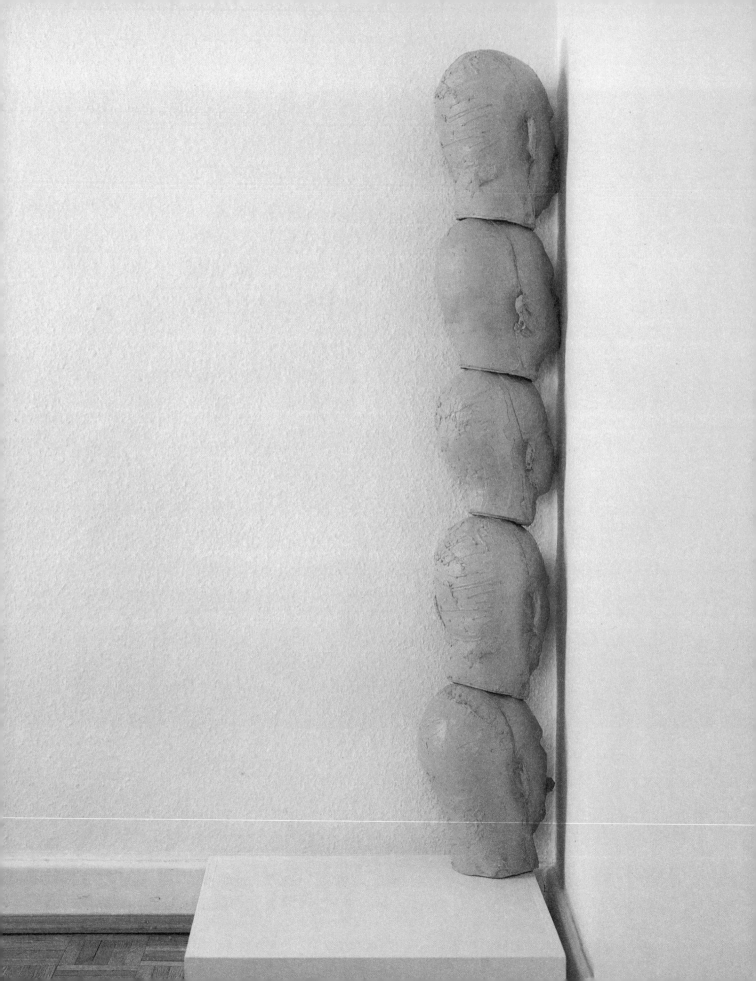

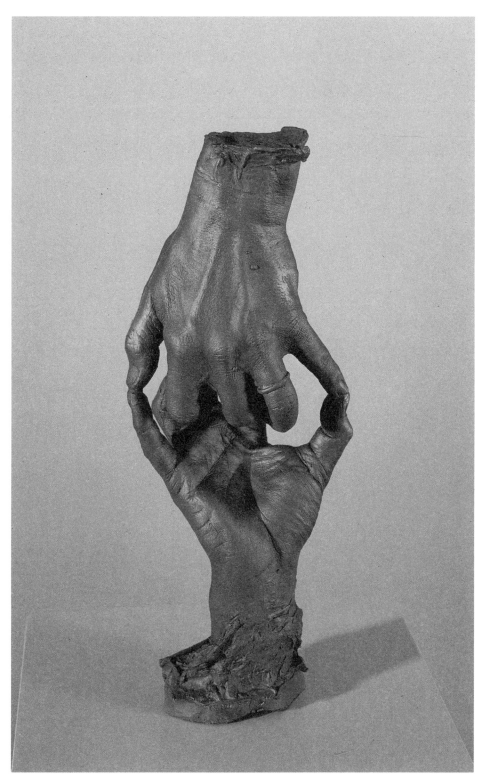

UNTITLED (PAIR OF HANDS), 1996
EDITION OF 2, WHITE BRONZE
14 3/4 X 6 X 3 3/4 IN.; ON BASE, 39 IN.
(APPROXIMATELY)
COURTESY DONALD YOUNG GALLERY,
CHICAGO
©2000 BRUCE NAUMAN/ARTISTS
RIGHTS SOCIETY (ARS), NEW YORK

OPPOSITE
FIVE PINK HEADS IN THE CORNER,
1992
EPOXY RESIN, FIBER-GLASS CLOTH
50 X 8 1/2 X 7 1/2 IN.
RALPH AND PEGGY BURNET, WAYZATA,
MINNESOTA
©2000 BRUCE NAUMAN/ARTISTS
RIGHTS SOCIETY (ARS), NEW YORK

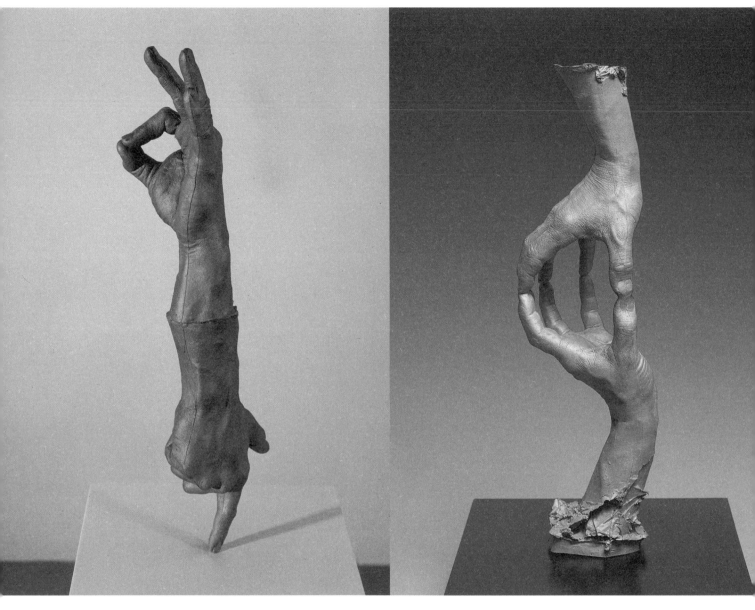

LEFT
UNTITLED (PAIR OF HANDS), 1996
EDITION OF 2, WHITE BRONZE, 19 1/4 X 6 X 4 1/2 IN.
DONALD YOUNG
©2000 BRUCE NAUMAN/ARTISTS RIGHTS SOCIETY (ARS), NEW YORK

RIGHT
UNTITLED (PAIR OF HANDS), 1996
CAST WHITE BRONZE, 21 X 14 X 8 IN. (APPROXIMATELY)
MARTIN ZIMMERMAN
©2000 BRUCE NAUMAN/ARTISTS RIGHTS SOCIETY (ARS), NEW YORK

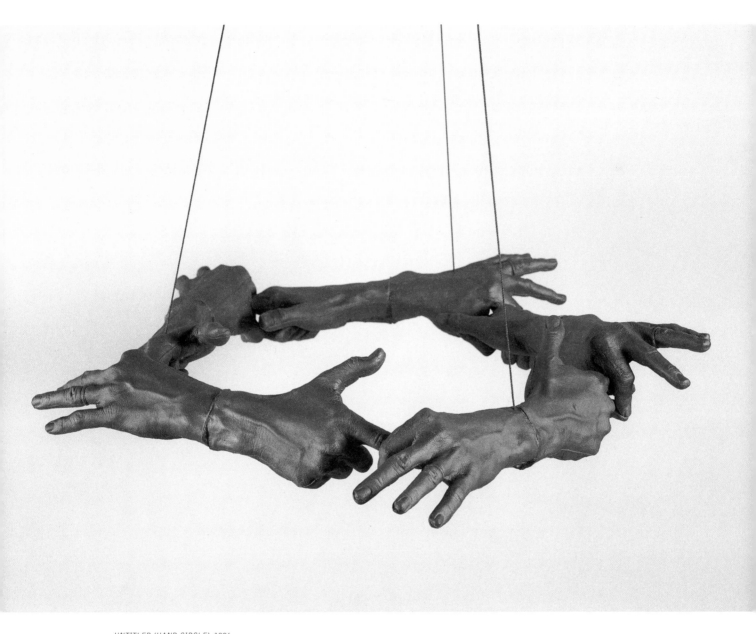

UNTITLED (HAND CIRCLE), 1996
CAST PHOSPHOR BRONZE, SILVER SOLDER, COPPER, BRONZE WIRE AND STEEL, 5 X 26 1/2 X 25 IN.
INDIANAPOLIS MUSEUM OF ART, HENRY F. AND KATHERINE DEBOEST MEMORIAL FUND AND
MR. AND MRS. RICHARD CRANE FUND
1996.248
©2000 BRUCE NAUMAN/ARTISTS RIGHTS SOCIETY (ARS), NEW YORK

NOTE: THE FOLLOWING WORKS BY BRUCE NAUMAN ARE IN THE EXHIBITION BUT DO NOT APPEAR IN THIS CATALOGUE.

AMAZING FOUNTAIN (PORTUGUESE), 1998
VIDEO DISC ON A SINGLE MONITOR
COLLECTION OF THE ARTIST, COURTESY SPERONE WESTWATER GALLERY

UNTITLED, 1993
GRAPHITE ON PAPER
22 X 30 IN.
COLLECTION OF JUDY NEISSER

GROUP EXHIBITIONS

1951 The Metropolitan Museum of Art, New York, N.Y. *American Sculpture 1951.* December 7, 1951, through January 24, 1952. Rickey, Smith.

1952 Whitney Museum of American Art, New York, N.Y. *Annual Exhibition of Contemporary American Sculpture and Drawing.* March 13 through May 4. Catalogue. Rickey, Smith.

1953 Whitney Museum of American Art, New York, N.Y. *Annual Exhibition of Contemporary American Sculpture, Watercolors and Drawings.* April 9 through May 29. Rickey, Smith.

1954 Pennsylvania Academy of Fine Arts, Philadelphia, Pa. *One Hundred and Forty-Ninth Annual Exhibition of Painting and Sculpture.* January 24 through February 28. Rickey, Smith.

1955 The University Gallery, University of Minnesota, Minneapolis, Minn. *A Selection of Contemporary American Sculpture.* September 30 through November 4. Rickey, Smith.

1959 The Museum of Modern Art, New York, N.Y. *Recent Sculpture USA.* May 13 through August 8. Traveled to Denver Art Museum, Denver, Colo., October 12 through November 11; The Art Center, Tucson, Ariz., December 5, 1959, through January 10, 1960; Los Angeles County Museum of Art, Los Angeles, Calif., February 22, 1960, through April 3, 1960; City Art Museum of St. Louis, St. Louis, Mo., May 3, 1960, through June 12, 1960; Museum of Fine Arts, Boston, Mass., September 14 through October 16, 1960. Chamberlain, Rickey, Smith.

1960 Martha Jackson Gallery, New York, N.Y. *New Forms - New Media I & II.* June. Catalogue. Chamberlain, Indiana.

 Whitney Museum of American Art, New York, N.Y. *Annual Exhibition of Contemporary American Sculpture and Drawings.* December 7, 1960, through January 22, 1961. Catalogue. Chamberlain, Smith.

1961 The Museum of Modern Art, New York, N.Y. *The Art of Assemblage.* October 2 through November 12. Catalogue. Chamberlain, Indiana, Smith.

 The New School for Social Research, Art Center, New York, N.Y. *Mechanism and Organism-An International Sculpture Exhibition.* October 5 through 27. Rickey, Smith.

 Carnegie Institute, Pittsburgh, Pa. *Pittsburgh International Exhibition.* October 27, 1961, through January 7, 1962. Chamberlain, Smith.

1962 Pavilion of the Arts, Seattle World's Fair, Seattle, Wash. *Art Since 1950: American and International.* April 21 to October 21. Catalogue. Traveled as *American Art since 1950* (in two parts) to Rose Art Museum, Brandeis University, Waltham, Mass., and The Institute of Contemporary Art, Boston, Mass., November 21 through December 23. Catalogue. Chamberlain, Smith.

 The Solomon R. Guggenheim Museum, New York, N.Y. *Modern Sculpture from the Joseph H. Hirshhorn Collection.* October 3, 1962, through January 6, 1963. Catalogue. Chamberlain, Smith.

Dwan Gallery, Los Angeles, Calif. *My Country Tis of Thee*. November 18 through December 15. Catalogue. Chamberlain, Indiana.

Whitney Museum of American Art, New York, N.Y. *Annual Exhibition 1962: Contemporary Sculpture and Drawings*. December 12, 1962, through February 3, 1963. Catalogue. Chamberlain, Smith.

1963 The Tate Gallery, London, England. *Painting and Sculpture of a Decade*. Chamberlain, Indiana.

The Art Institute of Chicago, Chicago, Ill. *66th Annual American Exhibition: Directions in Contemporary Painting and Sculpture*. January 11 through February 10. Catalogue. Indiana, Smith.

Battersea Park, London, England. *Sculpture in the Open Air*. May 29 through September 29. Organized by the London County Council. Catalogue. Chamberlain, Rickey, Smith.

Washington Gallery of Modern Art, Washington, D.C. *Sculptors of Our Time*. September 17 through October 10. Catalogue. Chamberlain, Smith.

1964 Tate Gallery, Gublenkian Foundation, London, England. *54-64, Painting and Sculpture of a Decade*. April 22 through June 28. Catalogue. Chamberlain, Indiana, Smith.

Alte Galerie, Museum Fridericianum, Orangerie, Kassel, Germany. *Documenta III*. June 27 through October 5. Catalogue. Rickey, Smith.

Whitney Museum of American Art, New York, N.Y. *Annual Exhibition of Contemporary American Sculpture*. December 9, 1964, through January 31, 1965. Catalogue. Chamberlain, Indiana, Smith.

1965 Embassy of the U.S.A., Mexico City, Mexico. *Art in Embassies*. Traveling exhibition of the Museum of Modern Art, New York. Chamberlain, Smith.

Musée Rodin, Paris. *Etats-Unis: sculptures du XXe siècle*. June 22 through October 16. Organized by The International Council of The Museum of Modern Art, New York, N.Y. Catalogue. Traveled as *Amerikanische Plastik-U.S.A. 20 Jahrhundert* to Hochschule für Bildende Künste, Berlin, Germany, November 20, 1965, through January 9, 1966; Staatliche Kunsthalle, Baden-Baden, Germany, mid-March through mid-April. Catalogue. Chamberlain, Rickey, Smith.

Institute of Contemporary Art, University of Pennsylvania, Philadelphia, Pa. *Seven Sculptors*. December 1, 1965, through January 17, 1966. Catalogue. Chamberlain, Smith.

1966 Joint Exhibition of the Public Education Association, New York, N.Y. *Seven Decades 1895-1965: Crosscurrents in Modern Art*. April 26 through May 21. Chamberlain, Rickey, Smith.

Whitney Museum of American Art, New York, N.Y. *Art of the United States: 1670-1966*. September 28 through November 27. Catalogue. Chamberlain, Smith.

Ball State University Art Gallery, Muncie, Ind. *150 Years of Indiana Art*. October 9

through December 31. Catalogue. Indiana, Smith.

Herron Museum of Art, Indianapolis, Ind. *Painting and Sculpture Today.* December 13, 1966, through February 4, 1967. Catalogue. Indiana, Wiley.

Whitney Museum of American Art, New York, N.Y. *Annual Exhibition of Contemporary American Sculpture and Prints.* December 16, 1966, through February 5, 1967. Catalogue. Chamberlain, Indiana, Rickey, Smith, Wiley.

1967 Carnegie Institute, Pittsburgh, Pa. *The 1967 Pittsburgh International Exhibition of Contemporary Painting and Sculpture.* Catalogue. Chamberlain, Indiana, Rickey, Wiley.

Whitney Museum of American Art, New York, N.Y. *Annual Exhibition of Contemporary Painting.* Indiana, Wiley.

Los Angeles County Museum of Art, Los Angeles, Calif. *American Sculpture of the Sixties.* April 28 through June 25. Catalogue. Traveled to Philadelphia Museum of Art, Philadelphia, Pa., September 15 through October 29. Chamberlain, Nauman, Rickey, Smith, Wiley.

The Art Institute of Chicago, Chicago, Ill. *Sculpture: A Generation of Innovation.* June 23 through August 27. Catalogue. Chamberlain, Smith.

Solomon R. Guggenheim Museum, New York, N.Y. *Guggenheim International Exhibition 1967: Sculpture from Twenty Nations.* October 27, 1967, through February 4, 1968. Catalogue. Traveled to Art Gallery of Toronto, Ontario, Canada, February 24 through March 27; The National Gallery of Canada, Ottawa, Canada, April 26 through June 9; Montreal Museum of Fine Arts, Montreal, Canada, June 20 through August 18. Chamberlain, Rickey, Smith.

1968 Whitney Museum of American Art, New York, N.Y. *Annual Exhibition of Contemporary American Sculpture.* Chamberlain, Rickey, Wiley.

National Collection of Fine Arts, Smithsonian Institution, Washington, D.C. *Opening Exhibition.* May 1 through August. Rickey, Smith.

Galerie-Verein München, Neue Pinakothek, Haus der Kunst, Munich, Germany.

Sammlung 1968 Karl Ströher. June 14 through August 9. Catalogue. Traveled to Neue Nationalgalerie, Berlin, Germany. Chamberlain, Indiana.

Galerie Schöne Aussicht, Museum Fridericianum, Orangerie, Kassel, Germany. *Documenta IV.* June 27 through October 6. Catalogue. Indiana, Nauman, Rickey, Smith.

American Federation of Arts, New York, N.Y. *Soft Sculpture.* Traveled to Georgia Museum of Art, University of Georgia, Athens, Ga., October 6 through November 3; State University of New York, College of Oswego, N.Y., November 24 through December 22; Cedar Rapids Art Center, Cedar Rapids, Ia., January 12, 1970, through February 9; Michigan State University, East Lansing, Mich., March 2 through 30; Andrew Dickinson White Museum of Art, Cornell University, Ithaca, N.Y., April 20 through May 18. Chamberlain, Nauman.

1969 Denver Art Museum, Denver, Colo. *An American Report on the Sixties.* Chamberlain, Rickey.

The Museum of Modern Art, New York, N.Y. *New Media, New Methods.* Chamberlain, Nauman.

Berkeley Gallery, San Francisco, Calif. *Repair Show*. March. Nauman, Wiley.

Neue Nationalgalerie, Berlin, Germany. *Sammlung 1968 Karl Ströher*. March 1 through April 14. Catalogue. Chamberlain, Indiana.

Kunsthalle Bern, Bern, Switzerland. *When Attitudes Become Form: Works - Concepts - Processes - Situations - Information*. March 22 to April 27. Catalogue. Traveled to Kresfeld, Germany, May 9 through June 15; Institute of Contemporary Arts, London, England, September 28 through October 27. Nauman, Wiley.

Whitney Museum of American Art, New York, N.Y. *Contemporary American Sculpture: Selection 2*. April 15 through May 5. Catalogue. Chamberlain, Indiana.

Dayton's Gallery 12, Minneapolis, Minn. *Castelli at Dayton's*. April 19 through May 17. Catalogue. Chamberlain, Nauman.

The Metropolitan Museum of Art, New York, N.Y. *New York Painting and Sculpture, 1940-1970*. October 18, 1969, through February 1, 1970. Catalogue. Chamberlain, Smith.

Fort Worth Art Center Museum, Fort Worth, Tex. *Drawings*. October 28 through November 30. Catalogue. Nauman, Wiley.

Stedelijk Van Abbe Museum, Eindhoven, Netherlands. *Kompas IV: Westkus USA/West Coast USA*. November 21, 1969, through January 4, 1970. Catalogue. Nauman, Wiley.

Leo Castelli Gallery, 4 East 77th Street, New York, N.Y. *Benefit Exhibition: Art for the Moratorium*. December 11 through 13. Chamberlain, Nauman.

1970 Institute of Contemporary Art, University of Pennsylvania, Philadelphia, Pa. *The Highway: An Exhibition*. January 14 through February 25. Catalogue. Traveled to Institute for the Arts, Rice University, Houston, Tex., March 12 through May 18; The Akron Art Institute, Akron, Ohio, June 5 through July 26. Chamberlain, Nauman.

Joslyn Art Museum, Omaha, Nebr. *Looking West 1970*. October 18 through November 29. Catalogue. Nauman, Wiley.

Indiana University Art Museum, Indiana University, Bloomington, Ind. *Noguchi, Rickey, Smith*. November 18 through December 13. Catalogue. Rickey, Smith.

Whitney Museum of American Art, New York, N.Y. *Sculpture Annual*. December 12, 1970, through February 7, 1971. Catalogue. Chamberlain, Nauman, Rickey.

1971 Städtische Kunsthalle, Düsseldorf, Germany. *Prospect 71*. Chamberlain, Nauman.

Openluchtmuseum, Middle Heim, Antwerp, Belgium. *11e Biennale Antwerpen*. June 6 through October 3. Catalogue. Rickey, Smith.

The Institute of Contemporary Art, Boston, Mass. *Monumental Sculpture for Public Spaces*. Catalogue. Indiana, Rickey.

Los Angeles County Museum of Art, Los Angeles, Calif. *Art and Technology*. May 1 through August 29. Catalogue. Chamberlain, Nauman.

1972 Indianapolis Museum of Art, Indianapolis, Ind. *Painting and Sculpture Today*. Chamberlain, Indiana, Wiley.

Museum Fridericianum, Kassel, Germany. *Documenta V.* June 30 through October 8. Catalogue. Nauman, Smith, Wiley.

1973 Leo Castelli Gallery, New York, N.Y. *Video Tapes by Gallery Artists.* September 28 through October 27. Chamberlain, Nauman.

1974 Hirshhorn Museum and Sculpture Garden, Smithsonian Institution, Washington D.C. *Inaugural Exhibition.* Catalogue. Chamberlain, Indiana.

Leo Castelli Gallery, New York, N.Y. *Group Drawing Exhibition.* February 16 through March 2. Chamberlain, Nauman.

De Saisset Art Museum, University of Santa Clara, Santa Clara, Calif. *Videotapes: Six from Castelli.* March 12 through April 28. Chamberlain, Nauman.

The Contemporary Arts Center, Cincinnati, Ohio. *The Ponderosa Collection.* May 3 through June 24. Chamberlain, Nauman.

Indianapolis Museum of Art, Indianapolis, Ind. *Painting and Sculpture Today.* May 22 through July 14. Catalogue. Indiana, Nauman.

John F. Kennedy Center for the Performing Arts, Washington D.C. *Art Now 74: A Celebration of American Arts.* May 30 through June 16. Catalogue. Nauman, Wiley.

Newport, R.I. *Monumenta: A Biennial Exhibition of Outdoor Sculpture.* August 17 through October 13. Catalogue. Rickey, Smith.

1975 Leo Castelli Gallery, New York, N.Y. *Summer Group Show.* June 7 through September 5. Chamberlain, Nauman.

National Collection of Fine Arts, Smithsonian Institution, Washington D.C. *Sculpture: American Directions 1945-1975.* October 3 through November 30. Catalogue. Chamberlain, Nauman.

Institute of Contemporary Art, University of Pennsylvania, Philadelphia, Pa. *Painting, Drawing and Sculpture of the 60's and 70's from the Dorothy and Herbert Vogel Collection.* October 7 through November 18. Catalogue. Chamberlain, Nauman.

Worcester Art Museum, Worcester, Mass. *American Art Since 1945 from the Collection of the Museum of Modern Art.* October 20 through November 30. Catalogue. Chamberlain, Indiana.

1976 The Chrysler Museum of Art, Norfolk, Va. *300 Years of American Art in the Chrysler Museum.* Catalogue. Chamberlain, Smith.

Zabriskie Gallery, New York, N.Y. *American Welders: 1950's -1960's.* Chamberlain, Rickey.

The School of the Art Institute of Chicago, Chicago, Ill. *Visions/Painting and Sculpture: Distinguished Alumni 1945 to Present.* Catalogue. Chamberlain, Indiana.

The Art Galleries, University of California, Santa Barbara, Calif. *7 + 5: Sculptors in the 1950's.* January 16 through February 15. Catalogue. Traveled to Phoenix Art Museum, Phoenix, Ariz. March 5 through April 11. Chamberlain, Smith.

Whitney Museum of American Art, New York, N.Y. *200 Years of American Sculpture*. March 16 through September 26. Catalogue. Chamberlain, Nauman, Smith, Wiley.

The Institute of Contemporary Art, Boston, Mass. *A Selection of American Art: The Skowhegan School 1946-1976*. June 16 through September 5. Catalogue. Traveled to Colby College Art Museum, Waterville, Maine. October 1 through 30. Indiana, Smith.

Leo Castelli Gallery, New York, N.Y. *Summer Group Show*. June 19 through September 10. Chamberlain, Nauman.

San Francisco Museum of Modern Art, San Francisco, Calif.. *Painting and Sculpture in California: The Modern Era*. September 3, 1976, through January 2, 1977. Catalogue. Traveled to National Collection of Fine Arts, Smithsonian Institution, Washington, D.C. Nauman, Wiley.

1977 Minnesota Museum of Art, St. Paul, Minn. *American Drawing 1927-77*. Catalogue. Smith, Wiley.

Art Association of Newport, Newport, R.I. *Two Decades of Exploration: Homage to Leo Castelli on the Occasion of His Twentieth Anniversary*. February 13 through March 27. Traveled. Chamberlain, Nauman.

Westfälisches Landesmuseum für Kunst und Kulturgeschichte, Münster, Germany. *Skulptur: Ausstellung in Münster*. August 3 through November 13. Catalogue (2 volumes). Nauman, Smith.

Baxter Art Gallery, California Institute of Technology, Pasadena, Calif. *Watercolors and Related Media by Contemporary Californians*. September 29 through October 30. Nauman, Wiley.

John Weber Gallery, New York, N.Y. *Drawings for Outdoor Sculpture: 1946-1977*. December 1977. Traveled through 1979 to Amherst College, Amherst, Mass.; University of California at Santa Barbara, Santa Barbara, Calif.; Laguna Gloria Art Museum, Austin, Tex.; Massachusetts Institute of Technology, Cambridge, Mass. Nauman, Smith.

Madison Art Center, Madison, Wisc. *Works on Paper by Contemporary American Artists*. December 4, 1977, through January 15, 1978. Catalogue. Chamberlain, Nauman, Wiley.

1978 Margo Leavin Gallery, Los Angeles, Calif. *Three Generations: Studies in Collage*. January 26 through March 3. Chamberlain, Nauman.

Whitney Museum of American Art, New York, N.Y. *Art about Art*. July 19 through September 24. Catalogue. Traveled to North Carolina Museum of Art, Raleigh, N.C., October 15 through November 26; Frederick S. Wright Art Gallery, University of California, Los Angeles, Calif., December 17, 1978, through February 11, 1979; Portland Art Museum, Portland, Ore., March 6 through April 15. Chamberlain, Indiana.

1979 Hansen-Fuller Gallery, San Francisco, Calif. *Related Figurative Drawings*. January 9 through February 3. Nauman, Wiley.

The Metropolitan Museum of Art, New York, N.Y. *Summer Loan Show*. July 17 through September 30. Chamberlain, Smith.

1980 Hayward Gallery, London, England. *Pier + Ocean: Construction in the Art of the*

Seventies. May 8 through June 22. Catalogue. Traveled to Rijksmuseum Kröller-Müller, Otterlo, the Netherlands, July 13 through September 8. Nauman, Rickey.

Wenkenpark, Riehen-Basel, Switzerland. *Skulptur im 20 Jahrhundert*. May 10 through September 14. Catalogue. Nauman, Smith.

Brooklyn Museum of Art, Brooklyn, N.Y. *American Drawing in Black and White: 1970-1980*. November 22, 1980, through January 18, 1981. Catalogue. Nauman, Wiley.

1981 Marisa del Re Gallery, New York, N.Y. *Sculptures and Their Related Drawings*. March 3 through 31. Rickey, Smith.

Museen der Stadt Köln, Cologne, Germany. *WestKunst: Zeitgenössische Kunst seit 1939*. May 30 through August 16. Catalogue. Chamberlain, Nauman, Smith.

Whitney Museum of American Art, New York, N.Y. *Drawing Acquisitions 1978-1981*. September 17 through November 15. Smith, Wiley.

1982 Solomon R. Guggenheim Museum of Art, New York, N.Y. *The New York School: Four Decades, Guggenheim Collection and Major Loans*. Chamberlain, Rickey.

Aspen Center for the Visual Arts, Aspen, Colo. *Castelli and His Artists / Twenty-five Years*. June 17 through August 2. Chamberlain, Nauman.

Museum Fridericianum, Kassel, Germany. *Documenta 7*. June 19 through September 28. Catalogue. Chamberlain, Nauman.

San Francisco Museum of Modern Art, San Francisco, Calif. *Twenty American Artists: Sculpture 1982*. July 22 through September 19. Catalogue. Nauman, Wiley.

Solomon R. Guggenheim Museum, New York, N.Y. *American Sculpture from the Permanent Collection*. November 23, 1982, through March 13, 1983. Catalogue. Chamberlain, Nauman.

1983 Richard L. Nelson Gallery, University of California, Davis, Calif. *The Slant Step Revisited*. January 13 through February 13. Catalogue. Nauman, Wiley.

Stedelijk Van Abbe Museum, Eindhoven, the Netherlands. *De Statua*. May 8 through June 19. Catalogue. Chamberlain, Nauman.

Whitney Museum of American Art, New York, N.Y. *Minimalism to Expressionism: Painting and Sculpture since 1965 from the Permanent Collection*. June 2 through December 4. Catalogue. Nauman, Rickey, Wiley.

Whitney Museum of American Art, New York, N.Y. *The Sculptor as Draftsman: Selections from the Permanent Collection*. September 15 through November 13. Catalogue. Nauman, Wiley.

Nassau County Museum of Fine Art, Roslyn Harbor, N.Y. *Sculpture: The Tradition in Steel*. October 9, 1983, through January 22, 1984. Catalogue. Chamberlain, Rickey, Smith.

The Museum of Contemporary Art, Los Angeles, Calif. *The First Show: Painting and Sculpture from Eight Collections 1940-1980*. November 20, 1983, through February 19, 1984. Catalogue. Chamberlain, Nauman, Wiley.

1984 Fort Wayne Museum of Art, Fort Wayne, Ind. *Indiana Influence: The Golden Age of Indiana Landscape Painting: Indiana's Modern Legacy. An Inaugural Exhibition of the Fort Wayne Museum of Art.* April 8 through June 24. Catalogue. Chamberlain, Nauman, Rickey, Wiley.

Donald Young Gallery, Chicago, Ill. *American Sculpture.* April 28 through July 28. Chamberlain, Nauman.

Merianpark, Basel, Switzerland. *Skulptur im 20. Jahrhundert.* June 3 through September 30. Catalogue. Nauman, Smith.

Margo Leavin Gallery, Los Angeles, Calif. *American Sculpture.* July 17 through September 15. Chamberlain, Nauman.

LA Louver, Venice, Calif. *American and European Painting, Drawing and Sculpture.* July 20 through September 22. Nauman, Wiley.

Whitney Museum of American Art, New York, N.Y. *The Third Dimension: Sculpture of the New York School.* December 6, 1984, through March 3, 1985. Catalogue. Traveled to Fort Worth Art Museum, Fort Worth, Tex., May 12 through July 21; Cleveland Museum of Art, Cleveland, Ohio, August 21 through October 17; Newport Harbor Museum, Newport Beach, Calif., November 7, 1985 through January 5, 1986. Chamberlain, Smith.

1985 Independent Curators, Incorporated, New York, N.Y. *Large Drawings.* Nauman, Wiley.

State Street Mall, Chicago, Ill. *Mile 4. Chicago Sculpture International.* May 9 through June 9. Catalogue. Chamberlain, Nauman.

LA Louver, Venice, Calif. *American/European, Part I - Painting and Sculpture 1985.* July 16 through August 17. Nauman, Wiley.

Frankfurter Kunstverein, Frankfurt am Main, Germany. *Vom Zeichnen: Aspekte der Zeichnung 1960-1985.* November 19, 1985, through January 1, 1986. Catalogue. Traveled to Kunstverein, Kassel, Germany, January 15 through February 23, 1986; Museum Moderner Kunst, Vienna, Austria, March 13 through April 27. Nauman, Wiley.

Solomon R. Guggenheim Museum, New York, N.Y. *Transformations in Sculpture: Four Decades of American and European Art.* November 22, 1985, through February 16, 1986. Catalogue. Chamberlain, Nauman, Smith.

Museum of Art, Inc., Ft. Lauderdale, Fla. *An American Renaissance: Painting and Sculpture since 1940.* December 15, 1985, through March 31, 1986. Catalogue. Chamberlain, Nauman, Rickey, Wiley.

1986 Musée National d'art Moderne, Centre Georges Pompidou, Paris, France. *Qu'est-ce que c'est la Sculpture Moderne?* June 24 through September 29. Catalogue. Chamberlain, Smith.

Philadelphia Museum of Art, Philadelphia, Pa. *Philadelphia Collects: Art Since 1940.* September 28 through November 30. Catalogue. Chamberlain, Rickey, Smith, Wiley.

Museum of Contemporary Art at the Temporary Contemporary, Los Angeles, Calif.. *Individuals: A Selected History of Contemporary Art 1945-1986.* December 10, 1986, through January 10, 1988. Catalogue. Nauman, Wiley.

1987 Whitney Museum of American Art, New York, N.Y. *Whitney Biennial*. April 15 through July 5. Catalogue. Chamberlain, Nauman.

Anthony d'Offay Gallery, London, England. *Works on Paper.* May 5 through 29. Nauman, Smith.

Leo Castelli Gallery, 142 Greene Street, New York, N.Y. *Art Against Aids: Benefit for American Foundation for Aids.* June 4 through 13. Nauman, Wiley.

Centro Cultural Arte Contemporaneo, Mexico City, Mexico. *30 Years Retrospective of Leo Castelli Gallery: Masterpieces of Mid-Century Art.* June 26 through October 18. Chamberlain, Nauman.

1988 Herron Gallery (Indianapolis Center for Contemporary Art), Indianapolis, Ind. *Welcome Back: Painting, Sculpture, and Works on Paper by Contemporary Artists from Indiana.* January 15 through February 27. Chamberlain, Indiana, Nauman, Rickey, Smith, Wiley.

The Museum of Modern Art, New York, N.Y. *Committed to Print.* January 31 through April 19. Catalogue. Traveled to Newport Harbor Art Museum, Newport Beach, Calif., July 15 through September 23, 1990. Indiana, Nauman, Wiley.

Milwaukee Art Museum, Milwaukee, Wisc. *1988: The World of Art Today.* May 6 through August 28. Catalogue. Nauman, Wiley.

Leo Castelli Gallery and Brooke Alexander Gallery, New York, N.Y. *Exhibition for the Benefit of the Foundation for Contemporary Performance Arts.* December 8 through 30. Chamberlain, Nauman.

Museum of Contemporary Art, Chicago, Ill.. *Three Decades: The Oliver-Hoffmann Collection.* December 17, 1988, through February 5, 1989. Catalogue. Chamberlain, Nauman.

1989 James Corcoran Gallery, Santa Monica, Calif. *Chamberlain, Judd, Nauman, Stella.* Chamberlain, Nauman.

Museum Ludwig in der Rheinhallen der Kölner Messe, Cologne, Germany. *Bilderstreit: Widerspruch Einheit und Fragment in der Kunst seit 1960.* April 8 through June 28. Catalogue. Chamberlain, Nauman.

National Gallery of Art, Washington, D.C. *The 1980's: Prints from the Collection of Joshua P. Smith.* December 17, 1989, through April 8, 1990. Catalogue. Nauman, Wiley.

1990 Gagosian Gallery, New York, N.Y. *Major Sculpture.* February 17 through March 17. Chamberlain, Nauman.

Tony Shafrazi Gallery, New York, N.Y. *American Masters of the 60's: Early and Late Works.* May 9 through June 23. Catalogue. Chamberlain, Nauman.

Milwaukee Art Museum, Milwaukee, Wisc. *Word as Image: American Art 1960-90.* June 15 through August 26. Catalogue. Traveled to Oklahoma City Art Museum, Oklahoma City, Okla., November 17, 1990, through February 2, 1991; Contemporary Arts Museum, Houston, Tex., February 23 through May 12, 1991. Nauman, Wiley.

Hofstra Museum, Hofstra University, Hempstead, N.Y. *The Trans Parent Thread: Asian*

Philosophy in Recent American Art. September 16 through November 11. Catalogue. Traveled to Edith C. Blum Art Institute, Bard College, Annandale-on-Hudson, N.Y., December 2, 1990, through February 4, 1991. Nauman, Wiley.

1991 Margo Leavin Gallery, Los Angeles, Calif. *20th-Century Collage.* January 12 through February 16. Chamberlain, Nauman.

Albright-Knox Art Gallery, Buffalo, N.Y. *Postwar Sculpture from the Collections.* January 19 through March 3. Chamberlain, Nauman.

Abstract Sculpture in America 1930-1970. Organized by the American Federation of the Arts. Traveled to Lowe Art Museum, University of Miami, Coral Gables, Fla., February 7 through March 31; Museum of Arts, Quebec, January 25, 1992, through March 21, 1992; Terra Museum of American Art, Chicago, Ill., April 11 through June 7, 1992. Catalogue. Chamberlain, Rickey.

1992 Lingotto, Turin, Italy. *Arte Americana 1930-1970.* January 8 through March 31. Catalogue. Chamberlain, Indiana, Nauman.

KunstHall, New York, N.Y. *Psycho.* April 2 through May 9. Chamberlain, Nauman.

1993 Brooke Alexander and Brooke Alexander Editions, New York, N.Y. *Sculpture & Multiples.* January 8 through February 13. Chamberlain, Nauman.

The Royal Academy of Arts, London, England, and the Zeitgeist Gesselschaft, Berlin, Germany (joint organizers). *American Art in the 20th Century/Painting and Sculpture 1913-1933.* Catalogue. Traveled to Martin-Gropius-Bau, Berlin, Germany, May 8 through July 25; The Royal Academy of London, September through December 12. Chamberlain, Smith.

1994 The Gardens at Naumkeag, Stockbridge, Mass. *Sculpture at Naumkeag.* July 1 through October 11. Rickey, Smith.

1995 Mead Art Museum, Amherst College, Amherst, Mass. *In Two Worlds: The Graphic Work of Modern Sculptors.* Rickey, Smith.

1996 The Solomon R. Guggenheim Museum, New York, N.Y. *Abstraction in the Twentieth Century: Total Risk, Freedom, Discipline.* February 9 through May 12. Catalogue. Chamberlain, Smith.

1997 The Solomon R. Guggenheim Museum, New York, N.Y. and The Fine Arts Museum of San Francisco, San Francisco, Calif. (joint organizers). *Masterworks of Modern Sculpture: The Nasher Collection.* California Palace of the Legion of Honor, October 1996 through January 1997. Catalogue. Traveled as *A Century of Sculpture: The Nasher Collection* to The Solomon R. Guggenheim Museum, New York, N.Y., February through April 1997. Chamberlain, Smith

LENDERS TO THE EXHIBITION

Gene Abel,
Bedford, Indiana

Robert E. Abrams,
New York

Albright-Knox Art Gallery,
Buffalo, New York

Archives of American Art,
Smithsonian Institution

Mr. and Mrs. Matthew D. Ashe,
Sausalito, California

Bank One Art Collection

Rena Bransten, San Francisco

Glenn M. Bucksbaum, San Francisco

Ralph and Peggy Burnet,
Wayzata, Minnesota

John Chamberlain,
Shelter Island Heights, New York

William and Barbara Crutchfield,
San Pedro, California

Elisabeth Cunnick and Peter Freeman,
New York

Des Moines Art Center

The Detroit Institute of Arts

Electrónic Arts Intermix, New York

Emanuel Hoffmann-Stiftung,
Basel, Switzerland

Five private collections

Diana Burgess Fuller, San Francisco

Gagosian Gallery

Mr. and Mrs. Ronald K. Greenberg,
St. Louis

Mr. and Mrs. Graham Gund,
Cambridge, Massachusetts

Louis A. Hermes,
San Francisco

Hill Gallery, Birmingham, Michigan

Hirshhorn Museum and Sculpture
Garden, Smithsonian Institution

Robert Indiana,
Vinalhaven, Maine

Indiana University Art Museum,
Bloomington

Indianapolis Museum of Art

Stephane Janssen, Carefree, Arizona

Collection of Dr. and Mrs. Arthur E.
Kahn, New York

L.A. Louver, Venice, California

Terese and Alvin S. Lane, New York

Locks Gallery, Philadelphia

Marsha Mateyka, Washington, D.C.

Lois and Georges de Menil, New York

The Menil Collection, Houston

Milwaukee Art Museum

Morgan Art Foundation Limited,
Geneva, Switzerland

Morgan Gallery, Kansas City, Missouri

Museum of Contemporary Art, Chicago

Museum Ludwig, Cologne

Museum Moderner Kunst Stiftung
Ludwig, Vienna

The Patsy R. and Raymond D. Nasher
Collection, Dallas

National Gallery of Art,
Washington, D.C.

National Gallery of Canada, Ottawa,
Ontario

ACKNOWLEDGMENTS

Assembling the sculptures and drawings and producing the catalogue, programs, and events for *Crossroads of American Sculpture* were made possible by the generosity of the lenders and the devoted, time-consuming, and often selfless work of many people, both within and without the walls of the Indianapolis Museum of Art. I hope that the following acknowledgments can, in some small way, express my gratitude for the assistance of these people.

I am particularly grateful to all the artists and their studios. Rebecca and Candida Smith and Peter Stevens, administrator of the David Smith Estate, not only provided crucial loans and photographs, but also gave their time by discussing Smith's work and providing new information on some of the works. George Rickey's generosity with his time and wisdom was particularly helpful in making a coherent presentation of his work. Birgit Mieschonz and Maria Lizzi, members of his studio, provided us with every conceivable document needed to write the catalogue essay, as well as photographs and specifications for the works. Maxwell Davidson, who represents Rickey in his gallery, was likewise helpful. Stuart and Phillip Rickey have made their father's participation possible through their support. John Chamberlain was not only generous with his time, but generously lent special drawings and sculpture that he has retained for himself. Prudence Fairweather's assistance with Chamberlain's loans and photography was appreciated. Susan Dunne, of PaceWildenstein Gallery, has been helpful with Chamberlain's work that is located in Europe. Robert Indiana generously allowed me to visit his studio in Vinalhaven and provided access to his drawing notebooks. His representative, Simon Salama-Caro, provided much of the legwork needed to assemble his sculpture. William Wiley has been a pleasure to work with. His good humor and time were much appreciated by me. His agent, Wanda Hansen, has been invaluable in assembling works and arranging for loans. Both have been very generous in lending needed works. Bruce Nauman's guidance about his works and his assistant, Juliet Myers, have been invaluable, as have Angela Westwater and Donald Young, whose galleries represent Bruce Nauman. And perhaps I am most grateful for the talent of these artists, whose works have meant so much for so many years, and continue to mean so much, to me and many other art lovers.

Each loan has required not only the willingness of the lender to part with the work, but also the lender's trust in the museum to handle it with care and install it respectfully, and to provide the public with accurate information about the artwork in the catalogue and galleries. I would like to thank each lender for taking the time to help us fulfill our obligations as a borrower. I especially appreciate the private collectors who have spent time with me and allowed me access to their collections, especially Mr. Lane and Mrs. Kahn. There are many other people who facilitated our loans, including the staffs of the many museums who have lent to the exhibition. In particular, I would like to thank Aprile Gallant, curator for the recent retrospective of Robert Indiana's work at the Portland Museum of Art in Maine. She was instrumental in helping to assemble his work for this exhibition. It was especially gratifying that so many museums were willing to lend work that normally occupies a prominent spot in their collection galleries.

My thanks also to the following people for assisting us in obtaining various loans: Chiara Alberetti, Jeremy Adams, Jill Weinberg Adams, Richard Armstrong, Michael Auping, William Crutchfield, Bo Joseph, Margo Leavin, Kathleen Merrill, Cynthia Nalevanko, Audrey Peirano, Maureen Pskowski, Suzanne Weaver, Sallie Wiggins, and Tad Wiley.

My appreciation goes to Dore Ashton, for her essay written so ably and promptly.

In completing the research for our essays, Lena Vigna and I are grateful to those individuals who generously allowed themselves to be interviewed about the atmosphere of Chicago and Bloomington in the 1950s. They include Jean Freas, mother of Rebecca and Candida Smith; the artist Robert Natkin; David Hayes and Lydia Finkelstein, both students of Smith and Rickey at Indiana University, and V. Louise Reinhart, a fellow high school student of Smith's.

Librarians and staff of Indiana historical museums have been more than generous in showing us their records and archives about these artists. Assisting us with Smith's early years were Mrs. Virginia Paulus and Don DeWitt of Paulding, Ohio, and Geraldine Sudduth of Decatur Public Library, Decatur, Indiana. Obtaining information on the Chamberlain family was aided by Shirley Willard of the Fulton County Museum in Rochester, Indiana. Carol Rossett, collections manager of the Richard L. Nelson Gallery, University of California, Davis provided information on the slant step project. The Indiana State Historical Society provided valuable assistance in locating records about the Clark family houses. Ursula Kolmstetter, head of the IMA Stout Reference Library, has been a great asset to our research.

Artists Gary Freeman and Jerald Jacquard were invaluable sources of information about the fabrication of steel sculpture.

The support of the Indianapolis Museum of Art and its staff has been enthusiastic and unstinting. Perhaps the greatest support the museum gave me was the funds to hire Lena Vigna as curatorial assistant for the exhibition and the Contemporary Art Department. In addition to organizing a group of department exhibitions, she has kept records of everything and handled the thousands of details pertaining to time schedules, lists, and catalogue entries with intelligence, accuracy and foresight. She has coordinated the needs of other museum departments. In her essay on the early life of the artists, she employed a careful scholarship that was a pleasure to observe. She was an able colleague in all respects.

Instrumental to this exhibition was administrative assistant Gabriele HaBarad. She handled many complicated assignments with an intelligence and skill that made everything run smoothly, not only regarding this exhibition, but also concerning other duties of the Contemporary Art Department that were simultaneous with the organization of this exhibition.

Also assisting the department was intern Melissa Martin, who employed her computer skills to set up files necessary to make record-keeping as easy as possible. Her help was invaluable. She, together with Lena Vigna, completed the list of joint exhibitions for the artists.

Ruth Roberts, who manages rights and reproductions for the IMA, assembled all the necessary photographs, obtained permissions for the catalogue, and made arrangements for all the additional photography that was needed. My sincere thanks to her for doing this work so efficiently and well. Jane Graham, the IMA's editor, has been responsible for the editing and production of the catalogue. I appreciate her thoroughness, counsel, and good planning.

Many of the museum's staff have been my colleagues at the IMA for ten to fifteen years. Although we have worked together on exhibitions frequently, each exhibition makes me appreciate anew how capable and creative they are, as they seem to rise to new heights with every exhibition that comes their way. I am grateful for the skill, good humor, and friendship of the following staff:

Sue Ellen Paxson, exhibition coordinator; Tad Fruits, photographer; registrars Vanessa Burkhart and Sherry Peglow; the exhibition designer, Sherman O'Hara, and his staff; object and paper conservators Hélène Gillette-Woodard and Claire Hoevel; prints and drawings manager David Hunsucker; the entire Education Division, especially director of education Susan Longhenry and Rosie May, who planned the symposium; Donna Wiley, deputy director of external affairs, and members of the Development Division, especially Stan Blevins, Cara Dafforn, and Arletta Newton; members of Marketing and Communications, especially Kathy Lang, its director, and Amy Sorokas, Anne Robinson, and Heather Pierce; Linda Hardwick, director of visitor services; and Brent Snider and his crew in museum security.

Finally, but not least, I appreciate the wonderful support of IMA chief curator and deputy director Ellen Lee and IMA director Bret Waller. They were instrumental in providing needed staff, advice when asked, and moral support for the undertaking. I was indeed fortunate to work under two supremely nice, as well as capable, people.

Holliday T. Day
Senior Curator of Contemporary Art

ABOUT THE AUTHORS

Holliday T. Day is senior curator of contemporary art at the Indianapolis Museum of Art. She received her B.A. degree from Wellesley College and her M.A. from the University of Chicago, where she wrote her thesis, *The Surfaces of David Smith's Sculpture*. She has served on exhibition juries throughout the country and on numerous panels for the National Endowment for the Arts. She is well known for articles that appeared in the 1970s in *Art in America* and the *New Art Examiner*. In 1979, she received an NEA grant for her writing on art. In 1983 she wrote the essay "David Smith: Spray Paintings, Drawings and Sculpture" for an exhibition at the Arts Club of Chicago.

Before joining the IMA staff as curator of contemporary art in 1985, Day served for five years as curator of American art at the Joslyn Art Museum in Omaha, Nebraska. In her twenty-year career as a museum curator, she has organized or co-organized more than sixty exhibitions, including five major traveling exhibitions: *POWER: Its Myths and Mores in American Art, 1961-1991; The Art of the Fantastic: Latin America, 1920-1987; Shape of Space: The Sculpture of George Sugarman; The Poetry of Form: Richard Tuttle Drawings from the Vogel Collection*, and *New Art of Italy: Chia Clemente Cucchi Palladino*. She also wrote or contributed to the catalogues for these exhibitions.

Dore Ashton is an internationally known art critic and educator. She has written extensively on art of the twentieth century, including *The Delicate Thread: Teshigahara's Life in Art* (1997), *The Sculpture of Ursula von Rydingsvard* (1996), *Noguchi, East and West* (1992), *Terence La Noue* (1992), *American Art Since 1945* (1982), *A Joseph Cornell Album* (1974), *The New York School: A Cultural Reckoning* (1973), *Picasso on Art* (1972), and *Modern American Sculpture* (1968). She is a graduate of the University of Wisconsin and Harvard University and received honorary doctorates from Moore College and Hamline University. Early in her career, she was associate editor of *Art Digest* and associate critic for *The New York Times*. She has been a professor of art history at The Cooper Union for the Advancement of Science and Art, New York City, since 1968.

Lena Vigna, IMA curatorial associate for contemporary art, received her M.A. from the University of Illinois at Urbana-Champaign in December 1998. Her master's thesis was *Ann Hamilton: Issues of the Body*. Initially hired in January 1999 as assistant for *Crossroads of American Sculpture*, her position expanded in August 1999. Since that time she has curated a number of exhibitions on contemporary art at the museum and has published catalogue brochures for two of them, *Anne Chu* and *Deborah Mesa-Pelly: Color Photographs*.

INDEX

Note: Page references in italics refer to illustrations.

A
Abel, Thomas J., 52
abstract art, 28
abstract expressionism, 16, 20, 31, 70
Adagio Dancers (Smith), *83*
Adams County, Indiana, 42
Agricola series (Smith), 69, *89*
Agricola XIII (Smith), *89*
Ahab (Indiana), *33*
AHAVA (Indiana), *181*
alphabet use, 22
Amazing Fountain (Portuguese) (Nauman), 227
Amusement Park (Smith), 29, *80*
André, Carl, 31
Annular Eclipse Wall Variation V (Rickey), *132*
antiform experiments, 20
The Anvil (painting) (Wiley), *200*
The Anvil (sculpture) (Wiley), *203*
Arsenal Technical High School, Indianapolis, 51
ART (1972) (Indiana), *179*
ART (2000) (Indiana), *183*
art gallery system, condemnation of, 35
The Art of Assemblage exhibition, 16, 34
Art Students League, New York, 17, 63
assemblage, 16, 34
Australia (Smith), 65
automobile manufacturing in Indianapolis, 49

B
Balliol College, Oxford, 63
Bard, Sara, 51
Bauhaus, 30, 35
Beat poets, 23
Beatnik Meteor (Wiley), *193*
Bed (Rauschenberg), 35
Bedford, Indiana, Wiley home, 52
B.L.O.T. (Wiley), *197*

Boccioni, Umberto, 16
Bolton Landing, 64, 73
Borton, Leroy, 67
Brancusi, Constantin, 16
Breton, André, 23–24

C
Calder, Alexander, 17, 18, 30, 70
calligraphy, 17
Calliope (Chamberlain), 31, *145*
cartooning, 45
Cast of the Space under My Chair (Nauman), 37
Chamberlain, Alexander, 47
Chamberlain, Betty, 69
Chamberlain, Jesse, 47
Chamberlain, John
 in *The Art of Assemblage* exhibition, 34
 birth, 47
 family taverns, 47, *47*
 grandparents' home in Rochester, Indiana, *48*
 materials used, 21
 mother and father, 47–48
 sculptures as "specific objects," 32
 sheet metal use, 32
 Smith and, 21
 wall reliefs, 30
Chamberlain, John, works of
 Calliope, 31, *145*
 Coll/108-84, *158*
 For Elaine with Love, *148*
 Enclosure 18", *162*
 Enclosure 27', *162*
 G.G., *147*
 Gondola Jack Kerouac, *157*
 Huzzy, *150*
 Longslide, *159*
 Madame Moon, *153*
 Suprize, *159*
 Taos Drop Off, *151*
 That's My Heart, *146*
 Thicket, *163*
 To Land from Sea, *156*
 Twice is Nice, *146*
 Untitled (1963), *152*

 Untitled (1966), *155*
 Untitled (1969), *154*
 Untitled (1971), *155*
 Untitled (1973), *155*
 Untitled (1979), *155*
 Verb Goddess, *160*
 View of Land from Boat, *156*
 Zaar, *149*
Chamberlain, Sylvester, 47
Chaos theory, 24
Chicago Bauhaus, 72
Circle I (Smith), *102*
Circle II (Smith), *102*
Circle III (Smith), *102*
Circle V: Black, White, Tan (Smith), *105*
Clark, Earl, 49, 51
Clark, Robert E. *See* Indiana, Robert
Cleveland Art School, 45
Cocktail Party (Rickey), 70
Coll/108-84 (Chamberlain), *158*
Columbia Elementary School, 48
Column of Squares (Rickey), *124*
Column of Tetrahedra (Rickey), *125*
Conceptual art, 24
Construction in Rectangles (Smith), 69, *93*
Construction (Smith), *77*
Construction with Forged Neck (Smith), 69, *94*
Corner Gong (Wiley), *205*
Crane Naval Ammunition Depot, 52
Cubi I (Smith), *108*
Cubi IV (Smith), *107*
Cubi IX (Smith), *101*
Cubi XIV (Smith), *109*
Cubi series (Smith), 17
Cubist pictorial language, 29

D
$\Delta\Sigma$ 5/3/53 (Estate #73-53.89) (Smith), *88*
$\Delta\Sigma$ 10/26/54 (Estate #73-54.156) (Smith), *99*
Dada, 20, 21–22, 35
Dancers (Smith), *82*
David Smith 6/6/58 (Smith), *86*
de Kooning, Willem, 21

Decatur, Indiana, Smith home, 42, 43
Die (Indiana), *177*
Drawing 3/23/53 (Smith), *66*
Drawing of a model of a plastic room with a rubber wallpiece (Nauman), *211*
Drawing series, 67
Drill Team (Nauman), *214*
Duchamp, Marcel, 21, 23, 35

E
East Chatham, New York, 73
Eat/Death (Nauman), *2, 222*
Eat (Indiana), *173*
EAT Sign (Indiana), *183*
Eating My Words (Nauman), *215*
Egyptian Barnyard (Smith), 67, *89*
Egyptian Landscape (Smith), *87*
Eleven Color Photographs (Nauman), 214, *215*
Enclosure 18" (Chamberlain), *162*
Enclosure 27' (Chamberlain), *162*
Enigma Doggy (Wiley), *191*
entropy, 24
Etoile, Variation II (Rickey), *119*
exhibitions, group, 228–237

F
Faceted Column (Rickey), *130*
Fifteen Planes (Smith), *100*
figural sculptural tradition, 30
First Mosaic (Rickey), *129*
Five Pink Heads in the Corner (Nauman), *224*
Five Triangles II (Rickey), *123*
Flesh to White to Black to Flesh (Nauman), *218*
Flute for A.G. (Wiley), *206*
For Elaine with Love (Chamberlain), *148*
Forging III (Smith), *94*
Forging IV (Smith), *95*
Forging V (Smith), *95*
Forging VI (Smith), *96*
Forging VII (Smith), *92*
Forging VIII (Smith), *96*
Forging IX (Smith), *97*

Forging X (Smith), *64*
Forging series (Smith), 33, *64, 67–70*
Fort Wayne, Indiana, Nauman home, 53
Foster, Hal, 22
4th Church of Christ, Scientist, Indianapolis, *50*, 51
Fox Wheel (Nauman), 37, *223*
Fry, Edward, 33
Funk art, 23

G
Gabo, Naum, 17, 18–19, 30, 70
Gestalt psychology, 24
G.G. (Chamberlain), *147*
Giacometti, 18
Giles, Christine, 52
Gondola Jack Kerouac (Chamberlain), *157*
Gonzalez, Julio, 17
The Good and The Grubby (Wiley), *204*
Goossen, E.C., 68
Gorky, Arshile, 16
Graham, John, 63
Great Depression in Indianapolis, 51
Greek alphabet, Smith and, 17
group exhibitions, 228–237

H
Hasse, Ruth Coffman, 51
Henry Moore Bound to Fail (Nauman), *217*
herms, 22, 33
The Hero's Eye (Smith), *84*
Hope, Henry, 63, 64
Hudson River Landscape (Smith), 29, 64, *66*
Huzzy (Chamberlain), *150*

I
Indiana, Robert
 at Arsenal Technical High School, 51
 in *The Art of Assemblage* exhibition, 34
 early life, 48–52

early sculptures, 33
 eat and die, use of words, 34
 English Avenue, Indianapolis home, *50*
 4th Church of Christ, Scientist, Indianapolis, *50*, 51
 Irvington Avenue, Indianapolis home, 49, *50*
 journal from 1961, 183
 literature and, 21
 materials used, 21
 Mooresville, Indiana, home, 49
 New Castle, Indiana, home, 49
 pages from journal from 1959-60, *168*
 pages from journal from 1962-63, *167, 170, 172, 174*
 stelae, 22
 U.S. Army Air Corps, 52
Indiana, Robert, works of
 2000, 183
 AHAVA, *181*
 ART (1972), *179*
 ART (2000), *183*
 Die, *177*
 Eat, *173*
 EAT Sign, *183*
 Jeanne d'Arc, *165*
 Love (drawing), *180*
 LOVE (sculpture), 22, 34, *178*
 Mars, *176*
 Moon, 21, *171*
 Mother and Father, 49, *140*
 Number 3 from *Maquettes for Large Numbers 1-10*, *182*
 Orb, *171*
 Six, 183
 Star, *175*
 Sun and Moon, 183
 Wall of China, *169*
 Zenith, *169*
 Zig, *166*
Indiana Limestone Company, 52
Indiana University, Bloomington, 63, 64, 72
Indianapolis
 automobile manufacturing in, 49

4th Church of Christ,
 Scientist, Indianapolis, *50*, 51
 in Great Depression, 51
 Robert Indiana homes, 49, 51
Indianapolis Star, 52
Institute of Design in Chicago,
 70, 72
Interior (Smith), 29
Italy, Rickey in, 63

J

Jeanne d'Arc (Indiana), *165*
John Herron Art School, 52
Johns, Jasper, 20
Journal from 1961 (Indiana), *183*
Joyce, James, 17
Judd, Donald, 20, 24, 31, 32

K

Kandinsky, Wassily, 24
kinetic sculptures, 70
Klee, Paul, 70
Krauss, Rosalind, 28, 33

L

Le Corbusier, 72
Léger, Fernand, 63
The Letter (Smith), 33
*Letter to Bill Allan: Three Well-
 Known Knots (Square Knot,
 Bowline and Clove Hitch)*
 (Nauman), *216*
LeWitt, Sol, 20, 24, 31
Lhote, André, 63
Lichtenstein, Roy, 20
Life magazine, 51
linear and planar elements of
 sculpture, 28
Lipchitz, Jacques, 29
Longslide (Chamberlain), *159*
Love (drawing) (Indiana), *180*
LOVE (sculpture) (Indiana), 22,
34, *178*

M

"machines of no use"
 Rickey and, 30, 70, 72
 Tinguely and, 31

Madame Moon (Chamberlain), *153*
Maquettes for Large Numbers 1-10
 (Indiana), *Number 3* from, *182*
Marcus, Stanley E., 69
Market-New York City (Smith), 78
Mars (Indiana), *176*
Marsh Plant (Rickey), *122*
Matulka, Jan, 63
Maxwell Davidson Car Company, 49
McGrath, Jim, 52
Medals for Dishonor (Smith), 17
Michael Row the Botha Soul
 (Wiley), *194*
Mies van der Rohe, 72
Minimalists, 20
*Mold for a Modernized Slant
 Step* (Nauman), 37, *213*
*Monument to Blackball
 Violence—Homage to Martin
 Luther King* (Wiley), *195*
Moon (Indiana), 21, *171*
Mooresville, Indiana, Robert
 Indiana home, 49
Morris, Robert, 20, 24
Mother and Father (Indiana),
 49, *140*
motion in work, Rickey, 30-31
Mr. Unatural, 35, 36
Mr. Unatural Takes a Bow
 (Wiley), *198*
music and Nauman, 54

N

Nauman, Bruce, 34
 Dada and, 22
 diffuse character of work, 23
 early life, 53–54
 Fort Wayne, Indiana home, 53
 Funk art and, 23
 move to Wisconsin, 53
 music influence, 54
 space and, 36–37
 Surrealism and, 22
 videos, performances,
 installations, 30
 Wiley and, 22
 words and objects, 37–38
Nauman, Bruce, works of

*Amazing Fountain
 (Portuguese)*, 227
*Drawing of a model of a
 plastic room with a rubber
 wallpiece*, 211
Drill Team, 214
Eat/Death, 2, 222
Eating My Words, 215
Eleven Color Photographs,
 214, 215
*Five Pink Heads in the
 Corner*, 224
*Flesh to White to Black to
 Flesh*, 218
Fox Wheel, 37, 223
Henry Moore Bound to Fail, 217
*Letter to Bill Allan: Three
 Well-Known Knots (Square
 Knot, Bowline and Clove
 Hitch)*, 216
*Mold for a Modernized Slant
 Step*, 213
*The original Slant-Step/wood
 and linoleum*, 212
*Plan for an object to be made
 of folded cardstock or sheet
 metal-tin aluminum galva-
 nized iron or whatnot*, 210
Study for a rubber sculpture,
 211
*Study for "Seven Virtues and
 Seven Vices,"* 221
Study for "Slant Step," 212
*The True Artist Is an Amazing
 Luminous Fountain*, 220
Untitled (1965), 209
Untitled (1993), 227
Untitled (Hand Circle), 227
Untitled (Pair of Hands), 225,
 226
Nauman, Calvin, 53
Nauman, Genevieve, 53
New Castle, Indiana, Robert
 Indiana home, 49
*No Cybernetic Exit (or) An
 Overview of Compensatory
 Reserves of Bituminous Coal*
 (Rickey), 31, 115

Nomad Is An Island (Wiley), 23,
30, 36, 199
Number 3 from *Maquettes for
Large Numbers 1-10*
(Indiana), *182*

O
Oldenburg, Claes, 20, 140
One Desk Base (Wiley), *207*
Orb (Indiana), *171*
*The original Slant-Step/wood
and linoleum* (Nauman), *212*
O.T.P.A.G. for E.T.S. (Wiley), *201*
Ozenfant, Amédée, 63

P
Pacing Upside Down (Nauman), *219*
Pages from journal from 1959-
60 (Indiana), *168*
Pages from journal from 1962-
63 (Indiana), *167, 170, 172,
174*
Palace at 4 A.M. (Giacometti), 18
Paulding, Ohio, Smith home,
42-44, *43*
Paulding High School yearbook
drawings (Smith), 44
Paulding Telephone Company, 44
Paulding United Methodist
Church, *43*, 44
Pevsner, Antoine, 18
Picasso, Pablo, 16, 17, 33
*Plan for an object to be made of
folded cardstock or sheet
metal-tin aluminum galva-
nized iron or whatnot*
(Nauman), *210*
Pollock, Jackson, 24

R
Rauschenberg, Robert, 35
"Realistic Manifesto" (Gabo), 18
Reinhart, V. Louise, 44, 45
Richland, Washington, Wiley
home, 52
Rickey, George
birth, 45–46
Calder and, 17, 18, 70

drawings, 66
Gabo and, 17, 18–19, 70
grandfather and, 46
in Italy, 63
kinetic sculptures, 70
large works, 65
"machines of no use," 30, 70, 72
materials used, 19
mobiles, 30
motion in his work, 30
sculpture themes, 28
Smith and, 63–73
South Bend, Indiana home,
45–46
steel use, 72
vocabulary of his sculpture, 30
Rickey, George, works of
*Annular Eclipse Wall
Variation V, 132*
Column of Squares, 124
Column of Tetrahedra, 125
Etoile, Variation II, 119
Faceted Column, 130
First Mosaic, 129
Five Triangles II, 123
Marsh Plant, 122
*No Cybernetic Exit (or) An
Overview of Compensatory
Reserves of Bituminous
Coal, 31, 115*
Sedge I, 72, 121
Silver Plume II, 65, 71, 72
Space Churn Theme, 116
Study for *Column of
Tetrahedra,* (1968), *127*
Study for *Column of
Tetrahedra,* (1971), *126*
Study for *Column of
Tetrahedra,* (1976), *126*
Study for *Column of
Tetrahedra, n.d., 128*
Study for *Etoile* (1960), *118*
Study for *Etoile* (1966[?]), *118*
Study for *Faceted Column,
n.d., 131*
Study for *No Cybernetic Exit*
(recto), *114*
Study for *No Cybernetic Exit*

(verso), *114*
Study for *Sedge* (1960), *120*
Study for *Sedge* (1961), *120*
Sun & Moon, 113
Two Lines Oblique, 70, 72
Wave I, 30, *117*
Rickey, Walter, 45–46
Rochester, Indiana, Chamberlain
family tavern, 47
Rochester, Indiana, home of
Chamberlain's grandparents, 48
Rosenberg, Harold, 15
Rugg, Samuel J., 42, 69
Ruskin School of Drawing at the
Ashmolean, 63
Russian constructivists, 16

S
Schwitters, Kurt, 22, 24
"A Sculptor's Point of View"
(Smith), 67–68
Sedge I (Rickey), 72, *121*
Seitz, William, 16, 34
Selz, Peter, 23
Serra, Richard, 20, 31
17 h's (Smith), 33, *85*
sheet metal use, Chamberlain, 32
Silver Plume II (Rickey), 65, 71, 72
The Sitting Printer (Smith), 69,
72, *90*
Six (Indiana), 33, *183*
*Slant Step Becomes Rhino/Rhino
Becomes Slant Step* (Wiley),
192
Slant Step (Wiley), *192*
Sloan, John, 17, 63
Smith, David
abstract expressionists and, 16
in *The Art of Assemblage*
exhibition, 34
birth, 42
cartooning and, 45
Decatur, Indiana, home, 42, *43*
drawings, 66
figural sculptural tradition, 30
Gonzalez and, 17
in high school, 45
at Indiana University, 63, 64

letter-like forms, 33
machinery and, 44
materials used, 19
mother and father, 42, 44
at Ohio University, 63
as painter, 17
Paulding, Ohio, home, 42, 43
Picasso and, 16, 17
pioneer ancestors and, 42
Rickey and, 63–73
"A Sculptor's Point of View,"
 67–68
sculpture themes, 28
"Thoughts on Sculpture,"
 67–68
training under John Sloan,
 17, 63
transforming pictorial language
 into sculpture, 28–29
trip hammer and, 67
welding, 63
Smith, David, works of
 Adagio Dancers, 83
 Agricola XIII, 69, 89
 Amusement Park, 29, 80
 Australia, 65
 Circle I, 102
 Circle II, 102
 Circle III, 102
 Circle V: Black, White, Tan,
 105
 Construction, 77
 Construction in Rectangles,
 69, 93
 Construction with Forged
 Neck, 69, 94
 Cubi I, 108
 Cubi IV, 107
 Cubi IX, 101
 Cubi XIV, 109
 $\Delta\Sigma$ 5/3/53 (Estate #73-53.89),
 88
 $\Delta\Sigma$ 10/26/54 (Estate #73-
 54.156), 99
 Dancers, 82
 David Smith 6/6/58, 86
 Egyptian Barnyard, 67, 89
 Egyptian Landscape, 87

Fifteen Planes, 100
Forging III, 94
Forging IV, 95
Forging V, 95
Forging VI, 96
Forging VII, 92
Forging VIII, 96
Forging IX, 97
Forging series, 33, 64, 67–70
The Hero's Eye, 84
Hudson River Landscape, 29,
 64, 66
Interior, 29
The Letter, 33
Market-New York City, 78
Medals for Dishonor, 17
Paulding High School year-
 book drawings, 44
17 h's, 33, 85
The Sitting Printer, 69, 72, 90
Star Cage, 29, 87
Steel Drawing I, 29, 81
Study for Sculpture, 88
24 Greek Y's, 33
Untitled (1955), 97
Untitled (1955, Estate #73-
 55.70), 98
Untitled (1955, Estate #73-
 55.77), 98
Untitled (1962, Estate #73-
 62.137), 104
Untitled (1962, Estate #73-
 62.189), 104
Untitled (1962, Estate #73-
 62.210), 110
Untitled (Cubi), 106
Untitled (Forgings), 91
Untitled, Star Cage, 86
Untitled (Virgin Island
 Tableau), 79
Voltri series, 18, 69
Wagon I, 111
Yellow Vertical, 69
Zig II, 72, 103
Smith, Golda, 44
Smith, Harvey, 42, 44
Smithson, Robert, 20, 24
South Bend, Indiana, Rickey

home, 45–46
Space Churn Theme (Rickey), 116
Spiral Jetty (Smithson), 20
Star Cage (Smith), 29, 87
Star (Indiana), 175
steel, Rickey and, 72
Steel Drawing I (Smith), 29, 81
stelae of Indiana, 22
Storr, Robert, 23
Studease for Post OOWII (Mr.
 Unatural Confrontself)
 (Wiley), 198
Study for a rubber sculpture
 (Nauman), 211
Study for Column of Tetrahedra,
 (1968) (Rickey), 127
Study for Column of Tetrahedra,
 (1971) (Rickey), 126
Study for Column of Tetrahedra,
 (1976) (Rickey), 126
Study for Column of Tetrahedra,
 n.d. (Rickey), 128
Study for Etoile (1960) (Rickey),
 118
Study for Etoile (1966[?])
 (Rickey), 118
Study for Faceted Column, n.d.
 (Rickey), 131
Study for No Cybernetic Exit
 (recto) (Rickey), 114
Study for No Cybernetic Exit
 (verso) (Rickey), 114
Study for Sculpture (Smith), 88
Study for Sedge (1960) (Rickey),
 120
Study for Sedge (1961) (Rickey),
 120
Study for "Seven Virtues and
 Seven Vices" (Nauman), 221
Study for "Slant Step"
 (Nauman), 212
Sun & Moon (Rickey), 113
Sun and Moon (Indiana), 183
Suprize (Chamberlain), 159
Surrealism, 20, 22

T

Tanktotem I and II (Smith), 65

Taos Drop Off (Chamberlain), 151
Thank You Hide (Wiley), 196
That's My Heart (Chamberlain), 146
Thicket (Chamberlain), 30, 163
"Thoughts on Sculpture"
 (Smith), 67–68
Tinguely, "machines of no use," 31
To Land from Sea
 (Chamberlain), 156
To the Bridge (For Grandfather
 Abel and his Children)
 (Wiley), 202
"tradition of the new,"
 Rosenberg, Harold, 15–16
trip hammer, 67
The True Artist Is an Amazing
 Luminous Fountain (Nauman),
 220
Tulane University, 66
24 Greek Y's (Smith), 33
Twice is Nice (Chamberlain), 146
Two Lines Oblique (Rickey), 70, 72
2000 (Indiana), *183*

U
University of Arkansas, 66
University of California, Davis, 34
University of Wisconsin at
 Madison, 54
Untitled (1955) (Smith), *97*
Untitled (1955, Estate #73-
 55.70) (Smith), *98*
Untitled (1955, Estate #73-
 55.77) (Smith), *98*
Untitled (1962, Estate #73-
 62.137) (Smith), *104*
Untitled (1962, Estate #73-
 62.189) (Smith), *104*
Untitled (1962, Estate #73-
 62.210) (Smith), *110*
Untitled (1963) (Chamberlain),
 152
Untitled (1966) (Chamberlain),
 155
Untitled (1969) (Chamberlain),
 154
Untitled (1971) (Chamberlain),
 155

Untitled (1973) (Chamberlain),
 155
Untitled (1979) (Chamberlain),
 155
Untitled (1965) (Nauman), *209*
Untitled (1993) (Nauman), *227*
Untitled (Cubi) (Smith), *106*
Untitled (Forgings) (Smith), *91*
Untitled (Hand Circle)
 (Nauman), *227*
Untitled (Pair of Hands)
 (Nauman), *225, 226*
Untitled, Star Cage (Smith), *86*
Untitled (Virgin Island Tableau)
 (Smith), *79*

V
Verb Goddess (Chamberlain), 160
View of Land from Boat
 (Chamberlain), 156
Voltri series (Smith), 18, 69

W
Wagon I (Smith), *111*
Wall of China (Indiana), *169*
Waller, Edna, 48
Warhol, Andy, 20
Wave I (Rickey), 30, *117*
welding, 17, 63
Wiley, Cleta, 52
Wiley, Sterling, 52
Wiley, William T.
 Bedford, Indiana, home, 52, 53
 Dada and, 22
 early life, 52
 family of blacksmiths, 52
 Funk art and, 23
 materials, 36
 Nauman and, 22
 Richland, Washington, home, 52
 Surrealism and, 22
Wiley, William T., works of
 The Anvil (painting), *200*
 The Anvil (sculpture), *203*
 Beatnik Meteor, *193*
 B.L.O.T., *197*
 Corner Gong, *205*
 Enigma Doggy, *191*

 Flute for A.G., *207*
 The Good and The Grubby, *204*
 Michael Row the Botha Soul,
 194
 Monument to Blackball
 Violence—Homage to
 Martin Luther King, *195*
 Mr. Unatural Takes a Bow, *198*
 Nomad Is An Island, 23, 30,
 36, *199*
 One Desk Base, *207*
 O.T.P.A.G. for E.T.S., *201*
 Slant Step, *192*
 Slant Step Becomes
 Rhino/Rhino Becomes Slant
 Step, *192*
 Studease for Post OOWII
 (Mr. Unatural Confrontself),
 198
 Thank You Hide, *196*
 To the Bridge (For
 Grandfather Abel and his
 Children), *202*
Willard Gallery, New York, 68
Williams, William Carlos, 22
Wisconsin, Nauman homes in, 53
Works Progress Administration, 63
World War II, artists and
 tradition after, 15–16, 17

Y
Yellow Vertical (Smith), 69

Z
Zaar (Chamberlain), *149*
Zenith (Indiana), *169*
Zig II (Smith), 72, *103*
Zig (Indiana), *166*

This book was composed in Adobe Garamond, Bell Gothic and Foundry Gridnik. It was printed on Mohawk Superfine 100lb. text and Neenah Classic Crest 80lb. text with end sheets of French Frostone 70lb. text.